THE PRISM OF HUMAN RIGHTS

THE PRISM OF HUMAN RIGHTS

Seeking Justice amid Gender Violence in Rural Ecuador

KARIN FRIEDERIC

RUTGERS UNIVERSITY PRESS
New Brunswick, Camden, and Newark, New Jersey
London and Oxford, UK

Rutgers University Press is a department of Rutgers, The State University of New Jersey, one of the leading public research universities in the nation. By publishing worldwide, it furthers the University's mission of dedication to excellence in teaching, scholarship, research, and clinical care.

Library of Congress Cataloging-in-Publication Data
Names: Friederic, Karin, author.
Title: The prism of human rights : seeking justice amid gender violence in rural Ecuador / Karin Friederic.
Description: New Brunswick, New Jersey : Rutgers University Press, [2023] | Includes bibliographical references and index.
Identifiers: LCCN 2022057053 | ISBN 9781978835320 (paperback ; alk. paper) | ISBN 9781978835337 (hardback ; alk. paper) | ISBN 9781978835344 (epub) | ISBN 9781978835351 (pdf)
Subjects: LCSH: Family violence—Ecuador. | Women—Violence against—Ecuador. | Women's rights—Ecuador. | Women—Services for—Ecuador. | BISAC: SOCIAL SCIENCE / Ethnic Studies / Caribbean & Latin American Studies | SOCIAL SCIENCE / Women's Studies
Classification: LCC HV6626.23.E2 F75 2023 | DDC 362.82/9209866—dc23/eng/20230412
LC record available at https://lccn.loc.gov/2022057053

A British Cataloging-in-Publication record for this book is available from the British Library.

References to internet websites (URLs) were accurate at the time of writing. Neither the author nor Rutgers University Press is responsible for URLs that may have expired or changed since the manuscript was prepared.

♾ The paper used in this publication meets the requirements of the American National Standard for Information Sciences—Permanence of Paper for Printed Library Materials, ANSI Z39.48-1992.

rutgersuniversitypress.org

For Gabi

CONTENTS

THE PRISM OF HUMAN RIGHTS

PROLOGUE
Gabi, Part I

People in the rural Ecuadorian village of El Carmen noticed a special bond between Gabi and me right from the beginning. In fact, they saw it more clearly than we did. I first met her in the year 2000 when she was only twelve years old. We hit it off right away. Despite an eleven-year age difference, our friendship felt natural and effortless. I never intended to play favorites, nor did I think I had treated Gabi any differently from the other children in El Carmen, a bucolic village in a valley of lush primary rainforest cut through with waterfalls. However, I later learned that every time I sent a gift to the school kids in El Carmen, my package would get delivered to Gabi. Everyone assumed that any gift from me was meant for her, never mind that it consisted of twenty-five pencils, twenty-five erasers, and twenty-five notebooks. They joked that we were sisters, and the more they joked, the closer we felt, until we started to play along with the idea of our sisterhood. A noticeable streak of blonde in her hair was the only visual evidence of our fictive kinship.

Gabi's story is a complicated and difficult one. I have often questioned whether to share it. But Gabi always insisted that she wanted to tell her story. More than anything, she wanted people to listen. To listen in order to learn and to understand. So I include it here and in the interlude and epilogue. For me, and hopefully for others, Gabi's story exemplifies how diverse forms of violence become normalized over time and intergenerationally. Even more, it drives home what it means to have very few opportunities to live a different life. Her story also speaks to the challenging questions that arise when researching intimate forms of violence: how do you make sense of something that produces chaos, resists meaning-making, and yet is so entangled in everyday relationships? If the violence is understood as normal, as everyday, as routine, does that make it any less painful or worthy of intervention?

The pain and violence wrapped up in gender and family are so wounding precisely because they emerge from the intimate realms of one's life. For some, opening up these private worlds to others only exacerbates the trauma, but for others it can be empowering and even crucial. This book is written in remembrance of Gabi's fierce strength, her aspirations for a better life, and everyone's capacity to listen, however challenging it may be.

INTRODUCTION

Understanding Gender Violence through the Prism of Human Rights

I was fast asleep one night in 2002 in a newly built health center in rural Ecuador when a young boy came screaming and banging on the door. Accustomed to late-night emergencies, my medical colleagues and I popped up as if on autopilot. The doctor answered the door while I prepared the consultation room. But this time we did not need the room. The fourteen-year-old boy had run from his home, thirty minutes away along a muddy riverside, desperate for help to protect his mother. He hadn't been able to stop his drunken father from pouring kerosene on her, but he did get her to the river to rinse off, momentarily protecting her from the most extreme risk of being set on fire. We notified a group of men who lived near the health center, and they set off for the boy's home. They calmed down the father, and the mother was spared that night. I asked after the family in the days that followed, but details were hard to come by. Most people confirmed that the incident had happened, but beyond that they were matter-of-fact and unemotional. "Yeah, I heard about that," they said. "I don't really know that family," or "What a shame."

I couldn't make sense of their responses. This was my first encounter with gender violence in Las Colinas, the rural region in northwest Ecuador where I had been volunteering for six months, and I couldn't reconcile the horrific details of this incident with people's nonchalance. Was I missing something because of my imperfect grasp of the local language and norms? Or was this apparent nonchalance a sign of something deeper—perhaps the normalization of violence in everyday life, communal shame, or even a general disregard for women's welfare? As a recent college graduate with women's studies and anthropology classes fresh in my mind, I was most convinced by the latter explanation. The broad devaluation of women fit easily with my assumptions about Latin American "macho culture." Plus, the solution this presented—that Ecuadorians simply needed to learn that intimate partner violence was wrong—fit nicely with my identity as a privileged, white, international volunteer. After all, I had learned throughout my life that

intimate partner violence was a problem that demanded a response. How could it be otherwise?

I continued to live in Las Colinas intermittently between 2002 and 2004, coordinating health, community development, and outreach projects through the community-owned health center and an international nongovernmental organization (NGO) that I call *La Fundación*. Unbeknownst to me, what was supposed to be a short stint as a volunteer was laying a foundation for two decades of work in this area on the topics of gender, health, and violence.

Las Colinas consists of twenty-six communities spread across Ecuador's only remaining patch of lush, coastal, tropical cloud forest. Despite its location within a nationally protected reserve that is considered a "global conservation priority," the region experiences extremely high levels of deforestation because of the six thousand settlers who make a living within its borders. Most inhabitants migrated there in the 1970s in search of productive land to grow coffee, cacao, and bananas. Today, however, the lack of land titles, the instability of cacao and coffee market prices, and an increasingly volatile climate create a context of extreme insecurity.[1] The men of Las Colinas find it hard to support their families due to limited opportunities in the market economy and the rising cost of consumer goods.[2] People's identities are increasingly threatened by these "failures" and by women's efforts to make up for lost family income, which unsettle the historically strict gendered division of labor. Furthermore, many houses are at least thirty minutes apart, making it hard to establish strong community networks that might otherwise buffer these economic blows. This is especially isolating for those women, who remain largely confined to the home and who suffer disproportionately from violence in its many forms.

To ameliorate these economic challenges and facilitate female empowerment in this rural region, a Canadian-Ecuadorian NGO established a women's microcredit organization in Las Colinas in the late 1990s. The result, the Women's Bank, became the first community-wide forum for discussing women's issues. Its members became the protagonists of many of the health and development activities of the health center and the sources of many of the insights in this book.

In a late-afternoon meeting with the Women's Bank in 2004, I asked how health center volunteers and coordinators might attend to the concerns of women when designing outreach programs. With little prompting, Lorena, a forty-year-old community leader, took the floor and announced, "Well, for one, women are sexual slaves for their husbands. Sexual violence is a big problem because husbands force sex onto their wives against their will. This is rape. If women refuse sex to their husbands, their husbands beat them." I was taken aback by this response. What I had been expecting was for the women to discuss their limited access to credit, contraception, or political participation. Since the midnight awakening at the health center two years prior, I had heard gender violence mentioned only sporadically, and only in the context of broader discussions about the everyday challenges of maintaining a viable livelihood in precarious circumstances.

From the detached way in which community members had spoken of the kerosene incident, I had assumed that gender violence was considered normal and acceptable. But in the conversation that followed Lorena's response, many women and even some men voiced nuanced and serious concerns. They insisted that *maltrato* (mistreatment or abuse) by husbands could harm women's health, family integrity, and the community's economic development. They reasoned that the whole community suffers when women are afraid to leave their homes and men "waste energy controlling their wives" and then "drink their savings to show off their independence," as interviewees told me. I quickly realized that gender violence might have been unremarkable to people in Las Colinas, but they certainly did not condone or accept it. There was a difference. In fact, they rarely spoke of gender violence on its own precisely because they understood that it was not separate from the structural violence and social suffering brought on by poverty, lack of education, and limited health care.[3]

However, their understanding of gender violence was not the only one circulating in the region. Since the 1990s, governmental organizations and NGOs in Las Colinas have tried to raise awareness of intimate partner violence *as a distinct social problem* that demands a unique response, ideally a legal-juridical one (Alvarez 2000; Lind 2005; Tapia Tapia and Bedford 2021). Through workshops on family relations, children's rights, intimate partner violence, and sex education, these organizations have sought (often unknowingly) to remold local ideas of justice, violence, and well-being along the lines of universal human rights. Instead of seeing intimate partner violence as a facet of domestic relationships that may be tolerable or justifiable, they have taught that *violence is always unacceptable*. Instead of seeing interpersonal violence as always entwined with structural violence, these organizations have framed domestic violence as a problem understandable and changeable in its own right. And instead of focusing on the barriers women face in addressing violence, these interventions emphasize that women have a right—and a social obligation as dignified women and responsible mothers—to report intimate partner violence and denounce the perpetrators.

In this book, I examine how human rights "hit the ground" in this rural region and the complex effects they have had. Over the last twenty years, the people of Las Colinas have seen three types of interventions against intimate partner violence: the human rights approach, which frames violence as a problem of rights awareness, cultural norms, and legal-juridical access that demands a response from victims and the state; the Women's Bank approach, which addresses violence slantwise, as one aspect of women's disempowerment that might be addressed through economic and social inclusion; and the diverse and organic responses of local women and families, which were based initially on preexisting cultural norms and have continued to shift in response to these two outside interventions. I show how these three different models—and the ideas attached to them—are interpreted and remade at the grass roots through a process that Sally Merry (2006; Merry and Levitt 2017) calls *vernacularization*. This allows us to see what human

rights actually become and how they actually affect gender violence at the level of messy, on-the-ground realities rather than as neat and tidy conventions, national policies, or NGO plans.

By following the same families for twenty years, I ask whether these human rights campaigns work and reveal what kinds of work they do. Yes, campaigns to define gender violence as a human rights issue have clearly changed the conversation about violence, suffering, and injustice in Las Colinas. Most people now speak of domestic violence as an issue and characterize it as unambiguously wrong. However, rates of violence against women are not necessarily diminishing, and the human rights framework has amplified a number of key contradictions that families face. Women, in particular, find themselves in a double bind, keenly feeling the limitations of human rights messaging when they do not have the economic, social, or political means to actually address or avoid violence. And yet, they often experience shame for tolerating long-standing violence. In short, we see women regularly claim that violence has diminished, while less visible forms of violence continue unabated.

What other kinds of work do gender violence interventions do? Women's rights have not only been introduced *alongside* globalization, development, and state building; women's bodies, sexuality, and rights have also been *a platform for* globalization, development, and state building. Thus, the women and men of Las Colinas interpret the new languages, identities, and relationships conveyed through human rights not only with an eye toward domestic violence but also as tools for negotiating the broader changes that are unsettling this rural region, as agricultural livelihoods become increasingly precarious and locals need new forms of institutional support.

GLOBAL HUMAN RIGHTS CAMPAIGNS AGAINST GENDER VIOLENCE

Understanding and eliminating violence against women has been one of the central challenges of our time. The signing of the 1979 U.N. Convention on the Elimination of all Forms of Discrimination against Women (CEDAW) and of the 1993 Vienna Declaration were both landmark moments that helped establish women's rights as human rights. Since then, international agreements, ambitious national laws, and the proliferation of human rights awareness campaigns have expanded legal services and made gender violence more visible. Despite such efforts, violence against women continues to increase in scope and intensity in all countries and socioeconomic groups (Merry 2009; True 2012). This book explores this conundrum through ethnographic analysis of gender and social change in rural coastal Ecuador, where although people may now characterize domestic violence as morally and legally wrong, rates and instances of violence against women are not declining.

While establishing human rights provides important openings for people seeking change, they do not offer easy, straightforward, or complete solutions. One reason, I argue, is that human rights are inherently paradoxical: they are simultaneously local and global, and the relationship between local and global is in constant dynamic tension. When we think of human rights, we think of a universal or global set of ideal "rights" every human deserves. But this ideal does not add up to much until it is applied to real lives and real contexts. In other words, "humans realize their rights only in particular places with particular instruments and with particular protections" (Stern and Straus 2014, 3). They become meaningful only in local practice, and yet their practical power derives from their abstract globalism, with their claims to a universally shared moral position.

A woman's right to live free from violence is enshrined in formal documents and conventions such as the 1949 Universal Declaration of Human Rights or CEDAW. But these "rights" mean something to the women and families in Las Colinas only when they actually hear messages about "human rights" or when their lives are affected by rights-based policies and programs in material ways. What exactly the human right means is shaped by how the messages, policies, and programs affect other aspects of everyday life. The ethnographic perspective in this book allows us to look at how global ideas about human rights are getting to the local regions of Las Colinas, and how policies and campaigns against gender violence are affecting people's lives there. In this book, therefore, I examine how global ideas about human rights, and especially women's rights, are understood, negotiated, and acted on by people in one locality—a rural coastal area of Ecuador.[4] This on-the-ground insight helps us understand the tensions between local and global processes, the reasons that rights frameworks have not reduced gender violence, and the other unintended effects of human rights campaigns.

THE LOCAL LIFE OF RIGHTS IN LAS COLINAS

Legislation against gender violence in Ecuador has been quite progressive, but its effectiveness varies widely for different groups, depending on social class and geographical location. Gender violence, and violence between intimate partners (IPV) in particular, is extremely common in Ecuador, as it is in many places across the world, including the United States and Europe. Broad estimates of prevalence are always challenging because of the private nature of IPV and the shame many women feel when communicating about it. However, prevalence data from various studies indicates just how widespread and persistent gender violence is in Ecuador. The most recent national-level study in Ecuador—the 2019 *Encuesta Nacional sobre Relaciones Familiares y Violencia de Género contra las Mujeres* (National Survey of Family Relations and Gender Violence-Against-Women)—*ENVIGMU* surveyed women (aged fifteen and older) in 20,848 households and found that 64.9 percent had experienced some form of gender violence during their lifetimes (INEC 2019).

This number had increased from 60.6 percent of women (of 18,800 households) reported in the previous survey in 2011 (INEC 2011).[5]

As recently as the early 2000s, the people of Las Colinas were not familiar with the term *derechos humanos* (human rights, or *derechos*, for short). Only a few had heard of children's right to education in the context of government campaigns to make sure children were sent to school. Over the next decade, men and women increasingly heard about women's rights, or *derechos de la mujer*, on the radio, on television, during health center workshops of various kinds, and through national and international campaigns and holidays (such as International Women's Day, International Day against Violence-against-Women, and International Children's Day). Others learned about their rights via their interactions with the state, when they filed police reports, applied for social welfare programs, or registered children for "child support." Many people first heard the term or understood the concept through a suite of informal processes, such as long-term interactions with international friends and volunteers in the region, me included.

Several years after people first heard the term *derechos*, the 2008 Constitution made these citizens' rights more explicit as part of a political platform promoting social inclusion and participatory citizenship. "React Ecuador, Machismo is Violence," said an educational campaign that accompanied the Constitution and that was launched through television, radio, billboards, and social media to combat gender discrimination and violence. This campaign, an initiative that I examine in chapter 4, aimed to denaturalize masculine gender norms and broaden public conceptions of what should be considered violence, including everyday sexist remarks, catcalls, and psychological and economic violence against women. It raised awareness of the high rates of violence against women (determined for the first time in reputable national-level surveys) and used powerful imagery to emphasize female victimhood and male brutishness. In fact, some of the more evocative TV commercials represented abusive husbands, literally, as prehistoric cavemen. The campaign exemplified the rights-based (and numbers-based) approach adopted by NGOs, UN agencies, and the Ecuadorian government.

Such newly promulgated ideas about rights are not isolated from messages about modernity, good health, development, and the importance of education. Development campaigns emphasizing women's rights have coincided with broader processes of globalization. Today, television, movies, internet, radio, and NGO programs increasingly expose people to transnational ideas about gender, sexuality, and health. Many of these messages are lumped together, communicated, and interpreted unevenly by a host of different institutions, interlocutors, and mediators. Furthermore, each term is reinterpreted through the prism of the others. For example, one woman in Las Colinas may have learned about "children's rights" through meetings with teachers while another learned about her right to free birth control at the health center from the attending nurse; in both cases, those teaching such concepts equated claiming one's rights to being a modern, sophisticated, responsible, and educated or healthy mother.

To capture this real-world messiness of rights discourses, I do not spend much time parsing the differences between "ideas of women's rights" and "actual policies based on rights." I lump ideas and policies together precisely because this is how people in Las Colinas understand them, "as something that outsiders (who appear more educated) say is good for me," and as a bundle of interventions that are supposed "to bring tangible benefits to me and my children." In addition, although I sometimes refer to the global as if it were separate from the local, this analysis ultimately asserts that local and global phenomena are mutually constitutive and inseparable (Stern and Straus 2014). This is one aspect of the paradox of rights I mentioned earlier, and it carries a range of conflicting value judgments. On the one hand, the global is considered more Western, cosmopolitan, progressive, and "civilized," especially in conversations on human rights. On the other hand, scholars and activists who resist the imposition of so-called Western values on diverse cultures often romanticize the local, such as indigenous forms of knowledge and justice they think should be prioritized over foreign ones. By seeing the local and global as fundamentally interconnected, however, I cut through this binary to illustrate that human rights are not simply an imposition from the global to the local or from the West to the rest. After all, human rights themselves came to be through local community mobilizations across the globe. Advocacy by women and families—all trying to address very local instantiations of violence—helped shape the global debate around human rights. The resulting global policies then provided tools that activists could use in their local struggles. Thus, human rights are constructed dialectically from action at multiple scales and across scales. While this creates an inherent paradox within rights, it also lends rights their power. Over twenty years, I have been able to see how Las Colinas's men and women have grappled with multiple understandings of rights, gender, violence, and themselves. I show how they have done this in relation to each other, in relation to their material surroundings, and in relation to other ideas and values such as modernity, health, and development.

WOMEN CLAIMING RIGHTS AND
EMBRACING THE STATE

In a rickety wooden house adjacent to the health center, community health promoters, health center staff, NGO staff, and volunteers from *La Fundación* gathered with the *Comité de Salud* (the community-run health committee) to make some tough staffing decisions. At this tense meeting in 2004, a male health committee member complained about the president's decision-making, implying that the president of the health center's *Comité de Salud*, a woman named Diana, was unqualified for her job.[6] The more agitated he became, the more dramatically his voice escalated, and we all grew uncomfortable. He was a physically intimidating man, and he knew how to use this to his advantage. Slamming her hand onto her desk, Diana jumped to her feet and thwarted his aggressive, masculine move:

If you have a problem with the decisions of the health committee—of which I am president—go ahead and hit me right now, as all the men do to their women here. We have been victimized for too long. You may not respect women here, but the state of Ecuador does. So go ahead and hit me. I will finally have recourse this time.

Diana voiced the growing awareness of many Las Colinas women: that they had a right to live free from violence. To me, this signaled a major shift in how women talked about violence. Violence was no longer a fact of life, often justifiable and therefore to be endured. This was also the first time I had heard a woman explicitly describe herself as a citizen who implicitly has rights.

Although the first law against family violence had been passed in 1995, these women in the remote cloud forest only learned of it in 2003 when a friend, another American volunteer, began to work with the local women's organization. Learning of this law was significant for local women: it was the first time they could point to the commitment of the Ecuadorian state to protect women and any abused family members, and to the fact that international instruments backed this commitment. The incident with the agitated committee member revealed how women were engaging multiple global discourses simultaneously as they sought to make sense of and re-create their subjectivities, citizenship, and local social relations. For example, Diana was working out her own relationship to violence and gendered disempowerment through the global discourse of rights, the Ecuadorean state's inclusionary model of citizenship, and *La Fundacion's* notions of NGO "good governance."

Diana's comments must be seen against a backdrop of regional invisibility and exclusion. Although most colonists first came to Las Colinas in the 1970s, in the early 2000s there was still no evident system of formal justice. Nor was there consistent electricity, roads, or potable water. The utter lack of state infrastructure was a powerful reminder of the physical, political, and cultural distance between Las Colinas's rural villages and the Ecuadorian state, which is centralized in the high Andes in Quito, approximately six hours away. After years of government neglect, Las Colinas's settlers were understandably distrustful and angry. But they were also proud. Their resentment was coupled with a valorized identity and a self-perception of being resourceful, independent, and autonomous, characteristics broadly attributed to people from Manabí. This pride and autonomy, however, was increasingly a point of contention in a changing world that required people to be more visible and legible to—and sometimes protected by—the state (Scott 1998). Indeed, Diana's comment shows how women's improved status, because it is tied to increased state power, might easily be seen as a threat to men's traditional control over both their wives and the region.

Until the late 1990s, Las Colinas was notorious for its isolation. Men who broke the law in other areas of Ecuador often moved there to establish homesteads far from the reach of the state. In the early 2000s, however, local community groups began to collaborate with both governmental and nongovernmental organizations

to improve the region's access to infrastructure. The process of connecting to national services and infrastructure such as roads, electricity, and educational and health services ushered in challenging new forms of citizen-state relationships and governance.

In the pages that follow, we will see that becoming legible, whether for protection against violence or to promote community-driven development, is invariably interwoven with changing notions of gender, rights, and violence. And this is not simply because rights discourses and state-building happen to coincide. In this context, "women's rights" are more than a series of messages, policies, and practices introduced by the global community and taken up by a local community. They also become the path through which both the state and the community of Las Colinas negotiate inclusion and citizenship in inherently gendered ways. *Vernacularization* is a process whereby human rights are not merely interpreted through the preexisting lenses of gender and sexuality, but also through understandings of self and community in relation to the state and "modernity." Ideas of rights, gender, and citizenship are co-constituted in relation to one another. For example, NGOs, the Ministry of Health, and the Ministry of the Environment have all instituted campaigns to highlight women's rights to bodily autonomy and to live free of violence. Such direct efforts to transform intimate relationships between women and men have also integrated Las Colinas into national and transnational networks, and yet this cultural and social change is not entirely forced on Las Colinas from the outside. Las Colinas's citizens have also taken up these projects in performative ways to "act modern" and accrue benefits from these same institutions, as we will see in chapter 5. Therefore, men and women become contemporary, participatory citizens of the state in part by enacting and performing "modernity" through violence-free relationships. Conversely, one way women and men enact violence-free relationships is by engaging the state in new ways. But neither of these processes is seamless.

Diana's appeal to the state, her condemnation of gender violence, and her challenge to male authority crystallizes many of these changes. This may be difficult for readers from the Global North to understand, but it is a significant change in identity for women like Diana to imagine that the state might provide recourse from the threat of violence. And suddenly framing violence as a "rights problem" marks a major transformation in how she experiences and understands violence and her family relationships more broadly. Examining Diana's story and the stories of other women in Las Colinas, as I do here, will help us understand how transnational ideas about gender and violence remake relationships between people, communities, and the state. But first it is time to locate Las Colinas and its people.

LOCATING LAS COLINAS

Approximately six thousand people live in the twenty-six villages that make up the region of Las Colinas, located in a patch of cloud forest in the southern part of

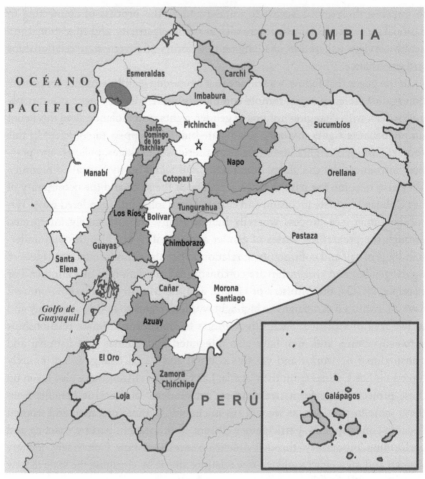

FIGURE 0.1. Map of Ecuador adapted from https://commons.wikimedia.org/w/index.php ?curid=31748142. Approximate location of Las Colinas indicated by shaded area. The capital, Quito, is marked by a star.

Esmeraldas province. *Mestizo* and, to a lesser degree, Afro-Ecuadorian settlers have been arriving in Las Colinas in search of productive land for subsistence agriculture since the 1970s. Most come from the neighboring province of Manabí, where agrarian reform, overpopulation, and climatic conditions have made cultivable land scarce. Not that life in Las Colinas is easy: its inhabitants live in a precarious state of poverty. They survive on minimal income, and, as squatters without formal land rights, their relationship to the land that sustains them is profoundly insecure.

Families occupy homesteads in sparsely populated villages ranging from one to ten hours from the nearest city, Quinindé. The remote interiors of the region are referred to as *adentro* (the inside, or the interior). People emerge from *la montaña adentro* (the lush, coastal mountains in the interior) every week or two to sell cacao, purchase goods, visit the health center, and connect with the wider world

via cell phone access, television, and now internet in the central community of Agua Dulce. Typically, men would make this trek alone while women stayed home with little social contact aside from the occasional party or school meeting, though this is changing.

Other than a handful of primary schools, government institutions and services are largely absent. The government provides occasional short-term road improvements but has yet to provide water or sanitation services to the region. For example, about fifteen communities became connected to the electric grid only in the last eight years, and the process was slow despite consistent community-based commissions and appeals to the municipal government. Much of the infrastructure in the region has actually been achieved only through global partnerships between the community and international nonprofit organizations, a pattern that has added to prevailing skepticism about the Ecuadorian government's ability and willingness to provide key services.

In 2001, in response to a major malaria outbreak, regional leaders organized to build a small health post and asked a German medical student who had been volunteering in the region to help them find funding. To do so, the medical student began a German NGO. I and others joined the effort, and later established a U.S.-based nonprofit to partner with an emerging network of NGOs in Germany, the United Kingdom, and Ecuador, all with the goal of raising funds, building a health center with adequate equipment and personnel, and developing community-centered health programming in Las Colinas. Despite the fact that the majority of funding came from other countries, the community was always at the center: as we developed fundraising infrastructure abroad, they formed a committee representative of the region's diverse communities, they became a legal entity and communally purchased the land for the health center, and they organized and provided labor and materials through collaborative work parties, or *mingas*, to build the health center and its associated medicinal plant gardens, clean water and energy infrastructure, and lodging.

For nearly fifteen years, the community health committee and the NGOs (together, I call them *La Fundación*) coordinated health center operations somewhat independently from the Ministry of Health. With local administrators, community health workers, foreign medical volunteers, and international donations of equipment, we had achieved a type of transnationally supported autonomy that fit well with people's identities (Friederic and Burke 2019). However, coordinating with the Ministry of Health was a legal requirement. Furthermore, as government health programs improved greatly between 2008 and 2018, the community health committee decided to transfer most of the operation of the health center to the Ministry of Health, though the committee still owns the center and makes final decisions. Importantly, these community–NGO collaborations enabled the community to more effectively lobby local governments. They also acted as a magnet, drawing other NGOs to the region to support environmental education, ecotourism, and microcredit initiatives.

Despite the existence of legal and judicial services in Quinindé, a city a couple of hours' drive away, Las Colinas itself has no formal law enforcement. Increased access to legal-judicial services in Quinindé has decreased reliance on community-based conflict resolution, but community-level moral discourses continue to shape the use of formal legal services in the city.[7] For example, people cite the refrain *no se mete en cosas ajenas* (stay out of other people's business) to justify nonintervention in most cases of domestic abuse unless fights are excessively and visibly violent. At other times, they argue that particular encounters do not count as "violence" because of the rationale or the context. Though community members can now file police reports in the city (which has helped in some cases), most cases of violence continue to be resolved informally or "put up with" by the survivors themselves. Even in 2022, I learned that multiple women have restraining orders against their ex-partners, and yet, these orders provide virtually no protection in this distant region without police presence. Understanding this context, which historically has been designated as "isolated," "out-of-the-way," and fiercely "local," is particularly important to my analysis of the political economy of gender and family relations, and to the relationship between local and global dynamics of social change.

RESEARCH AND ACTIVISM OVER THE LONG TERM

Capturing the enduring sociocultural impacts of human rights campaigns requires long-term research. This book draws on my twenty years of engagement with people living in Las Colinas. I entered the region as a volunteer (2000 to 2003) and have conducted ethnographic research, historical research, and applied work in collaboration with the Las Colinas community health center from 2001 to today. In addition to fundraising while at home, I have participated in a variety of community-based health and development initiatives on the ground in Las Colinas throughout these twenty years, including traveling with and organizing mobile medical clinics to distant communities, disseminating clean water systems, developing and giving reproductive health workshops, assisting with post-earthquake reconstruction of the central school, and building improved health communication networks throughout the region (Friederic and Roberge 2002; Ordoñez Llanos 2005; Friederic and Burke 2019). Most, but not all, of these initiatives were successful, despite all of the complex dynamics that accompany all "development" projects. Most importantly the relationships that have sustained these collaborations have proven resilient.

Occupying multiple roles as scholar, activist, and development practitioner offered three key benefits. First, it gave women and men confidence in me as "a member of the health center," not just the "domestic violence researcher," though I found myself having to continually remind people about my primary research project. Second, this applied work allowed me to see how people were grappling with new notions of rights, development, modernity, and citizenship across many

FIGURE 0.2. Conducting a mock interview with a research assistant. (Photo by Aldo Martinez Jr.)

domains of life. Without this, I would likely not have understood how the anxieties and tensions around "gender violence"—as it became a distinct social problem— revealed deeper forms of gendered disquiet about community development into the future. Finally, occupying multiple roles encouraged me to embrace a productive tension between critical and pragmatic approaches to gender, violence, and suffering, a topic to which I return in this book's Conclusion.

The ethnographic research for this book draws primarily on participation and observation (as a friend, researcher, activist, and development volunteer), in addition to eighty semi-structured interviews with women and twenty semi-structured interviews with men. All interviews were conducted between 2002 and 2016. In the earliest years of my involvement in Las Colinas, most of my friends were men, as they were the ones who most actively participated in community meetings and development projects. After a couple of summers, however, I began to conduct research on family health, for which I exclusively interviewed women about household decision-making. In these interviews, I learned more about the violence that was rampant within households. In many cases, I was shocked to learn that men, friends whom I deeply respected for their dedication to their community, were also violent toward their wives or children or had been so in the past. I chose not to risk conducting private interviews with men in the earlier stages of this project, as it may have jeopardized the trust I was building with women. Later, however, I interviewed men and vowed to represent them as multiply constituted individuals. Though I never excused or justified their use of violence, I felt it important to

FIGURE 0.3. Father with baby, traveling by horseback, from a remote community to the Agua Dulce health center. (Photo by Aldo Martinez Jr.)

portray these men as more than "wife beaters," especially because this is how I came to know them myself. In the end, however, the women's stories shape most of the narrative of this book, and though I include some men's perspectives here, they will be the subject of a future publication devoted to them in their own right.

To supplement these perspectives, I conducted oral histories with eight couples, and sequential interviews with a subset of fifteen women (once every two years, over six to fifteen years). The sequential interviews highlight changing experiences of gender, violence, and rights across time. Data from participant observation, focus groups, informal meetings, workshops, and casual discussions about gender relations, family health, and violence provided insight into the role of "gender violence" among broader concerns about community development. One of the richest experiences was my organization of the women's group meetings during my longest research period, over sixteen months in 2007 and 2008. Once a month, I invited women from Las Colinas's central village, Agua Dulce, to gather for an evening in a visible but private *comedor* (eatery) in the middle of the village. It was particularly important that the meetings be held after dinner was served and in a location visible to others, so there would be no question as to where the women were that evening, thus mitigating any concerns about their fidelity. I provided snacks, and we had informal conversations about a particular theme or topic of discussion. Unlike a focus group, I did not steer these conversations in any strict manner but rather let the conversations unfold naturally. The women cited these meetings as one of the most enjoyable aspects of my project and their day-to-day lives. They were moments of sharing, laughing, and solidarity building—all of

which were elements missing from the women's lives, as they did not have legitimate spaces to "hang out" together in public. They also served as opportunities for the women to "interview" me and challenge the usual hierarches inherent in ethnographic research, a dynamic central to feminist activist ethnography (Craven and Davis 2013). Finally, I incorporated institution-based interviews aimed at understanding the positions and interventions of various NGOs, including *La Fundación*, as well as state-sponsored programs that had been directly involved in health, education, and development in Las Colinas.[8]

POLITICS OF GENDER AND VIOLENCE AT MULTIPLE SCALES

Unpacking the stories of women like Lorena and Diana in an out-of-the-way place like Las Colinas has helped me examine how growing awareness of women's rights affects understandings of and responses to gender violence (Tsing 1993; Friederic 2014b). This book traverses multiple scales—from individual bodies to human rights institutions—to examine how new ideas about women's rights and gender violence reshape subjectivities, family relations, and citizenship. This process is shaped first and foremost by the region's history of gender politics. For example, Las Colinas (and Manabí province) is a place where masculinity is largely defined by the protection of women. The increased role of the state in adjudicating and providing protection for women and children, at the very least symbolically, challenges masculinity on multiple fronts.

Women suffer disproportionately from gender-based violence, but men are affected, too. Gender violence derives its power from the differences between men and women, and how these differences are asserted and leveraged. Therefore, gender violence must be examined and understood through the co-construction of masculinity and femininity. In a place like Las Colinas, this co-construction is quite explicit. There, it is widely believed that a man asserts and maintains his status as a respectable man (a "manly man" or a "real man") by demonstrating sexual prowess with women and protecting his own women (his wife, daughters, mother) from dangers, including the dangers of other men. Men see their dignity largely in relation to women, and women in Las Colinas often recognize themselves in relation to their role and duty to care for their husbands and children. In chapter 2, I explore this mutual constitution of masculinity and femininity in relation to violence. In the book as a whole, I approach the phenomena of violence, human rights, and community development from a gendered and relational perspective.

VIOLENCE AND MASCULINITY

In Las Colinas and in the province of Manabí, the performance of violence is and long has been central to male identity. As Sally Merry (2011) explains, the term *gender violence* characterizes situations in which "the meaning of the violence

depends on the gendered relationship in which it is embedded" (3). Often, those relationships are used to explain or sometimes justify the violence, as in "she deserved it because she disrespected her husband" or "Danny hit Herman because Herman insulted Danny's girlfriend" (3). Gender violence encompasses more than what is commonly understood as *domestic violence*, or violence committed by a male partner against a female household member, and as more than *intimate partner violence*, which captures violence committed between partners in an intimate relationship whether or not they are married or cohabiting. I address all of these forms of violence. While my focus is usually on intimate partner violence, I always examine it in relation to other forms of gender violence in Las Colinas. For example, in this region, land disputes between men are common and have resulted in shocking murders that many explain or even justify as a reasonable (if not entirely encouraged) aspect of masculinity. Because these manifestations of violence grow out of and shape men's understandings of themselves as men, they too can be considered gender violence. For people in Las Colinas, incidents such as these reinforce norms (associated with gender, violence, and their relationship), thus affecting how men and women engage in, make meaning of, and respond to intimate partner violence as well.

Because gender is taught, learned, and reinforced in everyday life, it also follows that the meaning and significance of gender violence can only be understood in context. Early studies of domestic violence prioritized episodic snapshots of violence, often focusing on the individual pathology of perpetrators or the psychological "syndromes" of female victims who suffered from repeated, cyclical abuse (Counts et al. 1999). Even though domestic violence is common in the United States, popular news and academic scholarship tend to blame or inadvertently attribute it to "other cultures" characterized by toxic forms of masculinity and male obsession with honor and purity. On the other hand, ethnographic research on gender violence has been principally concerned with more holistic approaches that examine the intersecting factors that make violence variable by cultural context.[9] Since 2005, a number of ethnographies on gender violence have emphasized the links between individual victims and structures of power to contextualize violence without dismissing or legitimizing it (Hautzinger 2007; Alcalde 2010; Wies and Haldane 2011; Parson 2013; Zheng 2022). This important work has encouraged us to ask what particular sociocultural, political, and economic dynamics produce and reproduce gender violence in different locales. This book builds on these previous works by situating gender violence in relation to the sociocultural and political-economic context of rural coastal Ecuador. This holistic approach is key to unlocking the power and grip of violence: for it allows us to see how domestic violence is connected to other forms of violence and suffering, how the threat of violence shapes men's and women's lives, and how people respond once violence is framed as a "social problem" (Adelman 2017).

So, what do we know about gender violence thus far? In her groundbreaking ethnography of domestic violence in Brazil, Sarah Hautzinger (2007) outlines

lessons from cross-cultural research on gender-based violence in the twenty years prior to her research. First, gender-based violence is "alarmingly widespread, but not universal" (32). Feminist anthropologists have painstakingly explored a range of societies to understand the dynamics and causes of women's subjugation and gender violence. While experiences are highly variable, they have determined that gender violence (in some form) "takes place in virtually all societies around the world" (Merry 2009), but the exceptions are important for underscoring that violence is socially constructed rather than natural and inevitable. Second, violence is both destructive *and* productive. For example, we may focus on how violence destroys relationships and undermines trust, but it is simultaneously a "key resource for the performance of masculinity" (Hautzinger 2007, 32). Third, experiences of violence and approaches to prevent it are not "one size fits all." Efforts to frame domestic violence as a universal experience tend to fail because, despite many commonalities across cultural settings, gender violence is always deeply embedded in a particular economic, historical, and cultural context. Local instances of gender violence emerge out of "particular kinship structures, gender inequalities, and levels of violence within the wider society," not to mention a range of other factors including patterns of marriage, the availability of divorce, how gender is defined, racism, and poverty (Merry 2009, 1). There are no singular causes, but there are intersecting factors that make gender violence more likely. Fourth, gender violence is preventable through a multifaceted approach that emphasizes broader measures such as material supports and conciliatory processes rather than merely criminalization and punishment, especially at a time when human rights approaches to violence against women have taken a sharp turn toward the punitive (Hautzinger 2007; Tapia Tapia 2018).

Because gender violence is multifaceted, activists and scholars regularly advocate interventions that combine awareness-raising, legal advocacy, policy change, and economic initiatives (Morrison et al. 2007; Heise 2011, 2012). States must address domestic violence, at the very least by criminalizing domestic violence, enforcing laws against it, and providing adequate access to legal and judicial services (Adelman 2017). However, an exclusive focus on legal or policy solutions can lead to dangerous unintended consequences, including failures to improve the circumstances that would allow women to leave violent relationships in the first place (Coker 2001; Adelman 2017; Tapia Tapia and Bedford 2021). Similarly, interventions that focus only on microeconomic empowerment, awareness, or consciousness raising are often unsuccessful and may bring increased rates of violence (Heise 2011). However, limited resources and short-term funding cycles for NGOs often lead organizations to opt for more economical educational interventions rather than for multipronged programs. Even worse, these awareness-raising interventions are often formulated in the language of feminism of the Global North, and based on experiences in North America, Europe, or urban centers in the Global South, not on rural contexts where gender relations and daily life are very different.

FROM SUFFERING TO VIOLENCE

One of my starting points for this book is that domestic violence must be understood in relation to other forms of gendered structural violence. Because many rights-based interventions in domestic violence are predicated on narrow understandings of gender violence (for example, gender violence as the physical abuse of weak women by hyper-masculine men), they fail to disrupt the social reproduction of violence in places like Las Colinas, despite raising important awareness of the issue. Anthropological scholarship on violence from the past three decades informs this starting point or argument.[10] Like many anthropologies of violence, this book aims to understand the inequitable distribution of violence and suffering as linked to historically driven political-economic processes, such as those that arise from the boom-and-bust, export-driven economy of coastal Ecuador. The experience of suffering may be universal, but it is far from equal in its distribution.

Violence and suffering, however, are also shaped and informed by meaning, that is, broader cultural understandings of masculinity, femininity, or marriage. A man in Las Colinas, for example, may slap his wife one morning because he is stressed about the family's finances (let's say he thought she spent too much money on the children's school clothes). His sense of "ownership" of these decisions is historically rooted in the ways that household decision-making and the sexual division of labor have been organized deep within the coastal jungle. But the pain she feels in that slap is not merely physical. Nor can it be explained solely by the financial stress or the historical political economy of the region (which also involves multiple other forms of violence like poverty, hunger, and political marginalization). She feels the burn of that slap on her skin travel deep into the pit of the stomach, and register painfully in her psyche, because it also challenges her sense of self-worth and dignity as a person, a wife, and a mother who thought she was doing what she needed to do to be a good woman. In short, this interpersonal form of violence is embedded in broader systems of meaning and in a political and economic context, both of which shape how the violence is experienced. Concepts such as social suffering and structural violence reflect attempts by scholars to merge phenomenological (or meaning-centered) and political-economic analysis in understanding suffering.

To account more explicitly for the institutionalized forms of violence that translate into everyday violence, anthropologists have used the concept of structural violence. Generally, this refers to systemic, often invisible, forms of violence that cause harm to individuals or populations and are produced and perpetuated by economic, political, religious, legal, and cultural structures. Differential access to resources, health care, and education constitute examples of structural violence. Paul Farmer uses structural violence as "a broad rubric that includes a host of offenses against human dignity: extreme and relative poverty, social inequalities ranging from racism to gender inequality, and the more spectacular forms of violence that are uncontestedly human rights abuses" (Farmer 2003, 8). Although

critics warn that this concept has been severely overused, structural violence remains valuable to the analysis in this book because it redirects attention to the invisible dimensions of violence and suffering caused by inequality and because it serves as a call to action.[11] The concept may not isolate specific perpetrators of violence, but it appeals to a sense of moral indignation and injustice that compels us to respond.

In this book, I treat violence as multidimensional—physical, psychological, social, economic, sexual, and structural. I examine how acts of violence and threats of violence also comprise "assaults on personhood, dignity, and the sense of worth and value of a person" (Scheper-Hughes and Bourgois 2004, 1). While I prioritize the intimate context of violence among heteronormative families in Las Colinas, I also embed intimate partner violence in larger social, national, international, and transnational structures and processes. This perspective, as we will see, is similar to how the women of Las Colinas often describe their suffering. It is also, I believe, an important corrective to the failings of many rights-based interventions, which focus too narrowly on physical or emotional violence against women in Las Colinas. This narrow focus has the unintended effect of making invisible the forms of inequality and violence that lead to the reproduction of gender violence more broadly. Structural violence helps us retain an explicitly broad view of violence, inequality, and suffering, which highlights their intersections and challenges the narrowing emphasis of targeted campaigns.

GENDERING RIGHTS

By most accounts, the institutionalization of women's rights as human rights has been a great success (Hodgson 2011). The framework of human rights has provided an extremely effective and powerful language for the recognition of gender violence. However, as many anthropologists have noted, the strength of the human rights approach is also the source of its weakness. Human rights draw power from their supposition of universality, so rights appear to supersede and rise above both "culture" and "history" (Hodgson 2011). In this formulation, culture and history become obstacles to rights, barriers that must be overcome in order to access a right. Anthropologists have used local-level ethnography to temper the optimism of powerful international agreements by demonstrating how rights—as ideas and in practice—can be both emancipatory and limiting at the same time. On the one hand, rights provide openings for and hopeful imaginings of a better life. They are often celebrated as markers of modernity, thought to be spread by civilized nations into more remote "backwards" corners of the earth. However, human rights can also simply reinforce the status quo. The spread of rights also implies increased surveillance and control and requires changes in people's subjectivities (Rose 2007; Speed 2008; Sweet 2014). Legal and policy instruments, such as CEDAW, help produce and communicate "particular cultural understandings of gender . . . associated with modernity and the international"

(Merry 2011, 89). Human rights agendas assume a universal "rights consciousness" premised on individualism and an "autonomous rights-conscious self," even though people rarely have such a sense of self (Merry 2003). Instead, most people define themselves first through their relationships with family and community rather than the law. Studies on family violence demonstrate that, as a result of this mismatch between the assumed and actual identities of women, women world-wide must undergo a significant shift in identity to act as rights-bearers (Merry 1997, 1990). When human rights campaigns ignore these cultural dynamics and the political and economic restructuring necessary to exit cycles of violence, discourses of female empowerment often result in blaming poor women and "their culture."

This book recognizes both the power of the rights framework and its inherent limitations. In it I ask whether or not human rights, "with their presumption of an individual, secular, gendered subject and their reliance on state-run legal systems as the mechanisms of implementation and enforcement," can ever truly be an emanci-patory strategy for women (Hodgson 2011, 5). By examining gender violence in Las Colinas, I explore precisely what a rights frame enables and what it ignores, dis-misses, and demands. To get a sense of this in people's everyday experience, I pay particular attention to the emergent contradictions in how men and women talk about their lives and what they want. Jeffrey Rubin and Emma Sokoloff-Rubin (2013) suggest that these contradictions are *holding paradoxes*, or the seemingly contradictory stances that women adopt when they try to reconcile their aspira-tions with the stark realities of everyday life in northern Brazil. At one moment a woman may publicly claim that she wants equal rights for men and women, but later that evening she cooks her husband the meal he demands at a moment's notice, sews his clothes for work, and withstands an insult without raising her voice in response. The concept of *a holding paradox* avoids casting her actions as expres-sions of inauthenticity, confusion, or weakness. The contradictions do not cancel each other out, so to speak. Rather, they help us see where men and women are, and where they would like to be. In the case of Las Colinas, holding paradoxes also give us insight into the local–global dimensions of rights struggles, as women try to reconcile local cultural norms with ideas from other places.

GENDERING HEALTH AND DEVELOPMENT

Today, gender violence, and violence against women and girls in particular, is widely recognized as a human rights violation, a public health issue, and a central concern of the international development agenda. Gender violence signifi-cantly affects women's sexual and reproductive health, mental health, risk of chronic disease, and the health and well-being of their children (Ellsberg et al. 2008; García-Moreno et al. 2013). It also adversely affects a country's human, social, and economic development (Klugman et al. 2014). The effort to promote women's rights, including the right to live free from violence, has become central

to broader fields of global women's health, as well as women in development (WID) and gender and development (GAD) strategies, in particular. From the 1960s to 1990s, international development approaches such as WID[12] and GAD[13] successfully made women (and their diverse forms of labor) more visible, but they were less successful at promoting a gender perspective that fully accounted for dynamic relationships between men and women. Ironically, while men have been the implicit focus of development since the beginning, particularly in terms of macro-level policies and major investments, the intentional and explicit targeting of women as active participants in health and development work is crucial to the violence of human rights, as discussed throughout this book. In Las Colinas, women have become pivotal in the various development projects (such as the health center, microeconomic projects, and antiviolence programs), and the responsibility for the success or failure of these projects lies disproportionately with women.

Finally, all of these variants of development have had an important effect on how people in Las Colinas think about what it means to be modern. Despite feminist and postcolonial critiques, international development has always depended on a linear model of modernization that presents the Global North as modern, enlightened, and wealthy and the Global South as backward, poor, and needy (Rostow 1959; Esteva 1992; Rahnema and Bawtree 1997; Escobar 1995). While this global hierarchy is certainly not simply imposed on the people of the Global South, there is no doubt that tourism, media, and development campaigns expose people in Las Colinas to this framework for evaluating global differences. They are often drawn to visions of a more modern, cosmopolitan society characterized by gender equity and middle-class lifestyles. After all, this distant society is marked as morally superior. As they have inadvertently learned through various discourses of rights and development, real development and well-being is accessible in Las Colinas only if they, too, begin to mimic this "modern," cosmopolitan lifestyle.

OVERVIEW OF THE BOOK

In the chapters that follow, I explore how reducing gender violence and improving relationships between men and women becomes a deeply cultural project for all involved, one that is at the heart of the region's vision for itself. Gendered bodies are central to negotiations between Las Colinas's inhabitants, the Ecuadorian state, and transnational organizations over the community's development. People's changing responses to intimate partner violence have as much to do with how gender violence can be used strategically in the local cultural politics of development as they do with people's increased rights awareness. Using a gendered political economy framework merged with close attention to local subjectivities, I argue that gender violence interventions based exclusively on human rights awareness and education are not only inadequate but also unwittingly insert "liberated" women into larger dynamics of gendered structural violence. Thus, these

interventions have also brought about dangerous contradictions in the lives of many women, resulting in increased self-blame and higher rates of suicide when women cannot escape abuse. A gendered political economy approach explicitly links gender violence to material inequalities, and it brings men into both the analysis and the solution. By illustrating how violence is produced through the economic, the social, and the political, I show how the rights paradigm fails to disrupt the reproduction of violence in Las Colinas because it evokes a symbolic ideal of a "better, more modern community" without offering men and women the actual resources to attain this ideal.

Because of the importance of appearing "modern" (as I discuss in chapters 4 and 5), women and men have developed elaborate justifications for violent incidents when they do arise. Ultimately, the circulation of "domestic violence" as a conceptual focal point in workshops, legal services, and community discussions has led to a narrowing of the very concept itself. While women once understood violence to encompass multiple modes of suffering brought on by their unequal status in their relationships and community, they now understand violence almost exclusively as physical abuse by one's husband. Thus, when it is sometimes reported that violence no longer exists, it has much to do with narrowing the definition.

Using intimate partner violence as a lens into community politics shows us how exposure to state media campaigns, laws, health policies, and international development partnerships introduce new ideas of gender and selfhood, new visions of rights, development, and citizenship, and changing definitions of what counts as violence. By following families over the long term, I demonstrate how women and men of all ages are struggling to develop new understandings of themselves and their intimate—and sometimes violent—relationships with one another in a context that challenges fundamental ideas about the gendering of politics. In contrast to many studies of gender violence that focus on power and violence at the interpersonal level, this analysis is explicitly broad. This breadth is essential for understanding the unintended consequences of human rights interventions and for improving efforts to reduce the incidence of gender violence. However, this analysis requires an honest reckoning with women's actual experiences of violence. Depicting violence and brutality can render it into a spectacle (Fassin 2013; Jones and Rodgers 2019), an injustice I hope to avoid by contextualizing and humanizing my friends' stories, and by illustrating how their lives are also subject to ongoing change. Certainly, the stories of violence I share (especially stories like Gabi's or those shared in chapter 3) should not be read alone, separated from the broader discussion.

Through a focused description of everyday life in Las Colinas, the next chapter (chapter 1) shows how particular ideas about gender and violence have become naturalized there. I argue that hegemonic norms of masculinity and femininity are not merely ideological but emerge from the material and structural dimensions of everyday life as a rural campesino, including land-use patterns, reproductive work, citizen-state relations, and kinship configurations. These details become impor-

tant because, as I show in this book, competing gender ideologies (like those communicated through rights campaigns) do not entirely replace existing ideas. Instead, these gender ideologies are refracted, like a prism, through the prevailing material and ideological terrain on which gender has been constituted thus far. Chapter 1 is built around the story of Marta, whose life history allows us to identify the hegemonic or dominant gender norms of Las Colinas, how labor and the challenges of rural living intersect with these norms, and how the norms are changing today. We see how she learned to be a woman and what she could expect as a *mujer del campo* (woman from the countryside). Marta's story—how she grew up, how she met and married her husband, and how she migrated to and lived in Las Colinas—paints a picture of everyday life for an older generation of Las Colinas men and women.

In chapter 2, I examine the social and political life of men's and women's bodies in Las Colinas and the ever-changing tensions between masculinity and femininity. Preexisting ideas about men and women's "natural essences" shape ideas about the morality and legitimacy of violence, even as violence becomes politicized through human rights interventions. Building on the previous chapter's discussion of the political-economic dimensions of everyday life, this chapter provides another entry point for understanding why women often tolerate violence in their relationships. Feminist scholars have prioritized constructivist views of gender that challenge the biological essentializing and stereotypical characterizations of gender and sexuality. Though problematic in their own right, I show that these hegemonic ideas of masculinity and femininity are fundamental to understanding how men and women "vernacularize" or interpret newly circulating discourses of rights that reframe the relationships between masculinity, femininity, violence, and protection.

Chapter 3 turns from the political-economic and cultural production of violence to women's actual experiences of violence across their life span. Through case studies of three women, I elucidate how physical, economic, psychological, and somatic forms of violence intersect. These case studies bring to life the full depth of women's experiences and responses, including the diverse ways in which they suffer and thrive. In addition, they demonstrate how multiple forms of violence reinforce each other. Like the warp and weft of tightly woven fabric, each kind of violence overlays and sometimes conceals the others, normalizing violence in all its forms and constraining women's responses. Finally, these stories also illustrate change by highlighting the forms of violence that people considered normal and natural when I first arrived, and the shifts that occurred as a result of subtle economic, politico-legal, and cultural changes. These shifts have created openings for men and women to rethink the role of violence in their lives and allow for more diverse responses to it, including resistance, prevention, and legal recourse. While rights-based interventions acknowledge the important intersections between structural violence and gender violence, here I argue that they deprioritize structural violence, put women at great risk, and hold women principally and unfairly accountable for ending gender violence.

Chapter 4 turns to human rights interventions and their effects, moving through various scales from transnational to national to local organizing related to gender violence and women's rights. Campaigns against gender violence within Ecuador have been implemented by state- and NGO-led alliances, many of which overlook the real material scarcity and cultural nuances of ethnic and geographic groups living in rural areas of the country. To understand the contradictions that arise from these urban-designed campaigns when they land in rural, infrastructure-poor areas, the bulk of this chapter examines people's responses to three rights-based campaigns in Las Colinas: a women's microcredit initiative, a media campaign focused on *machismo* as violence, and public health workshops about human rights, sexual health, and family planning. These campaigns differ in their messaging, but ultimately, they layer and build on one another to reveal a set of cohesive ideas about the wrongness of violence and the "right" avenues for women to address it. Through multiple narratives from men and women, I demonstrate how these messages are then interpreted and remade at the grassroots level through vernacularization. One of the central contradictions of these interventions, I argue, is a gendered double standard of accountability. For these human rights campaigns prescribe that women act as morally and socially responsible agents, demanding that they seek out the proper bureaucratic channels to resist abuse by intimate partners lest they be seen as backwards or unworthy of intervention. As a result, women feel immense social pressure to be good, modern women. The implicit messages for men are much simpler: men should not commit needless physical (i.e., visible) violence against their spouses. Ultimately, this gendered accountability stymies women's options for seeking justice.

Chapter 5 shows how efforts to promote human rights, health, and development converge in their focus on women's bodies as the key site for change. For intimate relations are also reconfigured as people negotiate new relationships between Ecuador's populist state, NGOs, and the community. A lively local debate about whether or not to allow a brothel in the central village of Agua Dulce, for example, brings to light the historically contested and currently changing nature of state-community relationships. While some community factions at the debate invoke modernizing discourses of women's rights in their struggle to shut down brothels and mitigate family violence, others use the same discourses to argue for unregulated sexuality as a way to diminish violence. Drawing on critical feminist scholarship on development, I use this debate to discuss the many ways in which Las Colinas's inhabitants are self-regulating and performing modernity in order to renegotiate their political autonomy vis-à-vis the Ecuadorian state.

In the Conclusion, I step back to examine where women find themselves amid the various campaigns, reinterpretations, and strategic negotiations of rights. Has the human rights paradigm, introduced through various women's empowerment initiatives, been successful in Las Colinas? Yes and no. I return to these central questions to explore precisely what a rights frame enables and what it ignores and demands, and what this ultimately means for rights-based interventions in

marginalized communities worldwide. I approach these central questions from both theoretical and practice-based lenses. On the one hand, I interrogate Sally Merry's concept of vernacularization to reveal how it is useful not only as an explanatory framework of how human rights develop meaning "in practice" in local settings but also how it points to the futility of a goal of universally diffused human rights. Human rights do not live in a closed system, confined to policy documents that merely need better translating to local contexts. Rather, they exist in a state of becoming (Goodale 2021). I posit that activists and practitioners can use vernacularization as a tool, one that helps them see and act on the contradictions and fissures that inevitably arise during the process of vernacularization. What becomes especially important in this discussion is the recognition that most campaigns worldwide are predicated on the idea that rights-based women—or women who are fully aware of their rights and have complete recourse to laws, policies, support, and infrastructure—*can* exist, and that these will be the women who can effectively resist violence. The Conclusion's discussion of vernacularization reminds readers that women cannot become pure rights-based individuals in this sense, disembedded from their cultural contexts. Gaining knowledge of the law and recourse to law and criminalization are themselves not enough to end gender violence (Tapia Tapia 2018, 2021). I then shift my focus to address the pragmatic and applied lessons for interventions against gender violence, aimed at ensuring that men *and* women across the world can more effectively embrace and determine their own rights, well-being, and development.

As I attempt to show throughout this book, the names, the definitions, and the explanatory models used in research and interventions have important implications for how violence is seen, acted on, and reshaped. These definitions resound not only in academia and in transnational institutions but also in the fields, houses, and village plazas where Ecuador's most rural women must make daily decisions about when, where, and how to confront violence and what types of violence are or are not acceptable. It is to those fields, houses, and village plazas that I turn next.

1 · "SOMOS DEL CAMPO"
Gender Politics of Rural Households

The news about Doña Marta reached me by phone in the United States. For over thirty years, my friend had been beaten by her husband, but the caller insisted that this time was different. Her neighbors made the expensive international call to notify me not just because they knew she was a good friend of mine but because for the first time anyone in Agua Dulce could remember, the domestic violence was public, not hidden behind closed doors. On this occasion, Doña Marta, a woman in her late fifties whom everyone knew and respected, had actively sought medical and legal help to respond to her husband's violence. That she did so became the centerpiece of conversations for weeks. Perhaps most remarkably, it provoked both a community and a state response.

The public story began early one morning in 2004, when families in Agua Dulce were awakened by loud screaming and banging coming from Marta and Felipe's home. After a long night of drinking, Felipe had finally made it back to his hilltop home. His wife and their grandchildren were getting ready for the day, bustling about so the kids could get to school. The last thing Marta needed was any complication in their morning routine. But when Felipe noticed that his grandson's shirt had a small tear, he became extremely upset. The boy blamed his sister for the tear, so Felipe hit and shoved the little girl. Doña Marta intervened, and Felipe hit her, too, and pulled out her hair. Then he knocked her over. She fell, hitting her head so hard on the edge of the bed that she suffered a large gash and a concussion that would have long-term health effects. Then she stood up, reaching for the metal cooking spoon she had been using to prepare his breakfast.

It was then that Marta's neighbors intervened. The loud screaming and banging lasted long enough that neighbors could not simply tune it out as a domestic affair. When a male neighbor finally got inside their house, he wrestled Marta and the children away from Felipe, who was drunkenly beating and berating Marta. Eventually, other neighbors half-carried Marta out of the house, down the hill, and through the village plaza to hoist her onto the *ranchera* (the truck that makes regular scheduled trips between Agua Dulce and the nearest city). On their way through the village, they yelled for people to find the driver to rush her to the hospital.

Though *ranchera* drivers are known for their unwillingness to deviate from their schedules or leave without enough paying passengers, this driver leapt up from his half-eaten meal when he saw Marta, her head and body covered in blood, followed by her husband running toward the plaza waving a blood-stained cooking spoon.

Villagers held Felipe back, and the *ranchera* rumbled to a start. The driver took Marta to a hospital in Quinindé, a seventy minute drive away. After a day in the hospital, for the first time ever Marta filed a police report against Felipe, despite having suffered from various forms of domestic violence since becoming his partner at the age of sixteen. As a result of that report, he was imprisoned for a few days, and eventually they separated for three years (a story which I will revisit in chapter 3). I asked her why she decided to file a report this time.

> It was more serious this time. It wasn't the first time [he hit me], you know. When I was in the emergency room, bathed in blood, the doctors asked me if I wanted to have him arrested, and I said yes. I told them that he had always hit me, as if he were beating up one of his enemies. When I was young, I put up with his beating because I didn't want [to abandon] my children, nor did I want them to suffer because they didn't have a father. I also hoped he would start behaving and he'd get better with time. I guess I finally realized that he never loved or respected me. So, I have now decided that it's better that he lives his own life, and I live mine. (Interview, 2006)

Marta would not have considered reporting Felipe had it not been for the attending physician, who told Marta she "should get a *boleto de captura*" (literally, a capture-ticket, or arrest warrant). She gave Marta a medical certificate, an important piece of evidence that would help her get a warrant. "Then some people there [at the hospital in Quinindé]—I can't remember who—I asked them to take me to the *Comisaria de la Mujer* [the Police Commissary where women can file reports about family violence]," said Marta. Later, she told me that she had filed the report this time because "enough was enough," and added, "I am learning [through workshops at the health center and national radio campaigns] not to accept this treatment anymore."

This particular beating jolted Marta into thinking differently about violence. It even captured the attention of the broader region of Las Colinas. But what made this moment nonnormative, and why did it deserve to be treated in new ways? The severity of the beating was only one reason. Whether or not violence becomes notable or noticed depends on many factors, among them the perceived moral character of the victim, especially their faithful fulfillment of accepted gender roles; the witnesses to the violence (the family, community, municipality, or tourists) and their sense of how others might perceive it; and how rights, victimization, and violence have been highlighted and framed in recent campaigns. Violence becomes worthy of attention only when several of these factors coalesce.

In the mid-2000s in Las Colinas, around the time of Marta's trip to the hospital, if a woman had been flirting in town and her husband had slapped her within the

confines of her home, the act would not have been worthy of notice. But Marta's story was. It was not enough that Marta was well known and liked. What was far more determinative was that most of the neighbors agreed that this act of violence was unjustifiable and too severe. Felipe was acting irrationally while drunk. And Marta was trying to act responsibly for her family. It made sense that Felipe might be upset about how his grandson looked with a tear in his shirt, and how this might reflect on him as a provider and on his family more broadly. And, according to most in the community, the tear was clearly his grandson's and Marta's fault. What did not make sense to the community was to use such severe violence to communicate his displeasure. In this case, the community had a right, but not an obligation, to intervene. And one might say they intervened morally as well as physically by casting open and loud judgment on the scene.

Nevertheless, while Marta's pursuit of justice and the community's intervention may have been important turning points, this episode by no means signaled "the end of intimate partner violence" in the region of Las Colinas, nor did it signal the end of its acceptance. In fact, in the chatter that followed this episode, people merely redrew the lines between what they deemed to be acceptable and unacceptable "domestic violence." In the process, they reinforced the acceptability of violence in certain situations.

Up to this point, Doña Marta's story mirrors many accounts of intimate partner violence as it focuses on the incident of violence and its immediate aftermath, including the woman's pursuit of justice. Examining it anthropologically and historically, however, allows us to unpack the multifaceted relationships between gender, suffering, and justice. This, in turn, helps us understand why violence is so intractable and why this story does not end simply for either Marta or the community. If we place this episode within Marta's life history and her lived experience of regional political economic and cultural histories, we can see how structural violence, violent social relations, and gender norms helped naturalize the abuse and ultimately limited her ability to live free of violence, even after her awareness was raised.

Over the next three chapters, I use Marta's story to illustrate how household violence develops and escalates, why victims tolerate and even justify it, and what happens as norms about gender, violence, neighborly intervention, and victims' rights change.[1] I begin in this chapter by exploring gender norms and family life in Las Colinas, and in Manabí more broadly, emphasizing how they relate to socioeconomic organization in this frontier region. This shows us how Marta learned to be a woman and what she learned to expect as a *mujer del campo* (woman from the countryside). Before her separation from Felipe, Marta's story—how she grew up, how she met and married Felipe, and how she migrated to and lived in Las Colinas—was a very common one among the older generation of Las Colinas men and women. Using Marta's story, I unpack the hegemonic or dominant gender norms, how these norms intersect with labor and the challenges of rural living, and how norms are changing today. In chapter 2, I shift from political economy

and gender norms to beliefs about men's and women's bodies, sexualities, and propriety that undergird how men and women interpreted and responded to the politicization of gender violence during the 2000 and 2010s in Las Colinas. Women's diverse and overlapping experiences of violence are the subject of chapter 3, where I use Marta's atypical story to depict the chameleon-like nature of violence in the region, as some forms of violence come into focus when politicized, while others become ever more obscure.

GIRLHOOD TO WOMANHOOD

Marta, like many older Las Colinas women, was a young teen when she eloped with her partner, Felipe. Her family lived in the remote *campo* (countryside) of Manabí province, and, like her six sisters, Marta was never allowed to attend school. Because of their remote location, the journey to and from school would have been three hours walking. Fearing harm from unruly men or dangerous animals in the forest, parents normally do not allow young girls to travel without an adult. Boys, on the other hand, go to school unless their assistance is needed in the fields. For this reason, Marta is mostly illiterate. As a result, she lacked a *cedula* (ID card) until late in life.[2] Therefore, she didn't exist in government records and could not access welfare benefits until her sixties. As one of eleven children, she was "encouraged" to marry into another family as a young teenager, a common practice. By law she was entitled to land in her home province of Manabí, but because she was female, her father sold the three hectares that should have been hers, and only gave her a quarter of the money she was due, an example of patrimonial violence (Deere et. al 2010).

When she married Felipe, they lived in his parents' house at first. Marta says she was a very conscientious wife and daughter-in-law, but her mother-in-law beat her and psychologically abused her, constantly telling her that she was not good enough for her son. Despite having access to a small house owned by Felipe's parents on a piece of nearby land, Felipe was an alcoholic and had never invested in basic supplies for their home, preferring that they stay with his parents. Marta's sister-in-law eventually took pity on her and, late one night, she snuck Marta out of the house by pretending that her son was feverish and needed medical attention. Since women could not travel alone, Marta would have to accompany her. Together they went to the nearest city and bought plates, silverware, and cooking utensils. According to Marta, "We returned in the afternoon, and the next day, with all that we had bought, I went alone to my own little house. My mother-in-law didn't want me to bring my child there [and at first], she wouldn't let me."

With the purchase of a few household items, Marta was able to assert her independence as a wife and mother and legitimately establish her own household. Unfortunately, this move did not end the violence. Felipe continued to abuse her "with his hands, kicks, sometimes a punch, or he'd grab me by the hair." When he came home drunk, he would usually beat her and demand food or sex. But

sometimes he just beat her *"por gusto,"* for the heck of it. While she recognized that this was *"una maldad, maltrato, como machismo"* (it was evil, it was abuse, like machismo), like many other women in the cycle of violence she said, "I thought he would change, so I started having lots of kids and I just ended up getting old, like I am now." She also elaborated on how during this time she worked hard to be the best wife and mother she could be. She felt that to gain his respect and stop the violence she simply needed to be better at those roles.

Marta was able to access legal resources eventually and to separate from Felipe (though, as we shall see in chapter 3, she struggled during the separation and eventually reunited with him, and they remain together as of 2022). But for now, I want to focus on the question of why Marta and so many other women of Las Colinas put up with violence in their households for so many years, and why they thought this kind of suffering and *"aguantando"* (putting up with it) was merely an accepted and acceptable part of being a woman and a wife (a belief to which many, though not all, women still adhere).

GENDER, EDUCATION, AND MOBILITY

Like Marta, most young girls living in rural coastal areas (*el campo*) in the 1960s and 1970s did not attend school either because they lived too far away from one or because they needed to help with chores or caretaking at home, or, because in many cases, their fathers did not think education was useful or appropriate for young girls. Though the rate of literacy is higher today, informal surveys that we conducted in the early 2000s found that approximately 14 percent of adult women in the region were not literate (Friederic and Palombi 2001; Friederic and Roberge 2002). Perceptions of appropriate geographic mobility for women are some of the greatest restrictions on women's access to education, work, and social participation. Women, especially those who live in the deep *campo* are discouraged from leaving their homes because people perceive they are in danger and are physically weak. As a result, many Las Colinas women only leave their communities when an emergency arises. For some women, this makes sense because women find that the challenging road conditions are easier for men to handle. Beatriz, a thirty-five-year-old woman from the distant community of El Carmen, explained matter-of-factly why her husband was in charge of the household economy:

> My husband makes all the economic decisions in our household because he is the one who leaves for the outside. He is physically stronger and can get out more easily. For example, he can sleep somewhere midway, if necessary, whereas I could not. I only go out [to the city, or the central community of Agua Dulce] if there is illness in the household, if a child is sick and I need to accompany him or her. I make decisions about treating my children's illnesses, but it is always better if he is the one that can travel. (Interview, 2008)

Intimately tied to these perceptions is the understanding that women are more physically vulnerable to physical and sexual violence and thus are more vulnerable to the stigma that sexual transgressions imply. Bluntly, women are discouraged from traveling, especially alone, for fear of rape. This concern is motivated not only by the more obvious physical and emotional harm that sexual harassment or rape might bring, but also by its less obvious potential symbolic harm, since both the woman and her husband might be judged for sexual impropriety. As in many Latin American contexts, the "farther that women go from home, the more sexual risks they are imagined to run—so that when a woman runs errands out of town, she frequently takes a child along as sort of moral shield, to make it clear that she is not slipping away to meet a lover" (Rebhun 1999; Hirsch 2009, 61). Merely by traveling alone, a woman could be blamed for her own rape or assault because of her lack of discretion. Maria, a member of the Women's Bank, explained,

MARIA: Sometimes we're criticized as women, especially when we go to the city to sell something, for example. We are told that rogues will steal from us and rape us. I used to be afraid, but we've learned about this [since joining the Women's Bank]. We don't need to be afraid. [Telling us this is] a form of control. We can also leave the region like any other person, if we need to, without problems.

KARIN: So, do many women now feel comfortable selling and buying in the city?

MARIA: Many, no. But some do buy and sell now on their own. And though I used to do it in the past when I had to, I am more comfortable with it now. We've learned through time that it's not a big deal, it's okay. (Interview, 2003)

Many women like Maria have talked about overcoming their fears of leaving the house as a crucial part of their growth and empowerment. Over time, and through their involvement in different women's groups, health center programs, and women's rights workshops, these women have recognized that certain fears and community pressures have been socially constructed to reinforce their oppression.

Julia, a woman in her forties, also from a remote, rural community in Las Colinas, described herself as someone who is constantly worrying about what might happen to her, on the one hand, and what people might say about her on the other. At times she cannot tell the difference between the two. She first cited financial reasons for rarely leaving her community. Then she elaborated: "Well, it's also I guess because I just don't want to leave. I always worry about things. It scares me to leave. They tell us so many bad things. And they say so many bad things about us. So I just don't go to the outside. Only when I have to get my *bono estatal*." (*Bono estatal* is the welfare check, to which only a few women were entitled at the time). While she admitted that she was jealous of other women who had learned to be less afraid and who no longer cared about what people said, Julia said she could never imagine getting over these fears. Ten years later, however, most of her family moved to Agua Dulce, the central and most populated village in the region

of Las Colinas because they needed to be closer to schools and to work. At that point she became accustomed to traveling back and forth between communities, often by herself. When I asked her how this felt, ten years after our first conversation, she said, "Sometimes I take a young kid with me because it feels nicer to have a companion, and people are less likely to talk. But my fears, well, I guess they're gone. They seem silly now. . . . Maybe I'm just too old to be afraid anymore."

Restricted mobility has important consequences for women's social support networks. For example, it means that women are much less likely than men to retain contact with extended families outside the Las Colinas region.[3] In June 2003, an emotional Juana told me,

> My family lives in Manabí, and we don't have any contact whatsoever. I have not visited my family for more than twelve years. [My husband] just doesn't let me go visit them. He always tells me what to do, both inside and outside the house. I just stay quiet and calm. Things have improved most recently [since moving to Agua Dulce from a more distant community], and he doesn't hit me very much anymore. But I still can't see my family.

Women's lack of extended family networks severely impedes them from leaving violent households or seeking a divorce. They do not have regular contact with extended family members for support or for intervention in cases of extreme violence. This was especially the case before cell phones, and when the roads were in worse condition. Juana's husband, for instance, has effectively cut her off from all friends and family, causing her deep sadness and grief. Much like Marta, she has few family members to whom she can reach out, and the extreme physical isolation of her home (like Marta's first home) limits the possibilities of neighbors intervening.

In rural regions, both men and women have limited options when it comes to education, assets, and employment. Yet the notion that men can better handle the physical risks of traveling gives men more access to education, employment (even in temporary alternative jobs as dayworkers or for harvest seasons), community meetings, and markets to buy and sell goods. Thus, these gendered patterns of mobility reflect existing economic organization and further mark as masculine any forms of work that require mobility (Fuller 2012). These beliefs also reinforce and perpetuate patrimonial violence, because they assume that women do not need access to assets and land, since they will be maintained by their husbands. Together, these interrelated features of rural life make it extremely difficult for a woman even to know about alternatives, let alone to exit a relationship of intimate violence. Changing the material conditions of their lives (for example, improving roads, access to income and assets, and transportation), as we will see in the next three chapters, is crucial. Raising awareness of a right to live free from violence is simply not enough when women's options are so limited.

SEEKING AUTONOMY THROUGH MARRIAGE

Marta and Felipe met when their parents introduced them. Though theirs was not technically an arranged marriage, her parents had a lot of influence over her decision. Felipe, a few years older than Marta, was actively seeking a wife. Marta was sixteen, which was quite old to marry by existing social norms. According to Marta, her father was looking forward to finding her a husband so the family "would no longer have to support me," and she had very little say in the matter. Felipe seemed like a decent man, she thought, and he expressed interest in her. Besides, it was time for her to be married.

More often, however, young people in Manabí and Las Colinas are able to marry partners of their own choosing, and this has become increasingly true in the 2020s. In Las Colinas, courtship often begins at community events without parents' knowledge or approval. When Beatriz was fourteen, she met Juan, an eighteen-year-old from a neighboring village, at a community event. They danced a few times at parties and then started communicating by sending each other notes through their younger siblings. One night at a dance, Beatriz and Juan agreed to meet and run off together, and the rest was history, so to speak.

Even though Beatriz and Juan agreed to it, the act of secretly running off is linked to earlier courtship practices known as *"rapto"* or kidnapping. *Rapto* still occurs, especially during times of particular economic hardship, but it is less likely to result in a long-term relationship or marriage. As a friend explained, "Often this happens when the guy doesn't have the money to get married. So instead, he comes in the night, like a *conquistador*, and he steals the girl from the home of her parents." In remote communities where adolescents may not regularly meet at school, young men and women interact at dances, parties, and other special events. Once a young man and woman begin to flirt, they might agree to start meeting clandestinely, either late at night or in the forest. Often, girls and boys keep their relationship private from everyone but their closest friends until they are ready to "settle" and be partnered, and the woman agrees to be *robada* (stolen) during the night.[4] The couple typically agrees on the details beforehand while dancing at a party or through handwritten notes passed along by younger siblings (or via text messages, if the teens are lucky enough to have access to a cell phone and a network). This gives the girl time to pack a small bag of belongings and prepare herself to meet her "fiancé." In the middle of the night, her suitor then waits outside her parents' home. Sometimes he whistles or throws a rock to signal her, or she meets him at a preordained place. The couple then ideally lives together (at his parents or another family member's) for weeks until they finally return to her parents' home to announce their marriage and call for a *brindis* (toast). Young women often accept the kidnapping as a convenient way to circumvent approval from their parents. In the past it was believed that if the young couple managed to be together for the entire night (when presumably the boy takes the girl's virginity),

they would receive their parents' blessings. Parents today are less likely to grant their blessing automatically; increasingly they consider the girls' education, employment, and future.

Most couples in Las Colinas and throughout the rural coast of Ecuador are in *uniones libres*, or common-law marriages, like Marta and Felipe. These can be just as stable as formalized marriages. Importantly, women in common-law marriages have the same legal property rights as formally married women.[5] Because both forms of marital union are legally recognized and respected in the region, and the distinction between the two types is rarely made, many couples opt for *uniones libres* because of the economic costs and bureaucratic difficulties associated with legal marriage.[6] If the cost of the marriage license itself does not deter the couple, then the costs of transportation, proper identification, and a formal celebration often do. However, even if the difference between the two forms of marriage is only symbolic, some consider it important.[7] For example, after six years of being in a *unión libre* with her husband, a twenty-four-year-old woman told me that she and her husband were planning to get married formally. When I asked why, she responded,

> Well, now it's different. Now we actually understand each other. Before, we were fighting all the time, we were young, and even if we loved each other, we didn't know any better. But now there is understanding (or *comprensión*) in our home. So we've been talking recently about how we'd like to get married, because we are more serious in our commitment. (Interview, 2007)

Some studies in Latin America have found that women in common-law marriages are more likely to experience intimate partner violence (IPV) than those in formal legal marriages (Flake and Forste 2006, as cited in Oduro 2015, 10; Friedemann-Sánchez and Lovatón 2012). Despite this, and despite the common perception that formally married couples are more serious and committed, I did not detect a connection between the type of marriage and rates of IPV or divorce. In fact, I suspect that improved relations between married couples have as much to with economic stability as emotional maturity, and certainly they are related.

Like Beatriz and Juan, or Marta and Felipe, most women and men marry between the ages of fifteen and nineteen, and men tend to marry younger women. But the average age appears to be changing.[8] In most cases, men and women are marrying later now than in the past, largely because young women now have more access to education and are encouraged to finish high school before starting families. People complain regularly, however, about the high rates of teen pregnancy. In 2017, teachers at the high school in Agua Dulce reported that an average of four girls (out of twenty) drop out every year due to pregnancy (Interview, 2017). While the numbers of young women getting pregnant has not changed much according to local health center data, these pregnancies are notable because more of these young women are not in committed, long-term relationships.

A young girl in Las Colinas may decide to marry early for many reasons. In the past, a young woman would often be encouraged to leave her birth home within five years of her first menstruation to begin her life as an adult (which implied marriage and a family). Today, however, more parents insist their children finish high school before they get married or have children. Regardless, many young girls agree to be "robbed" or decide to marry as a way to escape the family home. I did not appreciate the salience of this motive until I interviewed women about their experiences of gender violence and learned again and again that women left home to escape routine psychological and physical abuse by fathers, stepfathers, or other relatives. Many young girls (and perhaps young men) see marriage as one of the only viable ways to leave their parents' homes. In 2003, I visited a family on my trek to and from the distant community of El Carmen. I was surprised to see Ana and her seventeen-year-old daughter Sara upstairs with a newborn baby, who seemed to have come out of nowhere. I had known Sara well but hadn't seen her in a few years. Last I had heard, she had been "whisked" away by a lover and they had left the region together. When I asked what happened, the mother merely replied, "one day a guy touched her (*la tocó*), kissed her, and the next day she was off," implying that she had never been touched before. Anyway, Sara looked healthy and seemed very pleased about her new life. However, once I was alone with Sara, I learned that she had left her parental home mostly because she hated her father so much for routinely abusing her, her sister, and her mother.

Later that same year, another young friend recounted a difficult story of heartbreak, insisting that she was sick of men and wanted independence. She was planning to leave the region to work in Quito, and to possibly make her way to the United States where she could get a well-paying job. But a month later I was surprised to learn that she had been *robada* and was happily partnered (*comprometida*) living in her own home in a nearby village. When we finally spoke, she was a bit dismissive about our earlier conversation, saying, "Ah, Karin, things change and I have liked him for a while, so whatever, I'm happy." But later, I learned that she had been fighting with her stepfather after a long history of abuse, and her mother had been caught in the middle. When she saw an opportunity to escape the quarreling and the abuse, she took it and started her own household.

Though Marta never explicitly told me of violence directed at her in her birth home, she hinted at her father's extreme impatience that she was still living at home at the age of sixteen. When they encouraged her to marry Felipe, she was hardly aware of any other options available to her as an illiterate young girl who had spent most of her time at home in a rural area. Even with her mother's instruction, she had little knowledge of what marriage entailed other than "making your husband happy by having children, cooking food, tending to the animals, and keeping the house clean." When she was given only a quarter of the inheritance she was due, she had no knowledge with which to contest it. For Marta, marriage was merely a "patriarchal bargain" in which she agreed to exchange her labor and fidelity for financial support and protection (Kandiyoti 1988).

As in many places worldwide, ideas about romantic love and "companionate marriage" have gained a stronger foothold in the central village of Las Colinas over the last twenty years (Padilla et al. 2007; Fernandez 2010; Medeiros 2018). Due to the pronounced isolation of Las Colinas, this process had been occurring more slowly than in many other parts of the world. Recent conversations with Las Colinas women reveal that their expectations of marriage and relationships are changing dramatically. For example, they now "choose" whether or not to marry a man, they no longer condone violence by default, and they expect a lot more attention and respect than women in the past. They believe it is important to be able to date and to take some time to determine their emotional compatibility with a partner. This marks a shift toward "companionate marriages" that fulfill both emotional and material desires, away from marriages that function mostly for reciprocity (Rebhun 1999; Padilla et al. 2007).

Soap operas (or *telenovelas*), as well as stories shared and examples set by visiting volunteers (including me), have been powerful sources of imagery related to romantic love and relationship ideals. Since 2006, when televisions became increasingly common, women in Agua Dulce often spoke of characters and relationships from popular soap operas. In fact, the desire for romantic love, as envisioned through telenovelas, was and still is only one part of a broader suite of desires for a modern lifestyle. In 2015, women talked about wanting their men to be "*detallista*," or attentive in new and unique ways (Focus Group, 2015). Beyond the literal translation of "*detallista*" as "meticulous" or "perfectionist," the term captures a particular essence of romance that many Las Colinas women have begun to desire and expect: they want their partners to remember their birthdays and bring them gifts. They want to be invited to "*algún paseíto*," or some kind of outing, whether to the city, a restaurant in town, or nearby beaches. It usually involves spending some money or at the very least displaying forethought and planning. The new man must also be able to afford outings and gifts, something that might necessitate a significant livelihood shift (one that did not escape the women at the 2015 workshop). When they listed characteristics of men at the time, they had included "*trabajador*" (laborer, or worker) to signify a man who physically worked hard, usually in agriculture, to provide for his family. The desired man of the future, however, was characterized as "*empresario*," an entrepreneur or businessman, signifying yet another alignment with capitalist modernity that we will explore in chapter 4.

In Brogodó, Brazil, a more urban environment than Las Colinas, Melanie Medeiros (2018) notes similar changes in women's expectations, but she attributes them to shifts in the "patriarchal bargain" that come about when women gain employment, access income, and are no longer dependent on men for financial support (Kandiyoti 1988). Like women in Las Colinas, women in Brogodó emphasized their independence, regularly asserting that men's financial support was no longer enough to sustain a marriage. Women in Las Colinas similarly value economic autonomy and independence even though, unlike the women in

Brogodó, they rarely achieve either. Shifts in gender norms and social expectations now allow for some women to earn their own income, but the economic realities of life in the *campo* still make it rare for a woman to be able to sustain herself without a partner. Today, women will sometimes insist that they can survive on their own, but very few women actually manage to do so, and some end up accruing dangerous amounts of debt in the process. In fact, many younger women who have recently become single mothers have done so in part as an expression of their autonomy. While most of these women clearly prefer to find a reliable partner to raise their children with, in many cases they may willingly take the risk of unprotected sex and become pregnant if they are unsure of the man's commitment. When they do learn (or confirm) that the child's father is unwilling to partner with them, they often will immediately proclaim their strength and independence, stating unequivocally that they do not need a man to have a good life, or even to have a family.

Compared with Marta's generation, when autonomy was nearly impossible for unmarried or separated women, the possibility of autonomy today significantly shapes women's (and to a point men's) relationship expectations. Even if they choose to stay in an unhappy relationship, women now operate with an expectation that there should be another way to live. These women may realize that, even if it is more socially acceptable to leave one's husband and find another source of income, the reality of doing so remains extremely difficult.

A HOME OF ONE'S OWN: ASSETS, EMPOWERMENT, AND DECISION-MAKING

Feminist economists have long tried to determine the role of assets, wealth, and employment in women's decision-making power within the home and, in some cases, intimate partner violence. For example, access to assets can reduce the likelihood of intimate partner violence because it gives women more "bargaining power" (Kandiyoti 1988). Recent scholarship also suggests that women's homeownership can be a deterrent to domestic violence because it strengthens a woman's fallback position if the relationship should fail (Panda and Agarwal 2005; Bhattacharyya 2011; Oduro et al. 2015). In rural coastal Ecuador, Deere and Twyman (2012) found that women's command over resources in dual-headed households was strongly associated with egalitarian decision-making among couples.

Women in Ecuador, like in many other South American countries, have strong property rights compared to women in other parts of the world (Deere et al. 2010). Through marriage and inheritance, women have legal rights to assets and property that can be especially crucial to their well-being and that of their relationships, especially when men are the primary breadwinners who control most of the income and assets. However, many women are unaware of these rights, or they have difficulty accessing them. Thus, the gap between *de jure* rights (legal,

inscribed in the law) and *de facto* rights (implemented in practice) is extreme in a context like rural Ecuador.

Early on, Marta experienced precisely this disjuncture between *de jure* and *de facto* rights when she was granted a negligible part of her father's property upon her union with Felipe. According to Ecuadorian law, if someone dies without a will in place, "the estate [should] be divided equally among all of the children irrespective of gender" (and irrespective of whether or not they were born in marriage or of consensual unions or out of wedlock) (Deere et al. 2010). Although her father had not died, Marta knew that he did not have a will in place, and that he did not expect the laws about inheritance to be relevant to their rural household which was symbolically and physically distant from any state authorities. Her father had chosen to give Marta her land as an *"inter vivos"* or "advance inheritance," a rather common practice when a son or daughter begins a new household or family. Often this is done informally so they know what they will eventually inherit, or so they can build a home on that land, and it is intended to be a gift of individual property to the son or daughter, not a gift to the couple (Deere et al. 2010). Even though the inheritance regime treats sons and daughters equally, in practice disputes over land among siblings are common, especially when sons are given the best land and daughters or half-siblings lose out [something I have witnessed often in Las Colinas, and that Deere et al. (2010) found in various provinces].

Thus, women like Marta experience *patrimonial violence* at various junctures in their lives. It often occurs first when they assume it is up to their parents (or fathers) to decide how much land to allocate to their children via inheritance, when in fact each child is due the same amount, regardless of gender or occupation. Second, Marta, like many others, assumed that her property inheritance (or the assets from its sale) became communal property upon marriage, when in fact the "conjugal society" dictates that "all property that is acquired while a person is single remains their own individual property should they marry or form a consensual union" (Deere et al. 2010, 3).[9] For this reason, many women purchase household items or farm animals prior to marriage, if they can, because it allows them greater autonomy in two ways: one, these assets remain theirs should they need to move out, separate, or divorce; and two, having an outfitted kitchen and the basic goods to establish a household allows women (and sometimes couples) to establish autonomy from their parents and in-laws, as in Marta's case.[10] A third form of patrimonial violence occurs when women like Marta wrongly assume that if they separate or divorce their partners, they will lose the rights to all jointly acquired assets.

When couples divorce, the spouse or partner who gets custody of any minor children is entitled to stay in the family dwelling until the children come of age. Therefore, when Marta and Felipe separated, Marta could decide in which home she wanted to stay and Felipe could not legally kick her out. In this case, Marta was vaguely aware that she had a right to stay in the home if she remained responsible for the care of her grandchildren. But her children threatened to take the grand-

children away, casting doubt on her legal right to remain in the home. She also expressed a great deal of skepticism about whether or not her rights would be respected because she knew that so many lawyers and judges could be bribed. As she saw it, she was an uneducated, illiterate older woman from the *campo* and, as such, she had no way to demand her rights actually be respected.

Divorce is also a challenging prospect. Divorced women in Ecuador do not fare well economically due to social stigma, less favorable labor opportunities for women in general, the lack of alimony, and inadequate child support (Deere et al. 2010, 22–23). In divorce, a family's assets are equally divided between husband and wife, which is of particular benefit to wives who have not had incomes.[11] In these cases, the "equal division of community property upon dissolution of the union constitutes a compensation of sorts for domestic and caring labor" (Deere et al. 2010, 6). Many women are unaware, however, that they have a right to the income and assets acquired by their partners, in their partners' names. Not only is it more common for land and homes to lack formal titling in places like rural Ecuador, but men often fail to "register" major assets in the names of their wives, especially if they are not legally married.[12]

In Agua Dulce, the relationship between women's asset acquisition, female autonomy, and intimate partner violence is complex, and often changes over time. In my research, members of the Women's Bank who received small microeconomic loans and "gender empowerment training" experienced increased intimate partner violence in the short term. This trend has been observed in various studies worldwide, especially when a woman's acquisition of assets leads to a "status reversal" or highlights "status differences" (such as when "she has more education, is employed and he is not, or earns more than him") or if it makes a husband feel that his power is being diminished as a result (Bhattacharyya 2011; Oduro et al. 2015, 6).[13] During this period, it is often understood that "the husband [is] adjust[ing] to changing gender roles, either as these become the social norm or lead to increases in the household's standard of living" (Oduro et al. 2015, 6). However, I have also found that the risk of violence diminishes when men materially and physically incorporate new routines into their lives while discovering new sources for respect and dignity from other men (or themselves).

In sum, female-derived income and female-owned assets like land, homeownership, and domestic animals are beneficial to female empowerment and to reducing IPV more broadly, even if the strengths of the association depend on the interplay of broader factors, such as gender norms, economic stability, status differences, and more (ICRW 2006; Oduro et al. 2015). Parts of the Ecuador civil code are advantageous to women, including the marital regime of the conjugal society and the inheritance regime that guarantees children of either sex equal parts of the estate. But the benefits of the marital and inheritance regimes depend greatly on the ability of households to accumulate assets over the life cycle, as well as women's knowledge of and ability to lay claim to property rights.

GENDERED LABOR AND DAILY LIFE IN THE CAMPO

FIGURE 1.1. Las Colinas family in kitchen doorway of their home. (Photo by Aldo Martinez Jr.)

A day with Beatriz and Juan (field notes from a one-week stay with the family in 2007):

At 5 A.M. I heard the first sounds of someone stirring in the house, after a night of sleep punctuated by the sound of howler monkeys, roosters, and other creatures. I could hear Beatriz light the firewood and begin warming water for coffee. When I got up, she was reheating rice and beans for our breakfast. She also began preparing a *bola de maní* (ball of peanut, plantain, and pork) for her husband and eleven-year-old son, which was an easy meal for them to carry out to the forest up the *montaña* where they would be clearing land for planting. Beatriz gently reminded her husband Juan to take the cell phone to try to call her brother in Machala to find out how a sick relative was doing. There is no cell reception in the valley, but if he climbs to a certain clearing near the mountain ridge (about twenty minutes beyond where they were clearing land), he can usually get a few bars of *señal* (cell signal). He looks worried, and he mumbles that he might not have enough charge. If he doesn't, he will have to wait for next week's trip to the central village (Agua Dulce) to recharge it. If it's an emergency, he could ask a neighbor to use his generator but this always makes him uncomfortable, even if he helps pay for the diesel.

After Juan and her son leave, Beatriz, her daughters, and I eat rice, beans, and *platano asado*, and they leave soon after to milk their only cow, while I hunker

down to write some fieldnotes. This year, they are doing fairly well economically because they have a cow, twenty chickens, and three pigs. Beatriz is excited about this, and she takes obvious pride in caring for them daily. Because I am visiting, and I'm her son's *madrina*, one of the chickens has been reserved for tomorrow's meal (when godparents visit, it is a social obligation to *"matar una gallina,"* or kill a chicken, a phrase that the kids yell out repeatedly with excitement on these special occasions). Soon it will be Christmas, so one pig and some chickens will be killed to get through the period until the cacao and rice harvest.

At around 10:30 A.M., I accompany Juan's eight-year-old daughter Rosita as she heads out to the forest where her brother and father are clearing land to be able to keep more animals. We bring them rice, plantain, and beans held together in a packet of banana leaves. While Rosita shows me different plants and edibles that the forest has to offer, Juan and my godson clear the area until two in the afternoon, when we all finally set off on the forty-five-minute walk home. But now Juan mumbles that he is hungry again, and he hopes his wife will be there to heat up food even if he is coming home earlier than expected. He tells the kids to run ahead and give her notice that he's coming, since she would probably be at the river washing clothes. Later, when I tried to gauge how she felt about being called back to the house, she didn't have any problem with it. "He was hungry, so I headed home right away because I don't want him messing around in my kitchen." Cooking was her job, and she would prefer to be in control of the kitchen and do her job well, even if that meant accommodating to his timetable.

Like Beatriz, married women in the *campo* are usually responsible for maintaining the home by performing chores such as cooking, cleaning, collecting water, washing clothes, keeping the home well organized, and caring for their children. Here, the hegemonic dynamic of gender norms resonates in how people both talk about and experience gender. When I began interviewing men and women about gender roles and responsibilities, the responses were straightforward: women take care of the households, while men work outside the home and provide money or goods to sustain the household. Unsurprisingly, this distinction is much more fluid in practice, and it always has been. In countless instances, I have witnessed women like Juanita and Beatriz working alongside their husbands to harvest cacao, young girls splitting wood with their brothers, and women attending community meetings, especially—but not only—when their husbands were busy elsewhere.

Women also devote much of their time to raising farm animals such as chickens, pigs, and sometimes dairy cows. Though they are less likely to mention these tasks, most women regularly help their husbands by planting corn and rice, picking fruit, and harvesting cacao. This work often varies with the season and with the availability of help from other family members or hired laborers. With the help of children, women also regularly gather firewood, collect water (an extremely arduous task in most villages, especially those located along the higher-altitude ridges),

or sometimes catch fish in the river. A few women from more remote villages also produce their own artisan crafts, weaving *petates* (reed mats) and reed baskets for family use (Fadiman 2005). In her work on the Ecuadorian coast, Lynne Phillips (1987) observed that, contrary to their reports, "women also often supervise the production of cacao and rice for the market (these crops are dried in the sun before they are sold), degrain corn for family consumption, collect and chop wood for cooking, raise chickens and pigs for the market, sew, and attend small stores set up within their homes, as well as perform the usual tasks of cooking, caring for the children, washing clothes, cleaning the house, and sweeping the *solar* (house plot)" (115–116). Most Las Colinas women are deeply involved in productive activities and have a significant impact on the household economy, as do women in most rural settings in Latin America (Deere and León 1987).[14] While a few women claim that their husbands sometimes assist with cooking or cleaning, it is still much more common for women to take on more arduous agricultural tasks than it is for men to take up "women's tasks."

Men in Las Colinas understand their role in marriage as protector and provider, and these two roles are interrelated. Married men must bring food to the table by growing the food or earning the money to buy it. They also must earn cash to support the family's needs, an increasingly difficult task because the cost of essential household goods is rising. Men are usually in charge of most economic transactions including the sale of agricultural goods and farm animals, and the purchases of household items such as food, kitchen, and cleaning supplies, clothing, or anything considered of significant value.

Women's access to household funds varies greatly depending on the family. Many of the women I observed did not have direct access to money nor did they get involved in financial decision-making because their husbands did not trust their ability to manage it. Juana, who has suffered years of abuse at the hand of her husband, claimed bluntly, "He makes decisions about everything. He even treats the children if they are sick, and they have never gone to a doctor. I just cook and clean, but nothing else." In most cases, women are consulted about what is needed, but their husbands make the purchases and "buy as much as they can with the money they have." For example, one older woman who operates her own small restaurant reports that she makes decisions about minor purchases like food and supplies for her kitchen and restaurant, and supplies for her children, but her husband is responsible for all major purchases, including appliances and furniture. When I asked whether this bothered her, she said, "Not really," then noted that she actually prefers this: "He has the experience and he knows the prices of such things better than I do."

EXPANDING THE CIRCLE: NEW OPPORTUNITIES FOR SOCIAL PARTICIPATION

Due to widespread ideas about women's vulnerability and their dedication to the home, women in Las Colinas have been much less likely than their husbands to

participate in community-based initiatives, public events, or meetings. While this might make sense for the women in the most rural and isolated areas (like Juana, or Doña Marta in her previous home), the general consensus about men as primary decision-makers and men as workers outside the home has meant that these norms applied in the populated villages, too. Despite the great variability and increasing evidence of shared decision-making in many households, "when one person dominates the choices, this person is usually a man" (Gutmann 1996, 23).

Women are still encouraged to stay in spaces physically or symbolically associated with the domestic realm. In the past, this may have meant that women were pressured to stay within the physical confines of the home (or the spaces just around the home, where they would tend to domesticated animals or wash clothes). Today, women travel to meetings, the main village, or the city, but generally only to engage in activities that ultimately contribute to the household (for example, shopping for their children's clothes or attending a meeting to solicit new teachers for the school).

The exclusion of women from direct community participation is particularly significant in light of how crucial these forms of organizing have been for household survival from the beginning, when men worked in cooperatives to settle the area and organized *mingas*, community-wide work parties, to clear land for schools, roads, or fields. Twenty years ago, only men participated on town councils, school organizations, or other community organizations. Only in certain instances was it deemed acceptable for women to be involved. As Sofia explained,

> If there is a meeting of the *Padres de Familia*, and my husband is not present, I can replace him. And in this case, I don't have to ask his permission, because it's not right that he isn't there when he has to pay our family dues, for example. So of course, I will go, because I am the mother. They are also my children and I am also responsible for them. (Interview, 2003)

Women were involved in these initiatives in one of two ways, therefore: they participated if their husband could not, or they participated indirectly (though not insignificantly) through cooking and carework. Women often organized themselves to cook meals for the meetings and the *mingas*, a role absolutely crucial to community organizing, albeit less visible. Women themselves knew that, and they also often took the opportunity to participate in discussions and decision-making, even if their presence was legitimated only by their work in the kitchen.

In the past, women would often accompany their husbands to meetings, or take their place in certain situations. For example, Fátima reports, "My husband is boss. He is in charge when he is here, but when he is not, I am in charge." Most women acknowledged that they did not agree with this logic, but many were willing to abide by it to avoid conflict. In particular, they contested the restrictions on women's mobility and women's participation in household decision-making, as well as their husbands' refusal to assist with domestic duties. However, women

rarely challenged their perceived responsibilities and the division of labor itself. Rather they accepted and took pride in the responsibilities but asked for more power to fulfill them. As one woman put it, "Men and women each have their own type of work [and this is okay]; the problem is that both must be considered equally valuable."

The last fifteen years have seen significant changes in the gendered division of labor and community participation. When the health center was first established, for instance, the NGO (*La Fundación*) encouraged women to serve on the health committee. This caused much consternation and conflict in the community. While many in the community (including the women, who were themselves nominated) broadly agreed with the idea that women should hold political positions, in practice it was very challenging as they had to convince their husbands and fellow community members that they were not abandoning their responsibilities to their children and their husbands in the process. This required that they take on a double burden, dutifully completing their tasks at home while spending long hours at community meetings, traveling to the city to complete paperwork, and visiting other households to solicit people's participation in health center organizing.

Women are finding ways to leverage for more flexibility when they can argue that their actions are in line with family needs. After all, women are in a particularly compromised position: they are the most in tune with the subsistence and survival needs of the family, but they are the least able to generate income. If women have weak bargaining power in their households, they may not be able to discuss specific subsistence needs openly with their husbands, as men may interpret such dialogue as an insult to their ability to provide. Sofía confirms that many women resist their positions of low bargaining power:

> But now we are seeing a change. Say I need five dollars, because my children need notebooks for school. And someone comes along, asking if I'd like to sell my chicken. Of course, I will sell it because I know my children need the money. That should not be seen as me trying to gain my freedom, or me doing whatever the heck I want to do. I am doing it for my home. (Interview, 2005)

Similarly, while it was once expected that men would participate in community meetings, school organizations, the Town Council, or other community-wide initiatives, today many of these organizations are run primarily by women. People attribute this loosely to "women's empowerment" but also to the fact that traveling alone is less risky now that the roads have improved. Men also point out it is more socially acceptable for women to represent the family in meetings, and, in fact, they joke that it is more convenient for them to send their wives to these long-winded meetings. At a 2015 workshop, one man joked, "Men pretend it's because they are so busy and don't want to cut short their work in the fields, but really, we are sick of these long meetings so now we just send our wives. And they are happy because they think they can make more decisions!" In response, every-

one laughed. Many Las Colinas women are glad that they can now attend meetings when they want to. But just as many are already feeling the squeeze of the triple burden of female labor: reproductive work (domestic work, child care and rearing, adult care, caring for the sick, water- and fuel-related work, health-related work), productive work (work for income and subsistence), and community management work (Bukh 1979; H. Moore 1988; Lyon et al. 2017).

Women affiliated with organizations like the *Comité de Salud* (Health Committee) or the Women's Bank have certainly been judged for their excessively public roles, but their affiliations with these organizations have also provided them with legitimate reasons to travel and take on new tasks. Both organizations are well regarded in the region and are credited with many of the advances in the community. At first, many women felt extremely sensitive to community commentary when they joined the Women's Bank. They themselves sometimes even believed they had betrayed their own families. With time, they came to understand the other kinds of contributions they were making to their families through their participation in such organizations. Though some people continued calling them *mandarinas* (or women who dominated their men, a wholly unsavory concept), they felt more self-assured having a group of supportive women to remind them that they were acting in the best interests of their families. Though the gossip continued, the women learned to ignore it. As a result, each year more women walk freely within and between communities on their way to visit other homes or villages, attend meetings, or make purchases.

ECONOMIC PRECARITY AND GENDERED LABOR

With an unstable economy, rising prices for basic goods, and expanding desires and needs for electronics (such as cell phones, televisions, tablets, internet services, wireless routers, and sometimes the generators or electricity needed to power them), families find it increasingly difficult to make ends meet. In the early 2000s, most villages in the region had zero access to electricity. But since 2010, most households boast radios, televisions, and cell phones, even if access to electricity has become more reliable only recently. People expect to communicate with friends and family by cell phone, even if the communication is irregular and intermittent. For young men, access to a good cell phone, stylish clothing, and even a motorcycle is seen as a prerequisite for finding a girlfriend or a wife. At the same time, costs of living have increased dramatically (leading once again to countrywide protests in early 2022) and opportunities for social mobility are as limited as ever.

In response, families are trying a host of new strategies. Many have experimented with higher-profit products like passionfruit, African oil palm, or cattle (all of which have significant ecological implications for the area). However, the promises and benefits of these products are often short-lived. For example, an oil palm disease has wiped out the plantations that blanketed much of Ecuador's

FIGURE 1.2. Cacao, purchased by local merchant from various farms in Las Colinas, is drying before being resold. (Photo by author.)

coast, many of them now abandoned after causing massive forest loss in the last fifteen years. While many decide to take these kinds of risks so they can make more profit, others stick with what they are used to, even if that implies they can barely make ends meet. Beyond the farm, adolescent children often travel to perform seasonal labor in other parts of Ecuador, such as in the oil palm plantations in northern Esmeraldas. Families are also moving to Quinindé or the central village of Agua Dulce, where men and women have more employment opportunities as day laborers, drivers (of people, livestock, or potable water), construction workers, schoolteachers, and health professionals or administrators at the Agua Dulce Subcentro. Other better-networked families have taken advantage of global economic networks by opening dollar stores that sell low-cost clothing and plastic goods in small cities throughout the province. But the vast majority of families still struggle against the vagaries of the global markets, unable to make sufficient income on the sale of coffee, cacao, passionfruit, bananas, or African palm.[15]

Improved access to credit has also changed the economic landscape and brought new opportunities and challenges. When I first arrived in Las Colinas, many families joked that their bank was their mattress; today, most families have formal bank accounts, and thus access to loans. However, each year, a new crop of moneylenders and microcredit organizations appears, providing dubious, high-interest loans. As a result, families regularly take out loans from multiple institutions and borrow from friends and family as well. In the last ten years, I have watched numerous families default on loans and consequently lose their land and dignity. In the worst cases, they have also fallen out with other family or friends who lent them funds or

served as guarantors on their loans. Despite a clear understanding of the risks of high-interest loans, many friends insist that the only way to actually get ahead is to use a loan to purchase inventory or equipment for a business, buy a car or motorcycle, or finance a home.

These shifts have multiple implications for men, women, and families in Las Colinas. Men suffer from an inability to provide in ways that are deemed satisfactory. As a result, women's labor outside the home is increasing. Many young women leave home to attend schools in larger towns and villages, and both younger and older women engage in the wage economy by working in retail, at schools, or at their own storefronts or eateries. Women's experiences are also shaped by new images of the "good, modern woman": a woman who can afford the latest consumer goods, whose partner shows love and affection through gifts and visible caretaking, and who meets state and NGO visions of "responsible mothers" by taking their children to regular healthcare appointments and getting them their full suite of vaccines, for example. Thus, women are drawn to employment by need, but this is further entrenched by the new "needs" inherent in being progressive wives, mothers, and women.

Of those women who have managed to establish regular employment, most have husbands who are fairly unique in supporting their employment. In my experience, these men are either established "community leaders" who maintain and exercise their dignity and authority in multiple other ways throughout the community, or they are uniquely able to tolerate ridicule and criticism. As one of these men put it, "[The other guys] can talk all they want. I'd rather have more money at home, less headache, and besides, I trust my wife. If they don't trust theirs, that's their problem" (Interview, 2016). Most men, however, admit they are beset by mixed emotions: on the one hand, they want to be accepting and they appreciate the income. But on the other hand, women's increasingly public role in household economies is a big adjustment that chafes at them from time to time.

I have also observed the flipside of women's wage labor—men's increasing involvement in traditionally domestic activities. When women need to leave their homes to work or attend school, men in Las Colinas sometimes pick up the slack by cooking, cleaning, and caring for children. They often resist these activities at first, but over time they practice them more regularly and unconsciously. In fact, men report that such changes in their daily practice have led to the most significant shifts in their acceptance of alternative gender arrangements. As women take on more visible roles in the monetary economy, men may have "noticed" that their wives are responsible and trustworthy. This translates into women having more autonomy when it comes to spending money or making other household decisions, though this autonomy is most acceptable and least questioned when women are making decisions about their children's needs, because these activities are considered "maternal." Overall, men and women are experiencing a slow but significant change in the region's political economy and in household economies and gender norms. As we will see in the next chapter, one of the key lenses they

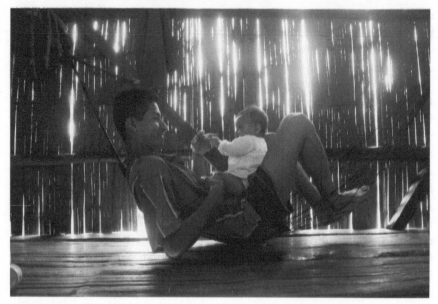

FIGURE 1.3. Las Colinas father in hammock, playing with his baby. (Photo by Aldo Martinez Jr.)

use to make sense of these changes is deeply entrenched understandings of gender as primarily biological and natural.

CONCLUSION

The gendered political economy of life in *el campo* means that women like Marta often learn to expect and justify physical, economic, symbolic violence. In this chapter, we have examined hegemonic gender norms and how they have shifted in Las Colinas since the early 2000s. Gendered norms and practices guide everyday life in Las Colinas, and these likewise sustain the often-invisible violence that women like Marta experience over their lifetimes. Changing labor (and educational) requirements and new messages about women's rights, empowerment, and autonomy have given women like Marta a glimpse of other possibilities. Road improvements have made it possible for women to travel more safely (in truth, I never once heard of an actual assault against a woman on the region's roads). They can travel to meetings and simultaneously fulfill acceptable social functions, such as attending the health center as mothers. For men, getting used to their wives appearing in public, traveling on their own, attending meetings, and making purchases has allowed them to make changes to their daily practices, and over time, accept more flexibility in the gendered division of labor.

An older generation of women and men could hardly imagine a different state of affairs. In response to many of my queries about daily living in Las Colinas, men and women would often reply with the simple refrain, "*somos del campo*," (or "we

are from the country"). On the one hand, they used this refrain to assert the importance of an agricultural livelihood to their identity, with all it implied culturally, economically, and politically. But they also used it to index a sense of stability in their struggle, underlining the constants that came with a life lived in regions far from urban centers of the nation-state. But, in truth, these perceived constants were changing, albeit slowly. Increased exposure to media and changing economic needs have made younger women more aware of alternatives, even if these are seldom easy to realize. Amid these changes, women and men of all ages are reconsidering notions of acceptable violence, suffering, and rights. Marta's story is a case in point, marking a shift in how IPV was handled and talked about. For the first time that anyone could remember, what was once considered to be private *domestic* violence became a *community* matter. Marta's years of abuse, sustained by her social and geographical isolation and her lack of schooling and knowledge about her basic economic and conjugal rights, came to an end.

After Marta reported Felipe to the authorities, she moved away from the isolated region that had been her home for over thirty years. She moved to Agua Dulce where she had increased access and proximity to social networks (friends and family), institutions (the health center, the hospital, the police, and the commissary), media (television, radio, internet, cell phones, and workshops), and employment. These resources were critical to her ability to respond to—rather than merely *aguantar* or accept—the violence within her home. Though she, like other women, had already heard messages about women's rights and empowerment, as well as the wrongs of gender violence when she lived in the countryside, those messages did not—could not—become salient in her life until these alternatives became thinkable and indeed actionable in Agua Dulce. As we will see, however, Marta's ability to respond to domestic violence was severely constrained by other forms of structural violence, and she eventually reunited with Felipe.

Culturally salient ideas about the biology of gender underlie most people's understandings of ideal types of masculinity and femininity. Las Colinas men and women speak of their roles as husbands and wives, and fathers and mothers, as moral-spiritual ones anchored in God's will and in the natural order of things. Though most do not think it is necessary to elaborate on their Catholic convictions, many refer to *"biología"* and *"lo natural"* to support and sustain their beliefs about the gendered moral order in which men are physically stronger but mentally weak, especially when it comes to the temptations of alcohol and sex. These ideas about men's and women's bodies, and what they imply for sexuality, propriety, and the acceptability of violence, are the subject of the next chapter. There, my theoretical analysis of the historical and ethnic dimensions of gender and sexuality among Manabitas highlights the challenges of disentangling violence from masculinity, and sets the stage for understanding the paradoxes, challenges, and particular dynamics that women's empowerment and rights campaigns have produced.

2 · "SOMOS ASÍ POR NATURALEZA"
Bodies, Sexuality, and Morality on Ecuador's Coast

Despite the weariness that follows any long trip, the truck ride into Agua Dulce yielded some of my best research moments. Wedged into the *ranchera*[1], I made new friends and joked with old ones we encountered along the way. I might comment on a strange-looking tree or a new plantation on the side of the road, provoking conversations about the ills or virtues of *palma Africana* (African palm), *maracuyá* (passionfruit), or *familias de afuera* (families from the outside) who were cutting down the primary forest. At other moments, my male friends on the truck would playfully pester me and other women about the dangers of female empowerment. For a sure-fire chuckle from fellow passengers, these men would complain about the social confusion caused by "women who wear pants and men who wear earrings." This fundamental illogic, they would imply, is what had turned the world upside down these days. Nothing was secure anymore; anything could happen.

Every six weeks or so, I made the six-hour trip between Quito and Agua Dulce. I needed emotional breaks from stories of violence and from everyday life in this small village in the cloud forest. Like other anthropologists who have discovered occupational hazards associated with long-term participant observation, I felt constantly embroiled in telenovela-like dramas tied to the politics of everyday life in a small community, not to mention the medical emergencies that consistently punctuated my fieldwork at the Agua Dulce health center. My breaks in Quito helped me withdraw, focus on research, communicate with friends and family, and attend to business with our nonprofit organization, whose office was located in the capital.

Returning from Quito entailed an early-morning winding and often-treacherous bus ride that took between five and six hours, landing me in the small city of Quinindé just in time to purchase supplies and jump on a ranchera for a bumpy seventy to ninety-minute ride into Agua Dulce. Travel between these two points entailed dramatic shifts. From the thin oxygen and polluted air at ten thousand

feet in Quito, I would descend the Andes and arrive in a bustling, dirty, and humid city in Esmeraldas, only to ascend once again into the cool and wet cloud forest on a jam-packed truck. It was both riveting and draining, as was my entire fieldwork experience.

Cresting the final hill, in one of the last tracts of primary forest before Agua Dulce, people invariably sighed in relief and expressed their appreciation of the *aire fresquito* that awaited them. The fresh misty air was consistently praised in contrast to the humid heat of Quinindé, or the stiff, polluted cold of Quito. Just before arrival, the women would sit up and arrange their hair and check for their earrings. The younger men would also stretch upward in their seats and smooth their shirts. When the ranchera rolled into town, townspeople and truck passengers stole quick, nearly imperceptible glances at one another. Through these momentary glances, townspeople could see who had traveled to the city, while passengers would scan the town to determine who was diligently washing clothes, saddling up their horses, or making purchases at the mini-tiendas in the muddy plaza of Agua Dulce. These seemingly mundane details served as crucial fodder for gossip and conversation about men and women and the rights and wrongs that cut across the relationships between gender, sex, and violence.

On an interesting day, one might notice that a woman—known to have been acting strangely of late—might be returning from a trip to the city without the accompaniment of her children or husband. Had she been visiting a lover? Why else would she go to town unaccompanied on a Tuesday? And nobody could miss the family man returning from Quinindé with a fancy new appliance that he placed prominently and uncovered atop the ranchera. It did not matter that the silver washing machine covered in new stickers was bought on a high-interest payment plan, or that the town lacked piped water. He was laying claim to his little piece of modernity and demonstrating that he could take care of his family. But some might wonder how much his wife had pressured him to buy this, because she always complained so much about washing the clothes. Was she neglecting her housework? Was she bossing him around?

These moments, which I infuse here with a sense of the typical gossip and chatter around me, were certainly loaded with judgment. Even so, this chatter should not be dismissed as mere small-town talk. Rather it attests to the significant ways people's lives are structured around ideas of being good men and women, good fathers and mothers, and good children and grandchildren in the eyes of others.

Morally laden ideas of what is appropriate masculinity and femininity permeate innocuous everyday events like a bus ride, leading to powerful forms of self-governance and community censure. Gender is performed in these instances for oneself and for others, helping both to uphold and contest hegemonic gender norms (Merry 2009). For example, when women in Las Colinas engage in "too much flirting," they are challenging dominant norms about acceptable femininity, but the resulting community gossip may simultaneously reinforce the line between

what is and is not acceptable (Butler 1990). Describing these constellations of "acceptable" masculinity and femininity as hegemonic does not mean that they *dictate* how men and women act, but that they most certainly shape and inform them in conscious and often unconscious ways.

Gender identity is constituted in multiple ways and performed in multiple are-nas. Because "doing gender" as a performance is always directed at an audience, delineating a variety of geographies of gender can be helpful. In her research on masculinities in Peru, Norma Fuller (2003) identified three spatial-theoretical dimensions of masculinity that are always in tension with one another: the *domestic*, the *"outside"* (public, the street), and the *natural*. Aspects of masculinity valued in each of these venues may conflict with the others. For example, caring for children to fulfill manliness in the domestic realm might be interpreted as weakness that limits men from fulfilling their ideal masculinity in the public realm. This three-dimensional model helps explain the dynamism and instability of "hegemonic masculinity," showing how subordinate and hegemonic masculinities influence one another. Thus, we see the careful balance that is central to manhood in Las Colinas, evi-dent in how men act differently in distinct spheres. These men have composite masculinities, multiple masculinities that overlap unevenly and often present contra-dictions, especially as they are performed in competing venues (Wentzell 2013).

Driving into Agua Dulce with a shiny new appliance atop the *ranchera* per-forms modern manhood for all those watching. The family man is at once showing everyone that he has money to spend and that he takes care to alleviate some of his wife's domestic burdens. Because gender is relational, subordinate and hege-monic masculinities also give rise to different notions of femininity. So, while many younger women celebrated the wife for convincing the husband to buy the washer, the gossip among older women tended to emphasize that his wife was act-ing high and mighty by thinking she deserves the special right to step outside what they perceived as her prescribed role.

In the previous chapter, I unpacked the story of Marta, an older woman who experienced intimate partner violence throughout her life and who finally invoked the law to end the violence. She eventually reunited with her partner and success-fully put a stop to the violence. I focused on the political-economic circumstances in the household and the community that led Marta to "put up with" (*aguantar*) the violence for so long. Here, I provide a second entry point for understanding why women often tolerate violence in everyday life. I uncover how bio-essentialist understandings of gender and sexuality make violence permissible and even expected for women in Las Colinas.[2]

In Las Colinas, predominant constructions of femininity and masculinity are rooted in dichotomous but complementary understandings of how males and females are by nature, or *"por naturaleza,"* as locals describe it.[3] Much of this *natu-raleza* is embodied—in bodies that are characterized by ethnoracial traits and that are seen as tools for and products of a rural political economy. As a result, male proclivity to violence is also understood as inherent, biological, and linked to

male sexuality, virility, and strength. Because "doing violence is doing gender," when violence becomes politicized, the "natural" order of things is politicized. The *naturaleza* of gender norms and gender violence is also taught through diverse forms of gender socialization, including the folkloric poetry that I reference below and through youth sexual education. Despite their essentialist and determinist bent, I show that some perceptions of *naturaleza* are changing as Las Colinas's men and women leverage these beliefs in new ways to mitigate or explain persistent violence. These local perceptions provide important texture to the process of vernacularization through which human rights become reinterpreted and enacted.

MANABAS AND MONTUBIOS: MACHISMO AND MASCULINITY IN COASTAL ECUADOR

Bio-essentialist understandings of gender, and "natural" links between masculinity and violence in particular, are nothing new (see Laqueur 1990; Bourdieu 2001; Gutmann 2003, 2021). However, these ideas have become more deeply entrenched in Las Colinas because they intersect with powerful racial stereotypes of coastal Ecuadorians. For example, when I tell Ecuadorians that I work with Manabas (people from Manabí), the response is predictable: they almost always say something about violence or *machismo*. As if to compensate for this negative first association, sometimes there is a subsequent mention of Manabas's famous seafood cuisine. The race-gender-violence associations are so strong that they can eclipse professional norms. For example, an anthropologist once responded to one of my public lectures by announcing that I should be commended for my bravery for working on gender violence among Manabas. She said:

> Wow, it's really impressive. You are working with people from Manabí? You need to be careful. I hate to say it, but they are truly primitive—the men, especially. They're the most *bruto* (brutish) of all Ecuadorians. And I say this as a well-informed person. I am from there.

While most Ecuadorian men are perceived as machista in some sense, men from Manabí are considered the most brutish, in part because they are seen as hyper-violent and unabashedly sexual. Coastal rural Manabí brings to mind rampant violence, both between men and against women. Manaba women, on the other hand, are known for their beauty, delicious cooking, and impressive strength (often with the implication that they are strong precisely because they have to put up with violent, jealous, and sexual men). Women who fail to abide by their husbands, or normative ideas about femininity, are often called *mandarinas* (or mujeres que saben mandar, women who call the shots).

Stereotypes about Manabas also intersect with those of *montubios*. An ethnoracial classifier, a *montubio* generally refers to a rural resident (or *campesino*) of coastal Ecuador who survives by working the land (Bauer 2012). Associated most

strongly with rural Manabí, Santa Elena, and Guayas provinces, and to a lesser extent with the northern coastal province of Esmeraldas, montubios are of mixed cultural and biological heritage, most likely Indigenous, Spanish, and Afro-Ecuadorian, though their exact provenance is contested. Those who embrace montubio identity often proudly emphasize their hard work, autonomy, and strong conservative family values, though the term is also used pejoratively. The montubio identity exists both literally and symbolically on the periphery of Ecuadorian consciousness; more than anything, to call someone a montubio is to contrast them with the whiter, city-dwelling mestizo, who is symbolically marked as more civilized, refined, and law-abiding. Many Ecuadorians elide Manabas and montubios, seeing them as one and the same.

The more pejorative associations characterize montubios as slow-witted, overly sexual, immature, hyperreactive, and violent. These stereotypes are best captured by a nationally renowned television program called *Mi Recinto*, which exaggerates them for comic relief.[4] The central character, *compadre Garañón*, has no self-control especially when it comes to women; he perpetually harasses and attempts to rape women. The show generally depicts women as seductive and promiscuous, of low intelligence, and as easily manipulated. The show, which aired continuously from 2001 to 2013, has long been criticized for its racism, sexism, and violence as well as its derogatory representations of coastal Ecuadorians and montubios, yet it was extremely popular, as are reruns today (León Franco 2008).

One of the more intriguing conversations I had with an Ecuadorian about general perceptions of people from Manabí was with an older Quiteño man, an avid reader of Ecuadorian history. I sat next to him on a long bus ride between Quito and the coast. When I explained that I worked with Manabas, he excitedly recounted all he knew about these coastal inhabitants. Predictably, he told me first that Manabas were known to be *prepotente*, referring to their heavy-handed, almost arrogant sense of pride and their tendency to be angered or easily excited. Manaba men in particular were machista and violent, he said, and they completely dominated their women: "A woman in Manabí is nothing without her man." He said that Manabitas were partly Mexican, implying a biological connection, but later he admitted that perhaps they had just been strongly influenced by Mexican culture. In his words, the Mexican macho, with his lassos, sombrero, machete, and rifle, "had found another home in Ecuador."

Machetes, even more than rifles, are central to the symbolic imaginary of montubios. Machetes both enable and symbolize manhood and autonomy: they are tools to clear land for agricultural homesteads, weapons to navigate interpersonal conflicts about land and injustice, and symbolic reminders to families and community members of who wields power. (Many men described to me flashing a machete to remind their wives "who is who.") Analyses of the rich montubio literature of the 1930s also reveal that the machete served as a powerful literary device (Gomez 2012). The machete assumed its own agency, making violence seem not like a choice of agentive men but a force that arises naturally to rectify the injustice of everyday

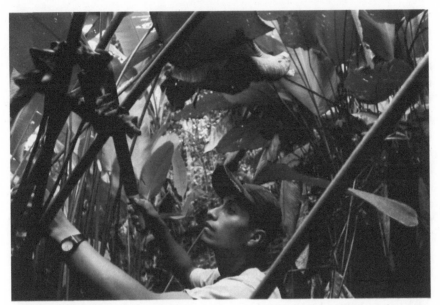

FIGURE 2.1. Man in remote community using machete to clear a path on his farm. (Photo by Aldo Martinez Jr.)

life in coastal Ecuador.[5] As these popular discourses circulate, they reinforce a belief that violence is natural, a defining essence of the geographic and ethnoracial identity of montubios.

We see the elision of Manaba, montubio, machismo, and violence even in government campaigns. In a press release disseminated during the national campaign against violence called *Reacciona Ecuador*, the provincial director of education of Manabí announced, "Manabí is the province with the highest number of complaints of domestic violence, most girls here are brought up with physical or psychological violence" (*Gobierno Nacional de la Republica de Ecuador* 2011). She goes on to say that this coastal province ranks fourth in terms of "the most cases of machismo." As evidence, she states that "in 2009, the Manabí cities of Manta and Portoviejo reported 3,954 complaints filed in the Women's Commissary." Not only do these numbers have little value when reported without any comparative context, but the report's mention of "cases of *machismo*" also demonstrates a common, problematic confusion between machismo and *maltrato de la mujer* (abuse of women). In some ways, this association is not merely incidental; after all, the statement was given for *Reacciona Ecuador*, a massive campaign against gender violence whose tagline was precisely, *"Machismo es Violencia."* As I discuss in chapter 4, the intent of the campaign was to highlight the multidimensional nature of violence inclusive of psychological, economic, and sexual violence, not just physical violence. The national campaign's use of the term machismo was meant to highlight and disavow any masculine behaviors that were oppressive, violent, or humiliating to women. However, because the campaign's messaging resonates

with preexisting ideas about normative masculinity, the term becomes more deeply associated with acts of extreme, usually physical/visible violence.

Together, these characterizations of montubios, Manabas, and machos generate an image of men who have tamed the elements of nature to secure land for themselves and their families. They value autonomy and independence and feel that the violence they enact is brought about by necessity, even biology. Manaba men think of themselves as courageous, hardworking, independent, or unwilling to succumb to the injustices of the state.[6] When I asked Manaba men in Las Colinas about some of the appellations that might be less flattering of them, they insisted that these traits—being strong-willed (*deciso*), sexual or passionate (*caliente*), and arrogant (*prepotente*) or short-fused, especially when protecting women and children—caused problems only if taken to their extreme. Otherwise, the traits themselves were ones they valued and were, if anything, part of their nature. To people in Las Colinas, men can be macho, implying that some of their behaviors are hyper-masculine. However, a machista (in noun form) is a man who takes his machismo too far, often by mistreating a woman, most likely his wife or partner. In Las Colinas, machismo usually refers to a broad constellation of male behaviors including drinking, violence, womanizing, and ideas about honor and shame, but it can also be used as a gloss for wife-beating.

MANDARINAS: DEVIANT FEMININITY ON ECUADOR'S COAST

As my bus companion informed me, "A woman in Manabí is nothing without her man." Despite the sexist implications of this statement, its cultural valence is also underlined by the fact that perceptions and definitions of Manaba femininity are often defined in far less detail, understood as mere contrasts or complements to Manaba men and masculinity. Thus, women are often defined by their beauty (their ability to attract and seduce men) and their dedication to the household through delicious cooking, hard manual labor (washing clothes in the river, for example), birthing and caretaking of children, and "putting up with" their husbands.

In Las Colinas, though men can shift from being macho to machista, women cannot be too womanly. The most likely transgression of a woman is acting too much like a man by wielding too much power, for which she is called a mandarina (sometimes interchangeably with a *mujer machista* or *mandona*), meaning an aggressive woman who orders her husband or other men around. The term is also used for women who seem overly independent—like the woman who might "leave her home without her husband," as one interviewee noted, a woman who participates in community organizations without the presence of her husband (especially before 2010, when such work was considered even less acceptable for women than it is today). For example, when I asked one middle-aged woman if it was possible for a woman to be machista, she replied, "Yes, definitely. I used to be

a mandarina, a woman that says, 'I call the shots, nobody orders me around.'" The risks of unruly women are greater; while a machista man doesn't imply the gender failings of his wife, a mandarina upends the order of things and emasculates her husband. When men are seen helping out around the house or allowing their wives to travel independently, unless they can clearly assert their own decision-making authority, they risk being ridiculed as mandarinas or mandados.

These stereotypes about Manaba (and by extension, Las Colinas) men and women are powerful. They are also incomplete. Like essentialized representations of any group of people, stereotypes are oversimplified ideas about how typical men and women act. In chapter 2, I demonstrated how these stereotypes are tied to hegemonic gendered identities that developed from the challenges of maintaining households in a harsh rural environment. However, for people in Las Colinas, they are not just abstract representations divorced from reality. These normative ideas that they see reflected in news, television stories, and the myths and stories they tell one another then shape the way people understand new ideas about gender and modernity as they continually remake and make sense of themselves, their relationships, and their futures. Understanding how machismo has come to be seen as an extreme—but wholly natural and almost expected—form of masculinity is crucial to understanding how men and women interpret messaging about gender, sex, and violence and reorganize their relationships accordingly. One way it has become so is through the gendered socialization of folk poetry.

EL AMORFINO: "ASÍ SON LOS HOMBRES" (THAT'S JUST THE WAY MEN ARE)

> Manabí is characterized by the courage of its men and the beauty of its women.
> —Manabí tourism brochure, 2008

While most understandings of masculinity and femininity in Las Colinas resonate with the stereotypes of both Manabas and montubios, local circumstances are themselves shifting and refracting how hegemonic gender norms are practiced and experienced. Anthropologists have demonstrated that despite appearances, ideas about gender as biologically fixed or "natural" are usually anything but. In fact, the idea of "natural" is itself constructed, and the "strategy of 'naturalizing' the cultural is as widespread as it is insidious" (MacClancy 2019, 8). Young men and women in Las Colinas are socialized into learning about hegemonic masculinities and emphasized femininities in diverse ways, ranging from simple observation of one's parents, friends, and family to receiving formal sex education talks at school. Some of these learning moments occur through community performances of Manaba traditions, sex education workshops, and messaging from parents.

Major public holidays and community events in Las Colinas are often marked by performances of *amorfinos*, a folkoric tradition and literary genre of contrapuntal

oral poetry considered to be a "marker of the identity of the pueblo montubio" (Barres 2014). An *amorfino* entails a lyrical composition that tends to be moralizing or "sententious in its transmission of popular knowledge" (Barres 2014). Ecuadorian folklorist Ordoñez Iturralde (2014) examines masculinity and machismo in amorfinos and montubio poetry more broadly and notes that in these texts "the montubio lacks any semblance of fear or cowardice, save for the natural shyness that he might display when confronting a person of authority or someone from a big city" (Ordoñez Iturralde 2014, 26). What might be deemed shameless at one moment is celebrated as courage and audacity in another; the montubio is at his best when he is being true to himself and his nature, defending his honor and dignity as a man. In this genre, the daring and virility of the montubio become central themes, as "the montubio is eminently sexual . . . for him, incest isn't necessarily taboo" (Ordoñez Iturralde 2014, 26, translated by author).

At special events, like the annual patron saint festival in Agua Dulce, young boys and girls perform these ritualized poems on the stage together, bringing crowds to hysterics because of the funny back-and-forth recitations and wordplay that is usually gendered and hyper-sexualized. While the themes can include everyday wisdom, jokes, songs, and advice, the most common amorfinos performed in Las Colinas are about everyday misunderstandings between men and women due to flirtation, infidelity, and violence (Barres, 2014; see examples).

ORIGINAL, IN SPANISH:

Excerpt One	**Excerpt One**
Mujer:	Girl:
Allá arriba en ese cielo,	There in the sky above
Brillan las estrellas	The stars twinkle bright
Brilla una y brillan dos	One twinkles, then another
Así es usted con el tiempo	Like you, over time
Anda con una y con dos	Going out with one, then with another
Varón:	Boy:
No te sientas mal mi amorcito	Don't feel bad, my love
Tú serás siempre la primera	You'll always be the first
Aunque ande con una o con dos	Even if I run off with one or two
Nos casaremos los dos	You and I will be married
Excerpt Two	**Excerpt Two**
Mujer:	Girl:
El [hombre] que tiene las mujeres	A man who has lots of women
Se cree muy macho	Thinks he's really macho
Se quiere con una	He may really love one woman
Y la otra le mete los cachos	While he flirts (or cheats) with another

While such amorfinos address various aspects of rural montubio life (including the natural environment and agricultural practices), the dynamics between

men and women draw the most laughs. In these excerpts, we hear men admitting their weakness for women and their moral depravity for having indulged in their sexual impulses. And yet a man's infidelity is also presented as an unavoidable fact of life that women must learn to tolerate, his shifting desires as natural as the stars that twinkle in the sky. The women he beholds, despite "losing their shine" (presumably through aging or losing their newness) are powerful in their captivating beauty. The women in the audience (both imagined and real) also hold power over the male figure by poking fun at him, his shamelessness, and his lack of self-control. Ultimately, the male subject of the first excerpt reassures his wife that, despite the "twinkling" and shiny distractions, he will always come back to the one he married, as she is his first and true love.

The last time I saw amorfinos performed, I could not help myself from asking audience members whether they found them sexist. Most readily agreed and condemned them as "not right," but generally they conceded that "it's basically the way things are, so we just have to laugh!" They also assured me that there are many amorfinos that celebrate the strength of women and the challenges that men have in their attempts to "conquer" them or gain their admiration.[7] Such amorfinos portray Montubio women as strong and demanding but also sacrificial and passive. The implication is that they are powerful in two ways: first, as potential seductresses (especially women of marriageable age who are single and without a stable family unit, i.e., women "out-of-place"), and second, as women of the home, where they have the right to make decisions about how the household is run. Men, however, are best suited to be the ultimate authorities, a fact that is underwritten by their biology—in particular, their superior physical strength.[8] Thus the moral question (as we will see) becomes how a man navigates his sexuality, infidelity, and violence in ways that abide by local moral-spatial codes of gender and marriage. These amorfinos speak to the nuances of sexual moral codes and to what Jennifer Hirsch (2009) calls a spatial geography of sexual desire, as some transgressions are to be expected.

POR NATURALEZA: GENDERED BIOLOGY AS DESTINY

Sí, claro, los hombres son más violentos y más sexuales por naturaleza
—Interview with a woman, 2008

An important part of the naturaleza that undergirds local gender norms is biological: the observable differences between men's and women's bodies and sexualities. In his body of work, Matthew Gutmann (2021) reveals and challenges "the tenacious hold that biological extremism about boys and men has on imaginations, seemingly rooted in experience and scientific evidence" to the point that fallacious assumptions about causal links between male physiology and behavior is rampant in both the literature on humans and other animals, including absurd generalizations about cross-species male violence (S182). Sayings like "boys will be boys" or catchphrases used to describe aggression among males like "Take it like a man," "It takes balls," "Man up," "Grow a

pair" are common in the United States, and most can be quite easily translated to other languages and contexts (Gutmann 2021). In Las Colinas, one parallel is the oft-repeated reply to my questions about the reasons for a man's behavior in a particular context: "*así somos, los hombres*" with implicit causation attributed to naturaleza. Beyond regional and global generalities about the bio-essentialist understandings of gender, what are the specific ways in which these ideas permeate everyday understandings of the body, sex, and sexuality in Las Colinas?

The people of Las Colinas understand men to be more sexual by nature than are women, a notion that they told me is evident from their more "obvious" genitalia, as one woman put it. All central aspects of masculinity derive from this fact. Similarly, Fuller (2012) argues that male sexual organs and physical strength form the "nucleus of masculinity" [in Peru], because they are "defined as innate and unchangeable" (137). Men live their lives trying to overcome and rein in the biological facts of their maleness—their strength, hyper-sexuality, and violence—but at the same time they have to honor them in order to confirm their manhood.

Because men are strong and virile, women are understood to be sexually reserved and passive, even if beautiful and seductive. Since men are typically physically stronger than women, one of their central roles in life is to conquer and also to protect women. As one young woman explained, "Each woman knows since birth that they are more delicate, they are born with the idea of being delicate" and therefore, we not only "have to be careful, but we should find a man to protect us, especially if we don't have a father."

However, people in Las Colinas perceive young girls to become sexual at an earlier age than boys, as evident in their earlier physical maturation (menstruation, the growth of breasts, and other secondary sex characteristics). And for many, a young girl's physical maturity is linked to her emotional maturity; she is viewed as able to handle sex and even marriage if her body is ready to handle it. For this reason, people pay little heed to legal age limits, as they believe that the body of a young girl says much more about her physical and emotional maturity than an abstract number.

However, perceptions of readiness for sex and marriage are slowly changing due to family planning seminars, health campaigns, human rights messaging about child marriage and pregnancy, and hopes that more young men and women will complete high school. For example, Rafael, a young man from Las Colinas, offered the following explanation for why men often marry younger girls: "Young girls are very different from young boys because they develop much more quickly than boys, you can see it in their bodies and so one thinks they're ready." At this point, Rafael became self-conscious, as he realized he might be justifying child marriage, so he quickly followed up by saying, "but physical development doesn't necessarily mean they're mentally developed or ready. And some learn more quickly and others more slowly, so it really just depends."

It is also widely believed that people on the coast are more sexual (or more open with their sexuality) than people in the Amazonian or Andean regions of Ecuador.

While there are important racial-ethnic and religious-historical dimensions to this, people in Las Colinas often ascribe it to climactic differences, as if there is a clear relationship between warmer temperatures, less clothing, and freer sexuality. Rahier (2011) captures the racial thinking of mestizo Andean Ecuadorians who consider Afro-Ecuadorians to be more intrinsically sexual. In one conversation with an Ecuadorian white-mestizo man he was told, "Black people, wherever they are found, never repress their sexuality; they have a much freer rapport to their bodies; their sexuality and their natural sensuality are important and normal parts of their daily lives. That is why they dance how they dance, with lascivious body movements; even the way they walk." While most people in Las Colinas are *mestizo* and technically montubio (from Manabí as opposed to Esmeraldas), many think that the Afro-Ecuadorian culture rubs off on all coastal groups, others recognize the likelihood that Manabas and montubios have some degree of Black, Afro-descendance. So, the thinking goes, while Afro-Ecuadorians on the coast are the most sexual and free, other coastal people are certainly more open than those who live in the Andes or in the Amazonian regions. Despite skin color, the "warmer" bodies of men and women in coastal Manabí or Esmeraldas are understood to be freer and less controlled than the "cooler" bodies of the highlands. Another dimension of this which often provokes a moralizing, racialized response from Quiteño and other highlanders is the fact that coastal women tend to wear tighter clothing, with less coverage, often accentuating their bodies. While Manabas (and other mestizos living on the coast) see themselves as distinct from Afro-Ecuadorians, there is a strong sense that all coastal peoples, especially those that live in the rural interior, are more primitive and closer to naturaleza because of their geographic distance from the civilized (and whiter) capital of the Sierra highlands.

NAVIGATING SEX AND INFIDELITY

Ideas about naturaleza also affect the dynamics of infidelity in Las Colinas. Men who have been unfaithful to their wives are often, but not always, forgiven. At times, their dalliances might be attributed to their naturaleza because it is understood that their sexuality cannot be controlled. However, there is a clear distinction "between flagrant and appropriately managed infidelity," similar to the patterns discerned by Jennifer Hirsch (2009) in rural Mexico. As we will see, if infidelity is appropriately managed so a wife's dignity is not abused, then a husband can retain his standing within the relationship while proving his masculine virility. Discrete infidelity thus becomes an important way to negotiate the tension between private and public masculinities.

Women in Las Colinas regularly asked me whether I felt it was acceptable that men had relationships or sexual encounters outside of marriage. Though I did my best to avoid simple, moralizing responses, it was clear that they were asking me because their own views on the subject were complicated, contradictory, and changing. To some degree, women accepted that their husbands might sleep

around. However, the tacit agreement for many was that their husbands had to be extremely inconspicuous to avoid the public eye of the community and the inevitable *chisme*, or gossip, that would result. One's wife should never have to face the reality of her husband's affairs, either by seeing it or hearing of it. As Hirsch (2009) details, there is also an important moral-spatial aspect, such that the affair should never affect or enter the home. For this reason, brothels (or in some cases, billiard-halls) have always played an important role in masculinity, as sanctioned spaces for men to "let go" and indulge their natural desires without jeopardizing relationships with either their own wives or other men (with whose wives they might otherwise have an affair).

While everyone believes that men are much more likely to have extramarital affairs or relationships, many also admit that there are cases in which women also cheat on their partners, despite the risks of domestic violence. Because it is understood that a woman's role is to pleasure her husband, not to seek her own pleasure, most women who are unfaithful are reviled and characterized as ungrateful and dangerously promiscuous. Powerful contradictions always emerged in conversations about women and infidelity, a surprisingly common topic in the informal women's group meetings we held monthly from 2007 to 2008 (and more sporadically, in other years). When the topic of extramarital relationships came up, women in these groups spoke openly: "Men here think that once he has a woman as his wife, she can no longer be his lover. But on the contrary, if a man would have his wife as his lover too, then there would be no need to replace her with another woman." In this way, they alluded to wanting to be able to have multiple forms of intimacy in their relationships, and a desire to have sex for pleasure, not merely reproduction.

However, they weren't entirely comfortable with the idea of sex for pleasure, either. One problem with women's pleasure and companionship is the morality of infidelity, since presumably only the very rare husband could be convinced to prioritize his wife's pleasure. For example, in one meeting women excitedly recounted the story of a woman who had left the region because she was overwhelmed by hostile gossip after flirting (and perhaps sleeping) with a local shopkeeper, a married man. This, to all, was inexcusable. Later, however, they brought up the story of another woman who had been married for many years, but who had a sexual relationship with a recently widowed man in town. This second case was not as straightforward to them. While many women criticized her for "lacking respect," for breaching spatial norms and etiquette by flirting with her lover in public, some, however, rolled their eyes and complained that she wasn't that obvious. Her search for pleasure might have been tolerable; nobody argued that the affair itself was wrong.

At the end of the meeting, while most people were filing out laughing, a divorced middle-aged woman wanted to explain why a woman might seek sex outside her relationship and risk violence at home:

Well, my Karin, there are many things we cannot understand. But think about it, you have talked to us women about sex, about pleasure, about things that most

women here don't dare to admit ever thinking about. These poor women, their husbands treat them like mothers, and never expect to have mutual pleasure with their wives. To them, that is what the prostitutes are for. So if you can imagine, some of these women are dying for intimacy, to be touched, to be wanted. It's no wonder that they want to go elsewhere sometimes. But if they do, it's [seen as] not good. And I don't mean I agree. That is not right [for women to leave]. But some do it anyway.

Repeatedly in these conversations I learned that women felt caught because they felt they could only be wives to their husbands, not lovers. They desired intimacy, especially the companionate forms of intimacy they had witnessed in certain relationships in the village or in soap operas, or learned about in family planning workshops and from international volunteers.

A second problem was simple knowledge. Many women knew next to nothing about sexual pleasure, and they believed that so much as thinking about it made them immoral. During one meeting I asked a room of older women if they knew what an orgasm was. The room erupted in uncomfortable laughter, as the idea of sexual pleasure was perceptibly shameful. Eventually, a couple of women in the group of twenty-five mentioned having experienced an orgasm, but to avoid isolating or embarrassing them, I dropped the direct question. Instead, I asked whether or not we should talk about it. Everyone present agreed that we "should" talk about it and that it shouldn't be embarrassing, but it was. "It just doesn't seem right," they said, and it feels wrong. An orgasm was okay if it just happened, but working for it made sex something different, something almost unnatural (presumably because it was beyond reproductive). To underline this distinction further, the women later agreed in conversations that, in the end, orgasms weren't so bad, but that "oral sex is where we draw the line!" One woman who, until then, had been embarrassed by very little in our conversations, jumped up and went to the front of the room and starting emulating giving oral sex to a man, but at the same time made bodily gestures indicating her confusion, as if she didn't really know what she was doing. As everyone present erupted into hysterics, she turned around and walk off the "stage," saying, "yeah, I just can't get myself to do that, it's so humiliating, so we can all just leave that for the prostitutes, ¿diga? (don't ya think?)" These women may seek intimacy on the one hand, but they risk everything when they might be considered "bad women," or women *de la calle* instead of women *de la casa*.

Young men have a slightly different sexual socialization, learning early on to separate emotional intimacy from physical intimacy. Yet men in Las Colinas believe that, once they physically mature (usually between the ages of ten and thirteen), they need regular ejaculation in order to remain healthy and manage bodily stress. As a result, young men often seek out "release" without emotional attachment, and it is often easier for young men to find sexual pleasure with a sex worker, a friend, or even an animal than with a woman whom he loves and hopes to marry. For one, if she is to remain "marriageable" she must demonstrate that she

can stave off his advances until they are married. As Jennifer Hirsch (2009) puts it, this "training in the separation of affect and pleasure" becomes "a way of learning to experience sex as something no more meaningful than a late-night plate of tacos on the way home from the disco" (70). For precisely this reason it becomes understandable that men might feel it is natural and acceptable to seek out extramarital sex, as was teased about in the amorfinos, as long as that sex is strictly about physical pleasure.

I learned that one way for men to distinguish the physical from the emotional is to perform different sexual acts with extramarital partners than they would with their wives. Early in my research I often heard women tell me that, in some ways, they actually wanted their husbands to visit sex workers so that they didn't have to deal with the shame and the physical challenge of putting up with their husband's sexual needs (especially when these women were pregnant or had recently given birth).

The demarcation between kinds of sexual acts within marital and extramarital unions has recently become much more complicated, as married or committed couples try to incorporate pleasure into their sexual relationship. Many women feel deeply ashamed by engaging in anything but passive, missionary-style sex with their husbands. And yet they told me that their partners are asking more of them or threatening to seek sex-for-pleasure elsewhere, something that these women no longer want to accept. Consequently, many women find themselves obliging their partners—but subsequently being subjected to humiliating emotional and psychological abuse.

In most cases, married or partnered women in Las Colinas are likely to look the other way if their husbands have one-off extramarital relations, either with a sex worker or with a woman from the city or another region. Women's reputations depend, of course, on not only how well they maintain their own sexual respectability but also how well their husbands do. Extramarital sex is more likely to preserve a wife's dignity if men fly under the radar by keeping relationships short and/or "adher[ing] to local conventions of sexual and moral geography" by limiting sexual encounters to "spaces that are beyond the reach of the wifely gaze" (Hirsch 2009). As we see in chapter 5, this is but one reason that the debate about the closing of a brothel in Las Colinas became an argument about helping families, more than anything so that men would have a sanctioned space for extramarital sex that did not risk shaming their wives and families.

"OUT OF HIS MIND"

In certain cases, however, men fail to navigate the spatial-moral geography adequately and consequently hurt their wives and jeopardize their family's reputations. These circumstances often lead to physical violence against women and are generally entangled with other forms of abuse. Relatedly, there is also a moral-spatial geography to violence, women often feel responsible for limiting their

public exposure to violence lest they be judged for being too submissive, or not being able to keep a husband in check (a consideration that is much more pertinent today than in the past). If a husband demonstrates flagrant and unchecked sexuality or violence that becomes visible to the public, then a wife must publicly punish him in some way to demonstrate her strength and moral standing. Some women may choose to leave their husbands; but in an environment in which leaving your relationship is extremely challenging, if not economically impossible, women and families have generated creative responses in order to "save face." Such responses, however, are almost always predicated on the idea that men are fundamentally and naturally hyper-virile and hyper-violent.

In one telling example, a man in his forties in the village of Agua Dulce had taken up with a fifteen-year-old girl, and as a result had kicked his wife Evelyn out of the house. People were shocked not so much by the affair but by the disrespect he enacted when he paraded his new girlfriend around town and kicked out Evelyn and her six children (most from a previous marriage). With nowhere to stay and no way to make a living, Evelyn left for relatives in another province. When I returned to Ecuador a year later, I was surprised to find Evelyn on the *ranchera* riding into Agua Dulce with me. She greeted me as she always had and told me to come by the house. Confused, I asked, "Oh, are you in the same house?" In response, she laughed as if I was being silly or forgetful, and said "Yes, of course I'm in the same house! Where else would I be!?"

Though I had passed her house and greeted her many times over the years, I had never before been invited inside. The next day, when I went by as requested, she asked if I wanted to come inside for coffee or some chicken and rice. I was surprised by this invitation, not only because it implied that she had reunited with her husband but also because I knew her husband to be the controlling type (friends labeled him "a typical machista") who might not like it if she had visitors in the home. Worried that my visit might cause her harm, I told her that my stopover had to be quick so that she could easily opt for a conversation on the stoop instead. As we sat there, somewhat awkwardly recounting the changes in the village over the last year, I mustered up the courage to ask, "I thought you and your husband had separated." To which she responded, "Oh yes, but that was only for a couple of months or so. You see, he was a little lost—well, sick—for a while. He was out of his mind but now he's okay again." I tried to probe a little further, but Evelyn shifted and turned away, letting me know that that particular conversation was over for today. At the same moment, one of her children appeared and jumped onto my lap. Later, I learned that the widely told story was that someone, probably the young girl herself, had cast a spell over her husband. This narrative absolved him of blame and relieved Evelyn of indignity and embarrassment.

In yet another story of marital infidelity, a man in his mid-thirties separated from his wife of many years and ran off with another woman with whom he had fallen madly in love. Most saw and knew that he and this woman were in love, and many (but not all) excused him for having left his wife and children (assuming

he would continue supporting them) precisely because he was so head-over-heels in love. His parents, however, were wholly unsupportive and they did all they could to convince him to return to his wife. After a few months of what seemed to be a fairly stable relationship, he split with his new girlfriend without any explanation. The girlfriend was horribly distraught because there was "no logical reason" for him to break up with her. It "came out of nowhere." Eventually he told her (and me) that he and his family believed she had given him some kind of potion that led him to fall for her against his will. In his mind, there was no other explanation for his irresponsible actions, the implication being that now that he was aware of her powers, she could no longer trick him. He would now make sure to avoid her and any magic she might perform in order to devote himself to his wife and children once again.

For men in Las Colinas who commit infidelity, rape, extreme aggression, and other forms of violence, the explanation that they were "out of their mind" is a common one. Usually, when men "lose their mind," it implies that they have lost their ability to temper their natural impulses and fulfill their husbandly duties. Men, partners, and even parents use this rationale to communicate their suspicions that the man in question had experienced some form of magic spell, unknowingly imbibed a magic potion, was "made crazy" by a partner or spouse, or in some cases, had become uncharacteristically drunk. Although I often heard such explanations, these justifications became more emphatic and more central to discussions about incidents of violence as people grew increasingly ashamed by this kind of behavior amid public discourses of women's rights and images of progressive, modern families—a discussion I continue later in the book.

Men often excused or spoke of their violence or infidelity in similar ways: either they were driven to commit these acts due to their partners' behavior (insubordination, pettiness, or lack of sex, for example), or they were spontaneously and involuntarily "out of their mind" for a short time (ranging from minutes to months), or they made a mistake (yes, many men did take responsibility). But, as Fuller (2001) shows in her work on gender violence in Peru, "the logic of violence is consolidated on a profound asymmetry which allows men to be extremely demanding with respect to women's duties and rather tolerant with respect to their own incapacity to comply with their matrimonial vows" (28). It is not only men who are rather tolerant with respect to breaking their vows; rather, most everyone in Las Colinas helps uphold and reiterate the notion that men are biologically driven towards sex and violence, and thus have much more reason to be forgiven for these transgressions, especially if periodic or discrete in nature.

TALKING ABOUT SEX IN LAS COLINAS

Many young men and women today would like to raise their children differently than how they themselves were raised. Younger generations still hold strongly to bio-essentialist views about gender "por naturaleza," but they also believe more

strongly in men's and women's capacity to temper these biological dictates out of respect for their partners. The contradictory nature of these ideas about gender, sex, and violence became quite evident when a student and I examined how families talk to their children about gender and sexuality in 2015 and 2016.[9] There is deep ambivalence about "talking about sex" with young children across generations, and many parents say they try to talk about it but that their conversations are typically short, uncomfortable, and hence abrupt. One young man explained: "Well, from personal experience, around ten years old we usually started to learn or understand what sex is, but then we would really discover it around twelve to fourteen years old. Parents don't really tell kids what it is." Many people, especially the older generation, believe that talking about sex only encourages sexual activity.

On the other hand, years of workshops on sexual education and reproductive health have convinced most families today that people, especially the youth, should learn how to protect themselves from disease and plan their families. Local midwives played an especially strong role in promoting sexual education and family planning, encouraging young couples to focus on "the quality of their children's lives, not the quantity of children." Increased use of birth control pills, IUDs, and condoms, as well as discussions of STDs, sexual violence, and consent, have recontextualized conversations about sexuality and infidelity. Still, most parents still resist talking to their children because they feel uncomfortable or unequipped for those conversations. As one woman reported in 2016, "I don't know very much about how it all works so I think it is better that my child learn about it in school, or at the health center."

Due to perceived differences in physical and emotional maturity of boys and girls around that age, some believe that parents should communicate about sex differently with boys than with girls. First, most believe that it is the mothers' responsibility to talk to the daughters, and that of the fathers to talk to the sons. Talking about these things early is important because "young girls can get pregnant at a really early age." With the understanding that men—especially young men—are naturally sexual and aggressive, parents, especially mothers, teach their daughters that the best way to avoid rape or impropriety is to maintain one's distance from men. Often, however, they advise this distance without explaining the reasons for it. When discussing the prospect of marriage for her adolescent children, Sofia responded,

> I have to be careful with my children, with my daughter especially, but I don't want to be too protective. But when I see that a young boy does not come from a good father, who is responsible for teaching him, I tell her firmly not to marry [him] early. And the worst is that we Ecuadorians see and believe that a man has the right to just leave a woman. I always remind my son, "Don't take advantage of the weakness of a young girl. Respect her. Never think that you need her only to sleep with her." That's a problem here in Ecuador. On the other hand, I have noticed that when the volunteers come through here, I see that some of the men and women

can sleep next to each other, even in the same bed, and nothing will happen. There, there is a lot of respect. But here, there isn't. Here, you can't trust a man like that. If he's young, you can't trust him because he already knows about her weakness, and he won't respect it. For the volunteers, it seems that one thing is friendship and the other is love. A boy and girl can talk to one another, play games, discuss, and there is none of this sexual pressure. My son remembers what I have told him, to respect women. And people have even called him a homosexual for that. He has it ingrained in his brain now, what I have always told him. I tell him even that to see a woman's naked body should not be such a big deal, or a cause for disrespect. It could be his sister. And he should respect her. I say that to all three of my sons, that they should respect a girl, as they would want their sister to be respected. I don't want to see that them take advantage of anyone. I don't want any of that evil coming from my family. I would explode with anger. I have had enough of that.

Men, on the other hand, are "usually more direct in the way they talk to their sons," according to Rafael. This meant many things, but it did not necessarily mean direct and open communication. Rafael said he never felt comfortable talking to his father about sex, and implied that few boys did. His father was very closed and very demanding, and he just couldn't have these conversations with him. As he described it,

My father got more involved, or concerned, when I was around thirteen years old because I think my dad was worried about my sexuality. I was delicate, or I was soft-spoken, and my dad, well, he was really machista so he was confused by me, and I think he didn't know how I would turn out, but he didn't know how to talk to me. But at thirteen years old, I started to develop, I mean I started to go out dancing, go out with girls, become interested, and the only conversation he had with me was, "Son, if you need to take a girl to a hotel, just tell me and I'll give you the money." But I never did, I mean, if your father had never talked to you about sex or sexuality, always had been machista, how are you going to tell him or ask him, "Dad, give me some money because I want to take a girl there, we're going out, I want money for ice cream" or whatever. Never. But as a result, I became really irresponsible, and I think this is because I didn't have my father's support or confidence, so I want to be different for my son. My mother was strong, and she was communicative, she led the house while my dad was just quiet, but it wasn't her role to talk to me about sex. It was his.

Otherwise, boys learn from each other, from pornographic magazines, and today, from movies and internet content. But, as Rafael described, "In the past when we didn't have these things, you learned more . . . directly."[10] Many men told me that their first sexual encounters were with sex workers or in some cases, with animals. As shocking as it sounds, sex with animals had been fairly common (and perhaps still is) among coastal populations in Colombia and Ecuador. When

Rafael mentioned sex with animals as one way that fathers "taught" sex to their boys, he became embarrassed, understanding that many see this as potentially deviant and immoral behavior. Many Las Colinas men talked with me about these formative experiences with regret, disdain, and shame. They resented being goaded into losing their virginity in these impersonal ways, and their shame was only exacerbated by the association with animals. These unforgiving rites of performative masculinity served as the ultimate test of masculinity for these early adolescents, often overseen directly by their exacting fathers.

As Rafael and others emphasized, nobody spoke with them about physical intimacy, reproduction, or emotional-physical relationships, outside of the demands for young men to perform and learn penetrative sex. In school, all they learned was that men's bodies and women's bodies were different, with the implication that women's bodies were responsible for reproduction. Most parents sent their kids to learn technicalities at the health center, but then these conversations were divorced from the kinds of helpful insights that parents share with their children. Furthermore, girls and boys in schools received very different lessons: there was a broad consensus that young girls should learn how to protect themselves physically and morally from men and boys, while boys needed to learn physically how to have sex, regardless of sexual partner, because having an outlet for sexual release was perceived as integral to becoming a man. Rafael, for one, felt unready for this "more direct" form of sexual education, and yet, as his father saw it, his body dictated that he was ready, even if emotionally he was not.

CONTRADICTIONS: LIFE COURSE AND GENERATIONAL CHANGE

Today, women and men in Las Colinas face a number of challenging contradictions, and with the politicization of gender violence, we see both women and men struggle to live up to seemingly incompatible sets of expectations. Many men in Agua Dulce feel this acutely, as they try to reconcile different expectations for acting in public, in private, and in being true to "their nature" as men, as Manabas, and as montubios. For example, when men are violent, they are just as likely to be judged as backward and primitive as they are to be celebrated for their strength and ability to maintain order in their households. Women who leave their abusive husbands will be praised by some for being progressive women who stand up to machismo and gender violence, and they will be demonized by others for breaking up their families. Women can be celebrated for getting their husbands to buy washing machines to relieve them of this challenging domestic labor, or they may be critiqued for their laziness and unwillingness to do the hard work of being a good wife. These contradictions speak to competing expectations in different spheres: the street, the public, and "lo natural." As I have shown here, the competing expectations that underlie these different spheres of gender performance are in no way static, either. They change over a person's life course and they are chang-

ing generationally, especially vis-à-vis constructivist discourses of gender that are critical of excessive male virility and aggression and celebrate women's insubordination to these patriarchal and misogynistic standards.

Young men, in particular, complained that their fathers expected them to prove their masculinity through sexual prowess, responsibility (in terms of work and sustaining a family), and leadership (either through formal leadership positions in the community or just by having the respect of other men). According to one twenty-year-old man, friends expected sexual prowess (often implying the use of brothels or other acts of infidelity) and a jovial attitude, which often meant being "laid-back, but also [displaying] a willingness to stay out, party with friends, and play pool, or even go to a brothel" (which, these men insist, is a fun place to drink, not just a place to pay for sex). According to younger men in Las Colinas, women in the past accepted that their husbands or boyfriends might be unfaithful at times, accepted that it was something that "just happens" when young men stay out late drinking.

In recent years, however, women have become more "demanding" in their expectations. In our focus groups in 2015 to 2016, we held many conversations about the ideal man, the ideal woman, and ideal families. In these groups, women spoke most often about men being attentive, affectionate, and respectful, focusing on attributes that were in contrast to what they understood as "men of the past." However, when we broke into smaller groups, the men immediately quipped that this is something that women say, but it isn't really what they want. According to them, "if you are sensitive and kind, women aren't attracted to you." They joked that they needed to be "a little macho, but not too machista, a little kind, but not too kind." In less public conversations, women also confirmed this. When I queried them about their preference for men who are "*detallista*" (attentive to detail) and "*respetuoso*" (respectful), some quickly intervened to clarify that there is a risk of men becoming too "*delicado*" (delicate and sensitive), "*fresita*" (spoiled), or "*aniñado*" (childish, immature), all of which were adjectives regularly used to signify men who seemed as if they were not self-sufficient, and thus still a long way from making it on their own without the help of their parents. In contrast, women spoke of being attracted to men who were kind, yet strong, someone who was still masculine, or "*un hombre fuerte, valiente, que habla duro*" (a man who's strong and courageous, who speaks with authority).

While some men complained about these new expectations, others didn't mind them, especially as they became older. Women and men consistently told me that gender violence tends to decline as men age, unless they are heavy drinkers. Many felt older men were simply less physically able or they were too tired to fight. Settling down and getting married also implied a different model of acceptable masculinity. As one recently partnered nineteen-year-old male admitted to me, "honestly, I don't want to go out with my friends anymore, and I don't need to look for sex elsewhere, but I feel like this is still expected of me, and so I just go out drinking with my friends sometimes when they pressure me to" (Interview,

2013). In her work on Mexican men, aging, and erectile dysfunction, Emily Wentzell (2013) examines how mature masculinities emerge over the life course in Oaxaca, allowing a reconfiguration of values that reoriented men more towards the "home" than the "street/public." Interestingly, these men also "frequently characterized bodily aging as a reprieve from macho impulses" (Wentzell 2013, 51). While it was important that these men had once indulged those impulses, for many men in Las Colinas, as in Oaxaca, "tempering these activities later in life [was] equally important to respectable masculinity" (51). Thus, across one man's lifetime, he may change how he aligns himself with the different expectations of masculinity accorded by the three spheres of house, public, and "lo natural," demonstrating yet another way that men simultaneously resist and enact specific cultural archetypes of masculinity (Wentzell 2013, 183).

While women's femininity is sometimes context-contingent in similar ways, the behaviors expected of them in each of these spheres and by distinct groups of people are not as contradictory. Women do not have their woman-ness at stake the way men do, but they experience deep-seated anxiety and shame about not being "good women" and "good wives." Women are expected to be devoted to the private sphere where they may exercise some degree of authority because it is their privileged space. Their public role is to engage only as much as necessary for stable household reproduction (to buy supplies, clothes, and food for the household, or to attend meetings in their husbands' stead) and, relatedly, to avoid any seemingly inappropriate interactions with other men (which might include flirting, sex, or just the perception or rumors thereof).

Girls today still learn that being a good woman means being a good wife and mother, or *ama de casa*. Yet, with the politicization of gender and violence, young women are also learning that, to be a good woman, you have to also take care of your own needs, in addition to those of your children and your husband. Those needs often involve asking more of your husband, for example asking him to be faithful, affectionate, or to spend more time helping at home. This changes the patriarchal bargain, especially as it pertains to sex and intimacy between couples. Today, if women no longer want their husbands to "sleep around as much," they must be both good wives and good lovers (with all the latter implies, for me), a combination unthinkable in the past and still uncomfortable for many.

CONCLUSION: HEGEMONIC MASCULINITY AND COMPOSITE SELVES

The tensions and contradictions that Las Colinas women and men face illustrate the complexity of gender and the unpredictability of targeting gender rights. Human rights and women's empowerment interventions are often framed simplistically, with depictions of a bad man who oppresses vulnerable women under the protection of patriarchal values. The notions of composite selves, always-contested hegemonic masculinities, and emphasized femininities help us understand why

these simple models may have unexpected results, and why men and women continue to challenge and resurrect specific models of masculinity and femininity. For example, in gender studies, the concepts of hegemonic masculinity and emphasized femininity refer to dominant cultural norms that become powerful through widespread adoption and through knowing contestation (Connell 2005 [1995]).[11] Together, these concepts speak to how masculinity and femininity can be upheld through both adoption and contestation, *and* how both concepts, working in tandem, uphold patriarchal gender relations. Adapted from Gramsci's (1971) concept of hegemony—the ability of the ruling class to control and govern other groups through consent, not coercion—hegemonic masculinity is not forced wholesale onto men. Rather, they might willingly take it up for social recognition or to please their family, and they may adapt certain aspects, discard others, and tailor their performance of masculinity to different spaces, spheres, audiences, or moments of their life course. Thus, concepts like "emerging masculinities" (Inhorn 2012), "composite masculinities (Wentzell 2013), and "variant masculinities" (Cornwall and Lindisfarne 1994) complement the literature on hegemonic masculinities by signaling a multiplicity of masculine identities that can shift in response to sociocultural and political-economic circumstances. This complex gender terrain—where certain things are assumed to be "just natural," where individual men and women may internalize, value, and perform different and even contradictory gender norms in different times and spaces, and where both acceptance and resistance can bolster hegemonic norms—is the terrain of vernacularization.

In the previous chapter, I examined how political economic conditions in the campo make escaping violence challenging. Here, I have revealed how ideas about sexuality and violence are naturalized at the site of the body, adding further challenges to recognizing and confronting intimate partner violence in Las Colinas. Bodies are not merely the canvas on which violence plays out, nor do they merely communicate the injurious effects of violence. How bodies are gendered and racialized shapes how people understand, manage, and respond to violence on interpersonal, community, and transnational scales. As I argue, deeply rooted beliefs in "lo natural" structure social expectations about men and violence, women, and suffering, and most importantly, how men and women should respond to gender violence.

Despite the fact that bio-essentialist understandings firmly undergird the hegemonic models of masculinity and femininity in Las Colinas, it is clear that change is underway due to both shifting political-economic circumstances and new desires among younger men and women that are informed (not dictated) by international development and public health messaging about sexuality, reproduction, and family planning for modern healthy families. The tensions that arise amid change are only further exacerbated, as we will see, when women try to reconcile existing understandings of femininity and dignity with emergent discourses on progressive womanhood, in which women should never put up with violence or the forms of hurtful infidelity that can constitute violence. It is in these moments

that we see women resurrect bio-essentialist understandings of men as naturally sexual and violent to explain persistent gender violence in a way that does not detract from their status as "modern Ecuadorian women."

As we will see later in the book, preexisting ideas about men and women's "natural essences" continue to configure unevenly the understandings of gendered morality, accountability, and impunity even when violence becomes politicized through various human rights interventions. Masculinity is deeply linked with violence, and femininity with suffering and care work, such that these concepts change the way people react to and respond to antiviolence campaigns. Despite their best intentions, both international development and human rights campaigns have further entrenched and exacerbated bio-essentialist ideas about men as naturally violent and, by extension, untrustworthy. They have rarely created space to build equity from existing alter-masculinities and alter-femininities.

Moving forward, I will show specifically how interventions to decouple gender and violence affect broader cultural politics of citizenship and belonging. Ultimately, the process of vernacularization and the concomitant transformation of gender norms in Las Colinas reveals deep historically seated anxieties, as local settlers experience great pride in being "true to their nature." However, they are at the same time resentful and concerned about being cast as primitive, especially in the new moral economy of development. It is in this specific moral economy that locals desire to appear modern (socioculturally if not economically, as laid out in chapter 5) so that they may more readily partner with nongovernmental organizations, allowing them to "develop" on their own terms, with their self-reliant entrepreneurial spirit and dignity intact.

INTERLUDE
Gabi, Part II

Here, I return to Gabi's story, introduced in the prologue, to tease apart how violence manifests across generations, shaping not only experiences of trauma and suffering but also expressions of resilience and strength. During the summer of 2008, I visited Gabi and her family outside of Chone, Manabí. I had not seen her since 2005 because her family had left Las Colinas and returned to their original home after her father died and her mother became ill. Many Las Colinas families follow this pattern, deciding to leave the region in order to live closer to a hospital and to extended family when one of them falls ill.

Soon after my arrival in the dusty coastal city of Chone, Gabi and I went into town to stave off the insufferable heat with some ice cream. By phone a few weeks earlier, we had discussed that I might hire her as a research assistant, so on our walk I told her about some of the research-related activities I wanted to accomplish while in the city. Within minutes, she helped me locate the home of a historian I wanted to interview and found the offices of a well-known family violence organization that we would later visit. So, with our plans set for the next day, we decided to take it easy and focus on ice cream and catching up. As we ate, Gabi warned me about our impending trip to the *campo* from which her family originated. It seemed at first that she was urging me to prepare myself for rough conditions (lots of walking and mule-riding in difficult, muddy terrain), but then she admitted that it would be really hard for *her* to go back there. This region of Chone was notorious for violence between families, but I hadn't recalled any stories involving her. So, at the time, I was unaware that her last visit had left an indelible imprint on her and her entire family. I didn't push for details; I merely said I was sorry, and that we could plan something else if she liked. But she quickly, unabashedly, said it would actually be important for her to go back. And then she proceeded to detail what had transpired in the years since we last saw each other.

With her father dead and mother ill, Gabi had bounced around between different households, helping with harvests, rearing nieces and nephews, and caring for sick relatives. Two years in a row, she had enrolled in high school but had to drop out to fulfill family duties and work to support her mother's health costs. At one

point, she traveled to the rural *campo* in Chone to help her sister Amelia for a few weeks during the cacao harvest:

> It was very difficult because my sister and her husband were having problems. They had four school-aged children, and Amelia wanted them to study in the nearest city. [The city was five hours away by mule, so the kids would spend months at a time living with another sister.] For some reason, the mention of the city provoked Amelia's husband, and he began to accuse her of having another man in Chone. Every time the topic of school came up, he would get angry. He would tell her, "If you go to the city, it's because you are seeing another man," and she would reply, "I'm not capable of that. I just want my children to study and have opportunities, and that's all." When I was around, I would support her and say, "It's true, I swear, she just wants a good future for them." Then one day we were picking beans and the topic came up again, and the discussion got heated. I remember I was really afraid of him that day. He was so crazy. He yelled at my sister, "I told you that you are not going to go!" I knew something bad was coming so I pleaded with him, "What are you going to do? What is it?" and he said "Nothing. I'm just going to kill her, and then I'll kill myself." And he pulled out a gun.

Knowing the lengths he might go to, Gabi and her sister desperately pleaded with him, reminding him of his children, of their love for their mother, of how much children suffer when they don't have a mother. Gabi yelled, "Don't do it, think of them," to which he replied, "I'm doing it for my children. They will continue growing and they'll be fine. I said I would do it, so I will do it." Gabi then threw herself in front of her sister, asking him to kill her instead. He pushed Gabi to the ground, and as she hit her head, she heard two quick shots. With his oldest son sitting ten feet away on the back stoop of the house, and his younger kids hiding just behind the bean stalks, he shot Amelia in the chest and then shot himself in the head.

Back in the ice cream shop, I could hardly respond. I had millions of questions running through my head, but they all seemed irrelevant. Eventually I managed to ask if he had been drunk. No. He was completely sober. Had he hit her sister regularly? No. He had hit Amelia a few times during the early years of their relationship, but he had not abused her since their children were born. I was strangely disappointed. Without an easier explanation based on alcohol or a history of violence, I fell back into pure shock. Gabi continued, however, and described the aftermath. She ran screaming toward her uncle's house ten minutes away to notify the family and get help. She tripped on a tree root, fell to the ground, and felt her body go limp. That was the last thing she remembered until a week later. Thankfully, Amelia's kids were swiftly taken into custody by the uncle and cared for by extended family. Gabi was in such bad shape that her family took her to the hospital in the city, where the doctors gave her a number of *calmantes* (anti-anxiety pills) and told her she had had a "*paro cardiaco, algo así, del corazón*" (heart attack,

or something like that, of the heart). I still can't experience any *sustos* (or moments of fright), she said, because my heart is still weak and I feel extremely vulnerable.

At this point, I asked Gabi how she felt telling me the story. She responded:

> The past is the past, at least that's what all my friends always tell me. "You have to think only about the future." But to that I say, "What happened *did* happen. It didn't *not* happen. I can't forget that." So, I have friends who I can talk to about it. But these same friends are also always bothering me, asking me how old I am, and when I say I'm almost eighteen, they respond: "But you're old enough to have a boyfriend, so why don't you have one!?" as if this is the most important thing. I just tell them, "Sure, male friends maybe, but boyfriends, no."
>
> To me it seems that there are so many women who have so many problems, so many children, and there are times that I just don't feel sure about that. I mean, I don't want that, and I don't think I can do that—you know . . . be the perfect wife. I have always loved children, but I don't feel as if I am capable of being the perfect mother. So, I'm fine the way I am, single. But who knows about the future?

We delved into a long conversation about gender norms and expectations. Despite my inability to use anything but semi-academic language to describe this, she understood me completely, or at least that's how it seemed. I told her,

> You should make decisions for yourself. It doesn't matter what people say, that you are "of the age to have children," or whatever. That's just what people say, but you have to do what you want. I mean, so many people here don't understand how I could not have children yet. But I am not going to let that bother me. And you know . . . in honor of your sister, you can live your life differently, and even think about ways that you can talk to and help other young women recognize how they too could live their lives differently.

I found myself feeling what I experienced so often while doing this work: the authentic desire to tell women that they deserve more, but the aching pain that this message may mean little, or nothing, amid all the challenges they face. But her face lit up, even if she had told herself this same message countless times.

We both knew at the moment that change was possible—of course it was—but what she was trying to overcome was deeply complex and had a long history. Her story, as with many women in Las Colinas, is part of a much longer trajectory of suffering borne by multiple generations of men and women in her family. Both burdened by this history and empowered by the possibility of overcoming it, Gabi struggled deeply with the contradiction between what she desired from her life, and what was expected of her. Unfortunately, she was never able to reconcile the two.

3 · "¿POR QUÉ ME MALTRATE ASÍ?"

Rethinking Violence, Rethinking Justice

In this chapter, I draw on case studies of four women—Marta, Sofía, Teresa, and Paola—to elucidate how physical, economic, psychological, and somatic forms of violence intersect. As noted earlier, we can think of violence as a tightly woven fabric. The warp and weft, or threads held in tension in opposite directions, each comprise a different kind or level of violence. The invisible strands threaded below the surface provide tension, sustaining the whole thrust of the violence and giving the sense that violence is a normal, natural feature of gender relations. Some forms of violence become noticeable at particular moments, while others are left invisible. Less visible violence not only inhibits women from escaping abuse; it also threatens their well-being, even as they advocate for an end to the most visible, actionable form of violence: the physical battering. Marta is a case in point: as we will see, even when she succeeds in ending physical violence by leveraging community support and appealing to the law, she also exacerbates her exposure to less visible, structural forms of violence. These other threads sustain the fabric by constraining a woman's ability truly to challenge her circumstances, allowing for the reproduction of violence in her life.

Gender violence is intertwined with structural violence, a form of violence that often goes unnamed because, even though it affects the everyday lives of people, it is both "invisible and normalized" (Merry 2009, 5). As I noted earlier, structural violence refers to the systemic forms of harm caused by economic, political, religious, legal, and cultural structures (Farmer 2004). Women in Las Colinas are not only vulnerable to various forms of interpersonal abuse; they are also structurally vulnerable to economic, political, and cultural "insults" (Quesada et al. 2011). I build upon a long history of anthropologies of violence to explore how interpersonal and structural violence come together in gender violence (Beske 2016; Adelman 2017; Goldstein 2003; Hautzinger 2007). But my analysis in this and the next chapter also adds something new by showing how the "success" of campaigns against gender violence often depends on (and exacerbates) the invisibility of

structural violence. Despite their claims to the contrary, women's empowerment and campaigns against gender violence tend to target rather narrowly particular visible, interpersonal forms of violence to the exclusion of invisible forms of structural violence. At the same time, they reinforce vicious forms of male impunity by laying the responsibility for navigating violence at women's feet, while largely letting men off the hook.

So, what are the forms of violence that people considered normal and natural when I first arrived in Las Colinas? And what are the shifts provoked by economic, politico-legal, and cultural changes? These shifts have created openings for men and women to rethink the role of violence in their lives and to craft diverse responses to it, including resistance, prevention, and legal recourse. We can see these subtle shifts over time only through the in-depth stories of Las Colinas women and families, which not only reveal "the effects of various forms of violence on their bodies, minds, and senses of self" but also demonstrate how violence is imbricated in the patterning of everyday social relationships (Parson 2013, 2). From these women's vantage points, we also see how "research on gender and violence is not only about how worlds are unmade by violence but also how they are remade" (Das 2008, 293; Das et al. 2000). For example, when women experience violence, they remake their subjective worlds either to reject the violence or to accommodate and reorient their sense of dignity amid continued abuse.

I begin by examining diverse and changing definitions of violence, then offer a detailed look at the experiences and reflections of Marta, Sofía, Teresa, and Paola, before finally examining women's justifications for violence, the work those justifications do, and the ways in which they are changing.

INTIMATE PARTNER VIOLENCE AND ITS INTERSECTIONS

For me, [experiencing] violence is about feeling stuck, like I cannot do anything at all to change the circumstances of my life.

—Sofía

I understand sometimes that he doesn't trust me. It can be hard for him, too, especially now that things are changing [with women's rights], but he doesn't have to always criticize me and make me feel bad. It's like every day, you know?

—Paola

Disaggregating and defining forms of gender violence is a thorny process for political, ethical, and practical reasons, both in the academic scholarship and in the settings in which we work (Wies and Haldane 2018; Farmer 2004). I use the term *intimate partner violence* (IPV) when I want to draw attention to the way intimacy plays a part in "assault[s] on personhood, dignity, sense of worth or value" (Scheper-Hughes and Bourgois 2004, 1). IPV is violence between intimate partners, whether or not they are formally married, and includes physical, psychological, economic,

and sexual forms of violence, or any clearly perceived assaults on a person's physical and moral senses of dignity and integrity. While there are rare cases of violence against men in Las Colinas, the absolute majority of IPV is perpetrated by men against women in heterosexual relationships.[1]

To understand how violence is experienced as assaults on dignity, it is critical to hear from survivors themselves, speaking from their cultural and political-economic positions. Even though women often normalize IPV, they also hope for and expect intimacy, closeness, and love from their partners. IPV thus becomes as insult to one's dignity because it violates expectations of intimacy, and because of the gendered power imbalance it reveals and reproduces. As I have shown, dignity in Las Colinas is closely tied to local understandings of being a good man or woman and a good wife or husband, gender ideals that can be at odds with one another. Even with shifting labels and definitions of violence over time, for women and men in Las Colinas the most readily identifiable definition of violence is feeling routinely devalued by intimate partners, family members, and close friends, precisely the people who should otherwise love and support them.

The other concept that figures centrally in my analysis is *gender violence*, which derives its meaning from "the gendered identities of the parties" involved, highlighting how violence is constitutive of gender for women, men, and other gendered identities (Merry 2009, 3). In Las Colinas, the way that men and women use and respond to violence does not merely reflect gender norms, but also helps remake those norms, as both gender and violence are performative in nature. When Felipe hurts his grandchild and Marta's sense of self-worth is tied to her ability to care for, nurture, and protect her children and grandchildren, this is also a form of violence against her. If Felipe has done this to his grandchild in order to hurt Marta, it is not merely collateral gender violence against her; it is a form of intimate partner violence. If a stranger hurts their grandchild, partly to make Felipe feel a lack of self-worth as a protector of the family, this too can be considered a form of gender violence. The pain and hurt of the assault are tied to Felipe's sense of masculinity. For women in Las Colinas today, IPV has taken on a relatively new gendered dimension. In the past, women were taught that good women and wives endured violence to keep the family together. Leaving a relationship, even on account of violence, was tantamount to abandoning one's family. Today, however, the opposite can be just as true: to be a good woman, you should no longer put up with violence, at least publicly. These contradictory expectations leave women in a bind. However they respond to IPV, they risk violating one of these visions of ideal femininity.

ASKING ABOUT VIOLENCE IN LAS COLINAS

While multiple understandings of violence have always existed in Las Colinas, certain definitions and frameworks take precedence at different moments as men and women explore and experiment with the various openings and channels

available to them (Friederic 2011; 2014). Women often define and experience violence and victimhood differently over time as they "try on" distinct legal subjectivities while interacting with state institutions and nonprofit organizations and through their exposure to feminist or human rights frameworks (Merry 2006; Hodžić 2009; Parson 2013). Thus, local terms have changed over the last decade as gender violence has become politicized and defined as a social problem. The use of particular terminology shapes how people categorize, experience, and respond to distinct forms of violence.

In the stories throughout this book, I use terms like *maltrato, violencia,* and *machismo* in locally specific ways to refer to different constellations of violence in Las Colinas. When I began talking to people in Las Colinas about *violencia intrafamiliar* or *violencia doméstica* in the early 2000s, people struggled to make sense of the terminology. At the time, most women used the word *maltrato* to refer to the variegated forms of physical, psychological, and economic violence enacted by their partners. *Maltrato,* in turn, caused multiple layers of suffering, or *sufrimiento. Maltrato* (or even *machismo,* at times) referred not only to hitting or slapping but also to the daily indignities that women experienced, such as neglect, insults, verbal abuse, jealousy, lack of trust, and control. In the early 2000s, the word violence or *violencia* was not regularly used in the context of interpersonal domestic violence. So, when I used *violencia* in conversations, some men and women initially assumed that I was only referring to the most extreme and visible forms of physical violence.

When I recognized early in my research how confusing, yet critical, this definitional terrain was, I knew I had to approach abuse, violence, and conflict from a variety of angles to be understood (see Friederic 2011 for a longer discussion of ethical and methodological challenges faced in my research). To my surprise, women were quite forthcoming about their experiences of IPV when I asked directly about household conflict or challenges. However, even when they were open about mistreatment, they were not forthcoming with details of the mistreatment or abuse they experienced. Instead, they treated it as a matter-of-fact phenomenon that I should know about from my own experience as a woman.

To appreciate the shape-shifting nature of local terminology and the depth of women's experiences of violence, I often started interviews by asking about *violencia intrafamiliar* (or *dentro la familia* or *entre la pareja*), also using *maltrato* (abuse, broadly construed) and *sufrimiento* (suffering) interspersed in the conversation to gauge carefully the kinds of responses and experiences the various terms generated. I also made sure to ask various sub-questions, sometimes in survey form because the perceived neutrality and distance of the survey format often allowed for new admissions and insights. The sub-questions solicited detail about conflict and argumentative discussions within the household, the incidence of particular acts of physical, emotional-psychological, or economic violence, and general feelings and experiences of suffering and happiness.

Over time, however, the term *violencia* became more common. It also began to take on new moral valences and crystallize certain understandings of gender vio-

lence as it grew increasingly politicized and visible as a problem, becoming a form of violence that necessitated a response. While I discuss the process of politicization through antiviolence and women's rights campaigns in greater depth in the next chapter, here I elucidate the ways that women (and men) came to understand, experience, and act on violence differently across time, highlighting locally salient turning points. My focus is on subjectivities amid change, as people struggle to make meaning of new possibilities and long-standing limitations in their relationship with violence.

THE CONTINUUM OF VIOLENCE

Feminist and anthropological theorizing of violence has collapsed distinctions between "private" and "public" forms of violence by pointing out how various forms of violence are interrelated on a continuum (Moser 2001; Cockburn 2004; Speed 2014). This idea posits that all forms of gender violence, from interpersonal violence on one end of the continuum to wartime rape on the other, are related because they emerge from dominant patriarchal ideologies (Scheper-Hughes and Bourgois 2004). While women in Las Colinas generally have not suffered from overt state-sponsored political violence, they experience structurally based political violence. In other words, their structural vulnerability to interpersonal violence is undeniably connected to their political, economic, and racial status as poor, rural women of color (Bourgois et al. 2017). For example, in the cases of Marta, Sofía, Teresa, and Paola, the power and pain of the assaults they experience is compounded by the gendered relationships between the assailants and the victims, and what those relationships mean for the relative amount of power they hold.

Visualizing a continuum of violence does help us understand the links between the violence a woman like Marta experiences in her household and the structural vulnerability implicit in her inability to get an identification card or access welfare benefits. But, like Shannon Speed (2014), I also find that the continuum of violence model, while useful, falls short because it is simply too neat. It prompts us "to understand different types of violence as discrete forms located along the continuum—each is in the same category of misogyny-inspired actions, but each is definitionally-speaking a recognizably distinct practice" (Speed 2014, 80). Representing violence as distinct practices obscures the mutually reinforcing nature of these violations.[2]

The various insults, injuries, harms, and violence that women experience in everyday life in Las Colinas are multiply constituted: they build upon one another and do not merely progress or exist along a continuum. When one kind of violence becomes identified as a "problem," people's ability to respond to it is constrained accordingly by their vulnerabilities along various axes. In some cases, women disproportionately suffer the blame for their inability to respond to IPV as agentive, modern women. But in fact, it is broader, less visible forms of violence that limit their options. So, again, while Marta was fortunate because doctors and

lawyers helped her file a report and put her husband behind bars, her position as a poor, dark-skinned campesino meant that her case was not taken seriously by the police, leading to the early release of her husband.

In short, Teresa, Sofía, Paola, and Marta experience multiple and interrelated layers of violence. As you will hear in their stories, they themselves rarely distinguish between separate categories of violence (certainly not the categories I have specified here); rather, they consider violence and suffering as an ongoing and inevitable part of life within their households and communities. To build on that understanding, I present these forms of violence at their intersections, focusing on how they are experienced and communicated through each of these women's stories. Each woman faces unique circumstances, and each responds distinctively to the interpersonal violence she experiences. However, I focus on these four women because they were often mentioned by other women as examples of different ways to address conflict and violence in relationships; while Marta and Sofía have become examples of resistance, Teresa and Paola illustrate how to *aguantar* (to put up with violence) and craft dignified lives despite continued suffering. Their stories and examples are evidence for both women and men that disrupting violence (through legal, public, material, or interpersonal means) is possible, even if only for the short term.

REVISITING MARTA'S STORY: VIOLENCE, JUSTICE, RECONCILIATION

Marta's experience of multiple intersecting forms of gender violence, both interpersonal and structural, spanned the course of her lifetime. In her relationship with her husband, she experienced physical, psychological, and economic violence, as well as neglect and isolation. Through her extended kinship networks, she also suffered physical and psychological violence at the hands of her mother-in-law. Structurally, as a poor rural woman, she suffered from the deprivation of legal, political, and economic rights. After an excessive beating, Marta was encouraged to invoke the law to "end the violence," which led to an extended separation from her husband Felipe. She eventually reunited with him and stopped the physical and psychological violence in her relationship. Certainly, filing a police report and separating from Felipe helped end the acute forms of IPV she experienced. But it exacerbated gendered structural violence. After the police report, her daughters and many close friends blamed her for breaking up the family; they broke off contact and would not let her see her grandchildren, her main source of pride. Felipe and Marta were separated for many years when she told me, "I never thought I would live alone, look—like this, alone." In a voice tinged with both determination and despair, she continued, "I am strong, I haven't given myself up to the pain and embarrassment of it all." But she also described a scenario that highlighted the challenges that arose within her family when she decided to *denunciar* Felipe.

After I filed the report against Don Felipe, and I finally came to [consciousness, after slipping in and out for many days], my daughter and other friends called me in desperation asking me to retract my report in order to release him from jail. As his first recorded offense, he was supposed to stay in jail for seven days.

Marta refused to rescind the complaint, but one of her own daughters hired a lawyer and Felipe was released after three days. Her daughters were upset with her for imprisoning their father and breaking up the family. In addition, Doña Marta had cared for five of her grandchildren for many years. Now her daughters were worried that Marta alone would not have the economic resources to care for them. In their anger, her daughters broke off contact with her and Marta lost most of her social and familial support networks. As you might imagine, Marta was devastated when they took her grandchildren away. Caring for them had been her main source of meaning and dignity in a life of tremendous *sufrimiento*, or suffering.

During their separation, Felipe went to live on their farm and Marta stayed in their house in the central community of Agua Dulce. Afraid of Felipe's wrath, Marta spent most of her days and nights at home with the doors blocked by beds and tables. Each time I visited, I stood on a ladder under her raised home waiting patiently for a few minutes while she moved the furniture that blocked the trap door entrance. When I asked whether she was guarding the door specifically from Felipe, she seemed unsure. "Yes, he might try to get in while he is drunk, or not, or others. I just feel afraid because people are angry with me." While many people in the community showed compassion for her suffering, they were less understanding of her decision to separate from her husband.

Leaving Felipe plunged Marta into three years of intense structural violence and social exclusion. She tried to support herself by selling empanadas at market and on soccer days, but it quickly became clear that this would not cover basic living costs. To make ends meet, she eventually found work in the city as a school cook. As an older single woman unaccustomed to city life and wage labor, the toll this took was significant and the wages were abysmal. She earned US$25 per week working from 4 A.M. to 7 P.M. Of this, at least $7 went to bus fare, leaving her with a net pay of less than 25 cents per hour. The circumstances were awful, but she was determined to stick with the job to sustain herself and save for her grandson's education. He had been pulled out of school when he was moved away from her home, and she was trying her best to get him to move back in so he could re-enroll. To make matters worse, most of Marta's family and friends believed her demand for dignity was not a legitimate assertion of autonomy, but rather an irresponsible threat to family health and security. Good mothers and grandmothers, they said, don't leave their homes, even for the sake of their own well-being. They put up with the suffering because others are depending on them. Because she defended her rights and asserted her independence, Marta's family and friends left her without social supports to buffer the blows of an unequal society.

By filing the *denuncia*, Marta demonstrated that she was able and willing to engage formal mechanisms of justice and to step away from the patriarchal relations of familial control that support violence in the home. Doing so, however, meant stepping away from all of her social support networks, which themselves were entrenched in patriarchal family and gender norms. After three years, life became too hard and she finally gave in to Felipe's pleas for forgiveness and reconciliation. But reuniting meant she now had to worry about the shame of breaking the news to her more "empowered" friends, including me.

Although Marta suffered on her own, her assertion of independence might have paid off in the long run. Over fifteen years later, Marta and Felipe still live together and are much happier. For many years since their reunion, Marta operated a small *comedor* in Agua Dulce, while Felipe traveled back and forth to their farm *adentro* (in the interior). She used the additional money to buy clothes and school supplies for her grandchildren, and she appreciated the independence and respect she gained by contributing to the household economy and the increased social connection of being in the public realm. Today, however, as they are becoming less agile with age, they are spending more time at home, and less time working in the *comedor* and on the farm. Most importantly, though, whenever Don Felipe drinks or misbehaves, she nudges him back in line with threats that she will leave him again. Her past bravery shows that these are not idle threats; she has a denuncia and the evidence that she can survive on her own (even if barely) to back up her claims. Her denuncia has also become a powerful example for others. Many women and men refer to Marta's case when they talk about how violence is no longer acceptable. Various women use Marta's example as a gentle reminder to their husbands that they, too, have some power.

The violence didn't only change Marta; it also changed Felipe. Felipe now understands how important it is that his grandchildren are educated, especially the young girls. He acknowledges how hard it has been for Marta to be barely literate. When he's in town, Felipe helps clean up after customers, fetches water, and performs tasks he would have scoffed at ten years ago. One evening over dinner, Felipe and I reminisced about changes in the *pueblo* over the past fifteen years, while his grandson (the same one whose shirt had been torn, only now ten years older) ran in and out with buckets of water from the rain tank. Turning suddenly solemn, Felipe told me about how he "was different now." He shook his head, repeatedly communicating his own disbelief about what he had done and who he had been back then. One major difference was that he had stopped drinking, which helped him temper his "extreme shifts in . . . character."

But Felipe thinks that most of the change in him happened in the years when they were separated and he had to live on his own, managing a household and feeling his guilt each day. Through Marta's absence, he recognized how much she had added to his life. He muttered these insights under his breath, not wanting to be heard by people passing by. Yet his utterances were punctuated by loud, sarcastic interventions by his grandson, who had managed to catch the drift of our conversa-

tion while coming in and out with water buckets. "Yeah, Karin, he's changed, but it's only because we don't let him get drunk anymore! And if he does drink, we just don't let him into the house anymore! It's true, you should have seen him out on the stoop just last week. We left him there for hours, *aja ja* [laughing boisterously]." To which, Felipe sheepishly nodded, saying "Well, I deserve it. What can I say?"

Doña Marta's story demonstrates not only the complex intersections of violence but also the contradictions that emerge as women learn about their rights but are unable to access and act on them fully. Each incident of intimate partner violence can be unpacked to reveal stories of violence more broadly construed. For IPV does not happen in a vacuum; it is hidden, normalized, and legitimized by other forms of symbolic and structural violence. Marta used certain openings to her advantage throughout her life. Her sister-in-law helped her escape from the violence of her mother-in-law, and later, with the help of strangers, she filed a legal complaint. Yet many other women are not so lucky. If and when opportunities arise for them, they may not be poised to take advantage of them at that moment. Fear of isolation and exclusion may tempt women to stay with the status quo and merely hope that things will get better.

SOFÍA, THE WOMEN'S BANK, AND DIVORCE

When I first met Sofía in the early 2000s, I was struck by her strength, determination, and no-nonsense characterizations of IPV. Like other women, she talked about her experiences of violence as commonplace and unremarkable, though she was clear that it made her feel awful. However, Sofía's life changed when she joined the Women's Bank in the late 1990s. According to her, this helped her make sense of the gendered inequities that patterned life for women in the region. For Sofía, a spark was lit when she learned about women's rights, particularly about the national and international laws that criminalized gender violence. It was massively powerful for her to feel that her own daily feelings of injustice and pain aligned with the experiences of women across the globe. Once she understood that her suffering was shared by so many women, it became her mission to combat this injustice in her own life and community.

Sofía was one of the founding members and principal leaders of the Women's Bank, the women-run microcredit organization (1998–2015) that provided women with small business loans and related training. In that role, she participated in multiple components of the project, including a visit to a women's shelter in Quito in 2003 where she had additional training about women's rights and family violence. In three days of workshops, she learned about the cycle of violence, the effects of family violence on men, women, and children, and about building self-esteem. A licensed psychotherapist also counseled Sofía to help her analyze and understand the roots and role of violence in her own relationship. Until this point, Sofía had thought that all men and all relationships were basically the same, with only the rarest exceptions. Some were a little better than others, some husbands were a

little more accommodating, but leaving one man for another would probably make little difference. I recall her surprise on discovering that it was normal and acceptable in "my culture" for a single American female volunteer (at the time, I was single, and I was affiliated with the health center) could spend all summer living side by side with a married male volunteer without sparking jealousy or causing problems. In her context, men and women could rarely be "just friends." She also thought that if she showed any resistance to abuse, she would end up alone, without the support of friends or family. Joining the Women's Bank and learning about global women's struggles gave her a sense that, at least symbolically, she wouldn't be alone. That might not have been enough for other women, but it was for Sofía. Unpacking her history helps reveal why.

Sofía met her husband, Julio, when she was fourteen years old. He was twenty-nine, more than twice her age. At that time, she had lived most of her life with grandparents and other relatives, and she recalls feeling ready to be on her own. "I did not realize at all what it meant to go off with him, but [it was as if] he sent me a letter, and I accepted it, because that's what you do when you get a letter. And my future was sealed." She expected that he would leave her at some point, because she was young and inexperienced, and says that would have been fine. All she really wanted was the opportunity to leave her uncle's home. She did not realize that leaving with Julio would mean having children, and that would end—not begin—her independence. Sofía explained, "I had a child almost immediately. Then I stayed [with him] out of obligation. We were not in love, but I thought that maybe love would come with time." In words that closely mirror those of both Marta and Teresa, Sofía mistook marriage as a way to discover her independence.

Looking back on her twenty-year relationship with Julio, Sofía recognizes all the different forms of violence that came together in her life. Economic and patrimonial violence constrained her ability to leave her home. Her inability to access her own income made it impossible to navigate the world semi-autonomously until she joined the Women's Bank. Sofía, like many other women I have mentioned, suffered from symbolic violence, evidenced in the way she saw her suffering as natural (for women), part of "the way things are." This symbolic violence constrained her ability to imagine other possibilities.

Sofía understood that pursuing autonomy and independence from her grandparents merely propelled her into a new version of subservience in which she had to fulfill the role of a wife and mother. In neither situation could she explore who she was as an individual. Though Julio hit her from time to time (in particular when she failed to fulfill the role of wife and mother in a timely manner), she was hurt most by the invisible everyday indignities: the psychological violence of everyday put-downs and criticism, and neglect. In fact, in her characterization of the violence she suffered, she homed in on the effects his neglect had on her, especially when she was pregnant. For her and other rural women, pregnancy is a time of great vulnerability because of the physical challenges of maintaining a household without support, and because of the distance from medical services

and support networks if something goes wrong. After their separation, Sofía recalled the pain of neglect:

SOFIA: [When my husband started traveling every week or two to attend workshops on sustainable agriculture], that's when I could say we really started to have serious problems. He used our money [which we desperately needed for other things] to attend his meetings in the city [five hours away], leaving me and the children abandoned. And he always told me some story: I have to go for this [reason] and stay longer for [that] reason. What hurt me most was that he would sometimes leave me when I was pregnant, just about to give birth. I was left behind like nothing. And I would tell him not to go, that the midwife said I would give birth any day now. Today, there are cars that can travel on the road by my house, but before, when it was pure forest, I was alone without neighbors. I would train my children to run to my *comadre*'s house [thirty minutes away] and ask her to run to notify the midwife [another thirty minutes away] if I was about to give birth. So that's what would happen to me. That's what has made me feel the worst, what has hurt me most, and I don't think that I can excuse him now because these things have already happened, and the pain is there. Who knows if he will come back to ask for forgiveness?

KARIN: So, will you consider excusing him, or forgiving him if he returns?

SOFIA: Now, no. Or maybe I could forgive him, so to speak, but I'm already carrying the thorns—the resentment—and we will just continue fighting the same if he returns. So in that respect, I would have to say that things are better now that we are separated (Interview, 2003).

Although neglect is rarely considered its own category in discussions of domestic violence, I was struck by how often this theme arose in interviews about relationships. Furthermore, the converse of neglect—attentiveness (or being "*detallista*")—has become central to women's vision of an ideal relationship. Strikingly, many stories of conscious neglect coincided with pregnancy as they did in Sofía's story. Though I heard some stories of women being physically abused while pregnant, more common were complaints that their husbands did not sufficiently provide for them while pregnant or allow them to rest or seek treatment as needed. In other cases, pregnant women were forced to engage in difficult physical work well into their third trimester, or risk abuse from their husbands.[3]

Though Sofía felt empowered and energized when she began to participate in the Women's Bank activities and to access loans, she also suffered considerably because of her husband Julio's resistance. Many husbands of Bank members were resistant at first, but with time they became accustomed to and trusted their wives' participation in Bank meetings. Julio, however, continued to show up at meetings, to offer unsolicited opinions, and to complain about how the Bank was making his wife more difficult. He would complain openly that the Bank was "putting ideas into my wife's head and she now thinks she can do whatever she wants."

Sofía increasingly resented her husband. Though she experienced physical, psychological, and economic violence throughout the relationship, he hit her on a few occasions in direct response to conflicts over her participation in the Bank. She was not the only one. Across the globe, many women-focused microfinance programs have sparked increased violence initially, often followed by a leveling out or long-term decreases. While one might argue that the "ends justify the means," these programs have understandably come under great scrutiny because of this direct link to gender violence (Schuler et al. 1996; 1998; 2013; Schuler and Nazneen 2018). Though many women in Las Colinas reported increases in household violence during the first ten years of the Women's Bank, violence eventually diminished as men grew accustomed to their wives attending meetings, making independent economic decisions, and traveling independently between villages. Sofía's husband, however, never quite became comfortable with these changes.

When Sofía was invited to attend a five-day workshop at the *Casa Refugio* in Quito, she knew Julio might not agree, but she had already begun to see her life in very different terms. She insisted that she could go and indeed that she had to go. Sofía had a very powerful experience at the women's shelter. She was by far the most outspoken and committed to the cause of women against family violence. A month after her return from Casa Refugio, I met with her and the other women to talk through their experiences. At this meeting, Sofía told us for the first time that her husband Julio had left her, but she assured us that she was committed to work with and help other women in the region.

It will be almost a month since my husband has left my home, and I don't even know where he is now. Our problems came to a head and blew the lid, one could say. Now more than ever I am realizing that women are super-oppressed (*superpisoteada*) by men, that men treat women like trash, though not *all* men, I guess. I lived more than twenty years with this man, and in all those years I have not had any happiness. I mean, having a child with someone should be the happiest time, right? Well, I have raised six children and I think for this reason I am fully capable of giving workshops to other women and helping them because I already know very well what women's problems are. It's come to the point where I find myself in a corner. Who knows if I could ever come to forgive my husband for what he has done—I can't even begin to speak about the things that man has done to me, even if I had five full days to tell my story. And I have never really bad-mouthed him before. I always endured (*aguantar*) in hopes that things would change, but no. Now I am entirely committed and faithful to this cause, because it seems like a lie, but all of us women are victims of abuse by men. So maybe some women will say, no I don't have a problem, but in some way they do. So I am ready and available to attend and to give workshops. It doesn't matter that I have two small girls. I will find a way to leave them with someone if need be. Actually, I can take my youngest girl with me. Yes, I will carry her. I am ready for this. I am finally free from this man. Because he, like a *machista*, wanted to keep me there in that house, so that I couldn't

leave. So I no longer have that problem. I can be wherever I need to be for our training. This is now my only obligation as far as I am concerned.

I learned that things in her household had been challenging for some time. Julio told me that she started being disrespectful and making decisions without consulting him. He pleaded his case with me—that some of these decisions had put him in a hard spot, that other men thought he was weak and laughable because his wife was openly insulting him, that some of her decisions had actually put the children at risk. On the other hand, Sofía would claim that she had had enough, that she deserved more from her relationship, and that the only reason the children had been at risk was because he refused to lift a finger to help.

In the month immediately following the workshops, Julio hit her for the first time in over five years. At this time, her children were growing older, with her oldest on the verge of his teen years, and they began to see their father's *machismo* and violence and call him out on it. With their emotional support, the following day she prepared a small bag of his belongings. She left it on the front doorstep and with this gesture, she asked him to leave. Sofía demonstrated impressive strength during this period. She was determined to find a way to earn money herself to support her children. Her disregard for community gossip proved essential because survival depended on adopting male responsibilities.

At one point, I asked Sofía if she would accept Julio back into her home if he returned. She wavered slightly, first stating that she would definitely not let him back home, but then said that maybe she would if he was the one to ask forgiveness. Though she was strong and determined, she occasionally felt flickers of doubt, questioning whether she could support her children on her own.

Six months later, Julio returned and they tried to live together, struggling but surviving. Two years later, he left again—and Sofía was forced to leave her children with friends while she worked restaurant jobs for months at a time in the nearest city. As she recalls, this period was the low point for her. Like Marta, she felt alone, abandoned by friends and family for having separated from her husband. She had to leave her children with others while making pennies and enduring sexual harassment from her boss. Today, however, over fifteen years later, she is happily married to a different man.

For Sofía, awareness of women's rights globally was an extraordinarily powerful pivot. It motivated her to take up the challenge of freeing herself from abuse and gaining her own income, which was powerful even if she never achieved independence. It helped that her oldest children actively supported her, and that she has a particularly strong personality. She had once been sensitive to gossip, but once she learned of the global struggles around rights, she vowed never to let "talk" influence her again.

In retrospect, it is easy for us to say that Sofía made the right decision in separating from Julio. Today, when she talks about her experiences, she skips over those years when she worked in the city on her own, trying desperately to find her

way while separated from her kids. Many women do the same. After all, who wants to dwell on those challenging in-between moments, especially when the struggle ultimately leads to something better? But it is important for us to recognize just how difficult this period was for her, and for Marta and countless other women. She experienced a deep disconnect between the ideals to which she aspired and the realities of daily survival.

In the next chapter, I explore in greater detail the contradictions and challenges that emerge when women learn about the promise of equal rights, and then how this promise rings hollow when no options are available. The incommensurability of paradigms that these women experience today produces these contradictions: on the one hand, a lifelong understanding that dignity is tied to being good wives and mothers who sacrifice and endure suffering, and on the other hand, the allure of being a modern woman who refuses to put up with violence.

TERESA'S STORY: "AGUANTANDO"

Teresa, a sixty-year-old woman, has been married since the age of sixteen.[4] She has eleven children with her husband, and he also has a child with another woman. At the time of our last interview in 2015, she lived in a small house in the central town of Agua Dulce. Much like Marta, she moved to Agua Dulce from a farmstead several hours away so that her children and grandchildren could attend school with greater ease and regularity. Her experience of violence is like Marta's in many ways, but her response has been very different, largely because she is Pentecostal Evangelical. When I first asked Teresa which topics in her household were most likely to lead to conflict or disagreement, she responded,

TERESA: My husband once had a child with another woman. He goes back to her sometimes, after being with me. But if I ever bring this up, he gets angry and aggressive. And let me tell you, when any of my friends talk to me about their husbands, they talk about how much they suffer because of the way their husbands treat them. And if the husband also has lovers, then it is worse. Then he is always *bravo* and always insulting his wife. [My husband] also gets upset when he hears rumors about me [my supposed infidelity, or if I do something publicly that I shouldn't]. Or if I don't serve lunch on time, he will start swearing and saying very bad things to me. Things I don't want to repeat. My young son always speaks up at these times, it's amazing. He says, "Daddy, you can't talk that way to Mommy."

Like many women I interviewed, Teresa is unequivocal and forthcoming about her suffering. Even if it is common, her suffering is neither just nor fair. But she takes some comfort in the fact that she is not alone. Her husband's infidelity translates into abuse in many different ways. She lives with a reminder that her husband has been unfaithful to her, and he uses it to his advantage by routinely threatening to leave her for the other woman. That threat is especially powerful because of her

economic precarity and vulnerability as a rural woman. She cannot imagine how she would survive without the money he earns. For some women, separating is easier to imagine later in life, when a woman might have some bargaining power, for example when older children can support them. Others say men grow to recognize how dependent they are on their wives. Teresa says aging helped because her husband became less attractive to other women. But she always saw *aguantando* as her only option:

KARIN: In the story you told me, you said you could not leave your husband. Why did you feel that way?

TERESA: I have been so scared and traumatized. I have had nowhere to go. I know that my husband has other women. He drinks, he leaves town, and I know he has money hidden, so he must have other women, or he is visiting prostitutes. But this is almost okay now. I wanted to separate from him, but now we live apart much of the time and, if he hurts me I tell him to visit a prostitute.

KARIN: What do you mean when you say he hurts you?

TERESA: I don't know, but I am in lots of pain when having sex and maybe it is related. He is very rough with me. I hemorrhaged once during pregnancy. I don't know. Deep inside it hurts, like in the intestines or the ovaries or I don't know what, but deep in there, I have pain. So I would prefer if he would have sex with others and leave me alone. But when he comes home drunk, there is nothing I can do. But the worst is the way he insults me and tells me how bad I am [during sex]. He tells me that I am very cold and stiff, and that other women are *caliente* [hot and sexy]. I feel very offended and hurt. So I tell him to sleep with the prostitutes to save me the pain and humiliation.

Teresa is one of many women who has chosen to *aguantar* or endure the suffering. As a young wife, she was regularly abused; her husband chastised her for not completing chores and for not being sufficiently excited about intercourse. Today, however, she regularly seeks strategies to minimize her suffering. She does her best to avoid sex but believes it is her duty to have sex with him at least occasionally. Using her children's education as a reason to live in a different village helped minimize the violence, and she has divided her time between the two villages for close to fifteen years. For a time, she even welcomed her husband's pursuits of other women because they allowed her to live with and provide for her children in peace.

Teresa lives a sheltered life. She stays within the confines of her home and sends her children and grandchildren to do the shopping. To avoid problems with her husband, she does not participate in any community organizations other than the parent-teacher organization that her husband sanctioned because her children were in school. In keeping with her strong Evangelical faith, she sees the outside world as threatening, full of evil and temptation. Her strict faith provides her with a clear sense of right and wrong to organize and make meaning of her life. It also

provides her with a way to avoid all possible recriminations from her husband, who used to beat her when he suspected her of infidelity. Now, she does not leave her home, and she abides strictly to her faith, which controls and limits her mobility and interactions with others She is proud of her morals, and she feels they also help keep her out of harm's way.

Despite multiple appointments with doctors, the pain in her "insides" appears to be without medical cause, but understandable because of lifelong experiences of marital rape. Doctors at the health center offer various explanations, but on some level, they seem to accept there is a physical-psychological aspect to this pain. They offer analgesics and concoctions made with lemongrass and other herbs. For Teresa, the physical violence is much more than slaps, shoves, and the like. Like many other women who have suffered from IPV, she experiences a series of bodily complaints that lack an identifiable, diagnosable physical origin, which may or may not be due to lack of quality medical care. Many women I interviewed spoke of their bodily pain and suffering as a consequence of violence (see Kwiatkowski 2018; Low 1985; Yarris 2011). When I would try to make a physical link or ask about long-term injuries, I rarely heard about easily identifiable injuries, apart from women who linked past head injuries to chronic headaches and migraines. Women often responded with diffuse symptoms (aches, stabbing pains, discomfort) that they connected broadly to the suffering they experienced in their relationships. The women seemed to be telling me that their emotional pain had become embodied.

I asked Teresa if the conflicts and violence had changed:

TERESA: Well, it's true that he doesn't usually hit me as much anymore. Oh, but he used to, and today I still feel scared because the threats continue. He sometimes flashes the machete to send me a message. And I know what it means. Only four years ago, I asked my husband a simple question about how many mules he had—he had just arrived from *adentro*. He got so angry with me because he thought I was second-guessing him, but I meant nothing by this. He pulled out his machete and hit it against the wall repeatedly to warn me. But then he hit me many times all the same. Thankfully it still had the cover on it. It hurt so badly but I did not bleed. He started to bleed though in some places, I don't know why, and I think God was protecting me and sending him a message. My older son came out and screamed at my husband saying, "You can't hit my mother like this, she is not like your little daughter." And my son packed a bag for me, saying that I should leave his father, but I could not.

KARIN: So, wait . . . was it common for your husband to hit his daughters?

TERESA: Oh yes, but it was only slaps or spankings from time to time.

KARIN: And do you think that this treatment of women is changing in the region among younger couples, or in the younger generation?

TERESA: No, it continues all the same. My oldest daughter, for example, is twenty-nine years old and her husband treats her very badly, abusing her often. She has been completely traumatized, and she tried to commit suicide some years ago. She took *veneno* (poison), but she survived. Unfortunately, the story continues all the same.

She has become an evangelical, like me, but her husband threatens to leave her because of this. He tells her, "it's your religion or me."

Because violence is so common, Teresa feels somewhat resigned. While many insist that violence against women is decreasing, based on her daughter's experience Teresa did not. She did agree that it was easier to respond to violence and to leave a relationship today because of new laws and services, but she did "not really believe that men had changed."

In recent years, Teresa has treated her marriage as an economic and moral relationship. She and her husband see each other as companions who enjoy their grandchildren together when he happens to pass through town. As her children grew, she worried about eventually needing to live with her husband full-time. But now that they have grown, little has changed. Her husband still has a reputation as a womanizer, though people joke that he is less successful in his old age. As he told me on multiple occasions, he believes that *por naturaleza* men want more than one sexual partner, while women can live happily in strict monogamy.

Throughout all these years, any suggestion of separating was literally waved off as an impossibility. She had much to say about her friend Marta's case, however, and she understood completely why Marta filed the *denuncia* against her husband: "sometimes women have to make this choice." But she is also glad to see that her friend Marta has chosen to reunite with her husband because it makes things easier on the whole family. Marta's actions have also benefited Teresa in some ways because it showed people in Las Colinas that filing *denuncias* is both legally and socially possible. This has given Teresa leverage in her own relationship because her husband recognizes that she could, in fact, leave him. She jokes that he "leaves [her] alone now" maybe because he knows he can't get away with the violence as he used to. Or perhaps, it could merely be that he's "older and lazier now."[5] Teresa also insists, "I don't care enough anymore to let it bother me. Now my goal is not to let my sons hurt their wives. Thankfully, my daughter has left her husband. My children and grandchildren, that's my concern now."

Most women in Las Colinas have chosen to *aguantar*, much like Teresa. This does not necessarily imply passive acceptance of violence, however, as women develop complex strategies to navigate their relationships and reduce the violence or its impacts. In her case, Teresa used her children—and her accepted role as a mother—to relocate to Agua Dulce, and she used her husband's infidelity to establish distance and even some peace. Were it not for the episode of extreme violence overheard by her neighbors, it's quite possible that Marta would have continued *aguantando* as well.[6]

PAOLA

A younger woman in her thirties, Paola is one of the few cases of a woman who has full-time professional employment.[7] Paola's story is instructive because she is

well-versed and knowledgeable about women's rights discourses, having worked closely with gender and health projects. She takes great pride in being a working woman and having her own source of income. On multiple occasions I have heard her say that "women have it much better today than in the past; we have our rights, we can work, and our men can't beat us without repercussions."

Publicly, her husband is attentive, taking her on small vacations and showing affection. Behind the scenes, however, her husband is controlling and jealous, needing to know where she is at all times. She has lost touch with some friends and family on account of his jealousy, and he makes her feel stupid through routine verbal insults. He criticizes her for working, and for not fulfilling her household duties, treating her as if she should be a full-time housewife in addition to having a full-time job. Sometimes he hits her, but that is very rare. He does, however, show her affection and love, and that makes a big difference.

When I asked if he acted differently in private, she admitted that "he some-times hugs and kisses me when he's in public so people can see us, and it feels like he does that when it suits him." She also admits that it makes up for some of his jealousy and his brusque mood changes. Thankfully, he is a happy drunk, not a violent one, unless she does something to really provoke him. In her responses, I can hear the emotional work she undergoes to make sense of her experiences with her husband. On the one hand, she understands him, as she admits that

it must be hard for men today who watch their wives have totally independent lives, so they have to constantly wonder what their women are up to. So sometimes our problems, I think they make sense. I mean, my mother lived and worked all the time at home, washing, cleaning, cooking, helping with animals. She never went anywhere alone. So, my father felt like he never had to question anything, his wife was secure, she was only his. But in my case, my husband feels insecure, like, wait, how is it that I just go wherever I want? It's an adjustment.

He does get mad sometimes, she reported, because "I can't manage to make all the meals for my kid, or get him ready for school, because I have to work, and so he gets upset because our kid ends up without food." In her case, her decision to stay with her husband, despite the "occasional" mistreatment and "rare" instances of physical abuse, is shaped by the fact that her first child was raised without a father.

In the abstract, Paola clearly thinks that a woman should never accept abuse. For example, when I asked if it is better for a woman to stay with an abusive hus-band in order to keep the family together, her response was clearly no. She clarified,

Suppose that he mistreated her a lot, that he hit her, wasn't around, or didn't pro-vide food for the family. How am I going to maintain a relationship like that? If he mistreats me and makes my family suffer, how can I continue? The best thing

would be separating immediately. Because one suffers, the children suffer, and even more so when she is mistreated every day.

Paola redraws the lines of what is acceptable, however, when she more deeply contextualizes her own situation, and what's at stake for her. For her, leaving is a last resort, because she has already had to raise one child without their father present:

> For some young women, having a child out of wedlock, it doesn't matter that much if you separate from the husband instead of getting married, and the child grows up without a father. But for me, it was very difficult, especially because I had a little girl and her father wasn't present for her. And it becomes really difficult for me when I start to think that [my son might] also grow up without a father. I just can't accept that, it's too hard. So despite the problems, despite my husband's jealousy, if I were to leave him or him me, the only thing I think is that then my son would also grow up without a father. And maybe later a stepfather would come, or someone else will come to mistreat my son who wouldn't have his father to protect him. That is why sometimes I say: *"yo aguanto"* or sometimes I say "maybe with time it can change." But I don't want the same thing happening to my son. And with my life, too, because with another man, then he'd be filling me with children again and I don't want that [so I'll grin and bear it].

On one level, this contradiction can be explained by the fact that abstract principles rarely hold up in the messy, complicated scenarios of our everyday lives. It also appears that Paola differentiates between daily and occasional violence, and in her mind, daily violence would be unacceptable, but occasional violence is part of the bargain she has struck. She admits, however, that she is not the ideal feminist who demands her rights at every turn:

> [W]e [women] understand a lot more about our rights today, but we could always be better, because sometimes we do know our rights by law, but we are afraid. I mean, there are some women who get mistreated and [immediately] say "go report it! go report it!" But others are afraid that he will get into trouble, that he will then hit them more, and so they abstain and do not do it. . . . It depends on the person.

She feels pressured by friends, who tell her she deserves better, but she insists that her situation is unique; even if she could survive economically, she doesn't want another of her children to feel neglected by their father or lose out on the support that, in her mind, only partnered fathers and mothers can provide. She also appreciates that her husband is not all bad; in fact, he does things for her in public that not only make her feel better about herself but also remind the community that he loves her and she isn't "settling" or "putting up with" abuse in ways that would be deemed morally unacceptable for a woman today.

As the youngest of the women here, Paola's experience is actually quite common in that she has borne children by different fathers. Today, men and women in Las Colinas feel more strongly that they should marry for love, not practicality. Likewise, romantic and sexual passion between partners is now more likely to be celebrated not demonized. Despite the availability of contraception, youth tend to think of contraception as something you use to time and space children once you are partnered and planning your family; contraception is not something you use during a spontaneous tryst with your lover, one in which you want (and perhaps need) to prove your love, especially if you are a woman. According to local beliefs, you can use a condom if it is convenient and unproblematic, but it is not likely that a young woman would be on birth control, unless she is (immorally) grooming herself to have regular sex outside of marriage. In these circumstances, many young people in Las Colinas are having children outside of marriage. Paola was a prime example, even as a woman who had regular access to contraception and who had herself participated in multiple sexual and reproductive health seminars. She was in love with her first child's father, but his family reacted negatively to the news of their relationship and forced him to end it. Paola, like all the other women featured here, prioritizes the well-being of her children. To these women, growing up with an attentive father and mother is crucial to a child's healthy and moral development, and it outweighs the risks of a child witnessing sporadic or irregular episodes of a father's violence. So, the question for them becomes: when does violence become too much, and when does it demand a response?

For most women, like the four whose stories appear in this chapter, much of the violence they experience remains invisible, despite the fact that *violencia intrafamiliar* and *violencia contra la mujer* have become politicized. In most cases, women like Teresa and Paola must select which forms of violence they are willing to accept and endure. The choice to *aguantar*, however, does not imply that a woman passively accepts the violence. Rather than using legal recourse, community censure, or separation, these women adopt other daily strategies and forms of resistance to reduce the violence and its effects. For Marta, the violence demanded a response from her because it was so extreme and so visible. For Sofia, it became extreme and unacceptable because of its quotidian nature; there was no respite. Her daily strategies of resistance and mitigation were no longer working; she was unable to carve out the space for any autonomy whatsoever, and the daily insults left her feeling completely powerless. After her involvement in the Women's Bank and after gaining a better understanding of her rights as a woman, she was able not only to contextualize the powerlessness she felt as a moral injustice, one that women suffer globally, but also as something that could change. But Sofía and Marta took major risks, and these exacerbated forms of economic and patrimonial violence that they experienced in the interim.

The community impact of these separations has been extremely important. On the one hand, couples throughout Las Colinas interpret Marta's and Sophia's stories as evidence that separation is possible and legal adjudication might allow for

child support and alimony. This has lowered the threshold for acceptable violence and suffering within relationships. On the other hand, just as often women have confided that the struggles and challenges that Sofia and Marta faced gave them great pause. They saw quite explicitly the harms of social isolation, economic precarity, and patrimonial violence. In light of these complex considerations, many women struggle to explain and make sense of the violence they experience. Their struggle amid all these factors becomes starkly evident through the deep ambivalence, the contradictions, and, at times, the misrecognition or denial of violence that has become even more commonplace in recent years.

¿POR QUÉ ME MALTRATE ASÍ?
MAKING SENSE OF VIOLENCE

Research shows that women who experience abuse tend to be more accepting of it. In contexts such as Las Colinas, where masculinity and violence are co-naturalized (as we saw in chapter 2), many forms of IPV are understood as normal forms of discipline that do not merit attention (Ofei-Aboagye 1994). To make sense of violence, women often justify it, arguing that they are to blame (Wies and Haldane 2018; World Health Organization 2005). Abused women often express two additional beliefs related to IPV: (1) they are willing to take the blame specifically because of their emotional and financial dependence on the perpetrator, and (2) they believe "that women are less valuable than men, or believe that men have a right to hold power over women, including access to sex regardless of a woman's consent" (Wies and Haldane 2018, 331). With increasing politicization of the issue in Las Colinas, however, women are learning that they do not deserve to take the blame. Furthermore, expressing self-blame now looks bad, as it does not align with norms for modern, forward-thinking women. In light of these changing standards, women have adopted new ways of explaining violence that rely partly on the further naturalization of violence and masculinity.

When I began studying violence in Las Colinas, many women expressed bewilderment and sadness at their husbands' use of violence. More often than not, they also offered a reason for his violence, often something they did that they said "provoked" it. For example, physical violence and threats resulted most commonly when a husband perceived that his wife did not fulfill a household obligation, such as having food prepared or completing the washing in a timely manner. One of the most common scenarios for IPV was when women were unable to provide drunk husbands with food as quickly as they demanded. Don Diego, a man who considered himself a "transformed" wife abuser and alcoholic, took great pains to explain how his violence arose from his perceptions of his wife's intransigence: "whatever she did, I had a problem with it." With his family gathered around in a group conversation, they recounted the terror they all experienced during mealtimes, especially dinnertime, because that was when he was likely to come home and find an issue with the meal served, whether it be the quality, the timing, or the temperature.

As a result, his now nineteen-year-old daughter recounted, "we kids always asked for food around four o'clock, and my mom didn't even realize why at first, but it was so we could be in bed by the time our dad came home." His wife added, "He wanted me to serve him food, so I would heat it. Once when I brought it to him hot, he said he no longer felt like eating. Then I would leave the food covered, ready to be eaten later. When he wanted it later, I reheated it after he let it get totally cold, and then he'd eat it. He would do this just to test that I would accommodate him, just for that reason." As his wife finished recounting this story, Don Diego shook his head and muttered, "Yes, I was an asshole, a complete embarrassment."

In many cases, husbands came home drunk when their wives were asleep, which meant the wives then needed to get up and rekindle the stove to reheat food. Due to their husbands' skewed sense of time and brusque character when drunk, women described this as a particularly nightmarish scenario. Using the metaphor of heat that women use to characterize the male character, one woman told me, "The man just gets hotter and hotter as he waits, and you have to get the food to him before he explodes." As a result, many women shared a surprising benefit to living in Agua Dulce, the central village, where there was easier access to propane tanks for gas stoves. As Marta explained,

When my husband was drunk, he would [often] come home calling me to get up from bed and asking me to serve him food. When I'd tell him what was on the stove, he'd say he wanted something else. So, I couldn't just reheat, but I had to prepare something new. I think he just did this to bother me. And you must realize that with our kitchens, with firewood, you just can't cook very fast. With a gas stove, one can cook quickly, but with firewood in the *campo*, often it's a bit wet and it just doesn't burn reliably, so you can't get the same quality heat as with a gas stove. Now lots of people have gas, but it's even worse for the women still stuck with firewood.

In this case I learned that some women's desires for goods like gas stoves were not only about modernity or domestic efficiency, but also shaped by strategies to reduce violence.

Jealousy, control, and suspicions of infidelity were also cited as common triggers for household conflict. Jealousy could lead to conflict in two ways: a husband's jealousy or suspicion of his wife's infidelity, or a woman expressing jealousy or suspicions of infidelity on the husband's part. Men reported that many violent quarrels started when their wives questioned them about their whereabouts, their spending, or their alcohol consumption. As yet another instance of differential impunity on account of gender, women tended to suffer regardless of who felt jealous. As Don Diego recalled in that same conversation, "I would drink myself silly, not come home for days, and when I did, I would get this paranoid sense of jealousy. It was an outright illness where I would beat my wife because anyone or anything, like a cricket, was hanging around the house." At this point, his wife jumped into the conversation. Laughing, she added: "Well, sometimes it was

a dog barking, or a hen clucking, but it didn't matter. He'd say it was my lover coming around."

Male violence against women in response to women's perceived failure to comply with household responsibilities is often legitimized. Yet the shape of this legitimacy is changing. Women can also be punished for transgressing their domestic realms, either physically or symbolically. Identifying the specific source of men's anger at this transgression is complicated, however, as it is often unclear whether men are upset by their wives' actual violation of the perceived domestic realm or by other people's perceptions and talk about her "misbehavior." In Sofía's marriage, Julio's alcohol use and unrealistic demands on her labor seemed to play a less important role than his fear of community gossip questioning his masculinity or authority. Several women mentioned that their husbands grew particularly irritable when they heard rumors that their wives were disloyal, or that they were acting like *mandarinas* (see chapter 1). For husbands in Las Colinas, this was a complete insult to a man's dignity and often provoked violence as a way of reasserting (and publicly performing) control. Because masculinity in Las Colinas is deeply intertwined with the notion of controlling a household, men's anger is deeply linked to their need to retain a strong public profile. Both men and women contributed to the gossip. Therefore, even if men are the actual abusers, deeply rooted hegemonic gendered identities underpin this legitimized abuse of power.

Women's narratives strikingly often identified how their actions brought on violence in ways that sounded like self-blame, but ultimately very few women felt they deserved violence. In fact, some women felt quite strongly that "other women" deserved abuse, especially if they had embarrassed their husbands publicly. However, while most women did not feel they deserved it, they often felt it was not worth fighting because violence was a normal part of family life. As "wrong" as that sounds, belief in the universality and inevitability of violence helped women circumvent the full weight of self-blame and preserve their personal sense of dignity. Today, however, the naturalized link between men and violence is weakening, though we shall see in the next chapter how some human rights campaigns actually reinforce links between men, machismo, and violence.

SYMBOLIC VIOLENCE

> Women's punishment by men is often deserved, definitely. I have never deserved it though. I have been just like a pigeon locked up in a cage. I don't want liberty or true independence. I just want to be able to leave the house sometimes.
>
> —Maria, Interview 2003

The contradictions in women's explanations of violence intrigued me as much as the changing definitions of violence. Symbolic violence is at the heart of this instability. *Symbolic violence* refers to the subtle ways in which violence reproduces itself because it is taken for granted and even expected, such as when men's illogical

fits of rage became glossed as *por naturaleza*, or "just what men do." In this way, symbolic violence is an invisible mode of domination, similar to structural violence. Symbolic violence is significant because it silently reproduces inequality and perpetuates marginalization without coercion or force, by obscuring power relations and, for example, by making men's power over women seem normal, natural, and matter of fact (Bourdieu and Passeron 1977).[8]

In this view, women are as responsible as men for upholding gender norms that underwrite inequality and violence (see Bhattacharyya 2018 for a helpful parallel among middle-class Assamese women). As we see in Maria's claim, she fervently complained about male control and violence in the household, but she also felt that many women were at fault for acting out of line. She also thought that disciplining one's wife was sometimes important to the integrity, morality, and stability of the household. For example, she once criticized another woman for provoking her husband by flirting. To my eyes, the "flirtation" was an innocent interaction between a customer and shopkeeper, but Maria said my observations did not matter. Since a woman should know what her husband thinks, if she transgresses her husband's beliefs about staying at home or socializing with others, then she is being *intentionally* provocative. This willful antagonism needs to be eliminated for the benefit of the whole household. This view is less common now that men and women interact publicly more often, but this layer of judgment and justification has not disappeared entirely.

Maria's claims illustrate how symbolic violence works through misrecognition, "the process whereby power relations are perceived not for what they objectively are but in a form which renders them legitimate in the eyes of the beholder" (Bourdieu and Passeron 1977, xiii). Maria has not been forced to hold these views. She believes that women, unlike men, are not inherently promiscuous and sexual. A flirtatious woman must therefore be acting knowingly and intentionally. Maria does not believe she deserves violence—her intentions are pure—but neither does she challenge a man's right to violence more broadly. In this way, "culture adds its own force to [unequal] power relations, contributing to their systematic reproduction" through this process of misrecognition (Bourdieu and Passeron 1977, xiii).

Maria's misrecognition of power isn't confusion, misunderstanding, or bad feminism, nor is it simply symbolic violence through hegemonic gender norms. I find it more useful to view these instances of misrecognition as "holding paradoxes," moments of contradiction in which people try to reconcile what they hope for with what they are actually living (Rubin and Sokoloff-Rubin 2013).[9] Maria is living amid competing moral frameworks that speak to a theorized emancipatory feminist future on one hand and, on the other, the feminist future that seems possible where she is. So, we hear Maria say different things: she does not deserve violence because she is not looking for "liberty or true independence," yet she does not deserve the control and violence that delimits her everyday life; women should not be beaten, yet women who provoke their husbands by not adjusting to their expectations may deserve physical discipline. I propose that these paradoxi-

cal expressions provide us with powerful insights into how people wrestle with the optimism of the aspirational and try to reconcile it with what they can manage within their circumstances amid the moral frameworks that still guide their self-understanding. Maria must construct a viable compromise because economic independence is impossible for her, and it also goes against the kinship moralities in which she is embedded. A woman's integrity is defined largely by her sacrifice to her family, even under awful circumstances. As I revisit in the Conclusion, we can use such holding paradoxes to see local/global tensions within rights struggles and to help women construct localized notions of rights.

SEEKING JUSTICE

In Las Colinas, acts of gender violence are often performative, as are survivors' responses. Despite increased formal access to judicial services, fear impedes women from claiming their rights to justice, as Paola noted. Rural Ecuadorian women rarely file criminal complaints (*denuncias*) despite knowing their rights and having (some) access to legal services. Those who do often admit that they filed a complaint in order to send a message. Sometimes they then choose to withdraw the report before the accused is convicted or to shorten his detainment. Just as Boira et al. (2018) found in another rural sector of Ecuador, many people in Las Colinas get to the point of notifying the police or a doctor about an incident of IPV, but never follow through with the prosecutor's office. Starting the process conveys that violence has exceeded tolerable thresholds, but completing the process risks upsetting friends and family, provoking retribution from their partner, and losing social and economic supports.

Seeking legal and judicial recourse, of course, is a fairly recent option, especially for women in rural areas of Ecuador (Jubb 2008; Pequeño, 2009; Tapia Tapia 2022). As mentioned, the first law against violence (*Ley 103*) was implemented in 1995; it was partly replaced by the 2014 Penal Code and then fully replaced by the 2018 law to eradicate violence against women. Before this, women had no recourse, other than asking friends and family to intervene or developing the micro-strategies detailed throughout this chapter. In one of my first interviews in 2003, one woman conceded,

> When women are abused [here in Las Colinas], what a woman does is . . . take the hit and cry. And that is all. But, when she has good friendships, when we are close to our parents, sometimes we will go to them and tell them that we demand that our husband no longer hits us for a specific reason. In that way, we have a form of support. But when we live at home [in the countryside, distant from extended family], there is nothing we can do but cry.

Though she reports having an equitable relationship with her husband, this woman identifies with battered women in Las Colinas in her speech, switching from third

person (she/they) to first person (we). She understands the pressure to endure. Women do not feel that they lack options; they lack good options. "Some women leave and ditch their children," one woman explained, "while others go away with their children, and others, like me, stay and endure [*aguantar*] because they don't want their kids growing up without a family." Ana, in the following excerpt, emphasizes her "investment" in her family and her unwillingness to squander it:

> I don't want to leave this home that I have built up. I have been working for this family for more than twenty years, for my kids, for my house, for this relationship. I cannot give up now and leave him with it all. I cannot go to my [extended] family. I have not seen them in so long and I don't want to bother them now. I guess there is talk of shelters in some places, but I don't know of them. Why would I go somewhere where I know nobody? I could never go with my kids. He would never let that happen. They say that in your country the government actually helps women, but in Ecuador, they don't do anything for us. So, I just hope that he stops bothering me one day so we can just get on with our lives peacefully.

With few good options, the dilemma for women is an intensely contradictory one. As Merry (1997) points out in her groundbreaking study of gender violence in Hawaii, when women seek legal protection, they are forced to end a relationship that usually includes "caring and financial support as well as violence" (65). Women generally have little contact with extended family, no source of independent income, and a desire to stay with their children for obvious reasons. Retaining the sanctity of the family is of extreme importance to these women. It is also important to the community. Community discourse about family violence is more likely to judge the battered woman than the battering man for this reason. In this excerpt from my field notes in 2005, I recounted the following:

> One evening, a couple (Gloria and her husband) had a very vocal fight, which most of the community could hear on account of the closely clustered housing in Las Cruces. Although I am hearing many variations of the story, apparently Gloria's husband had been hitting her (with the flat edge of a machete in some accounts) because he suspected that she was having an affair. Gloria then left the region with her youngest daughter, leaving behind her other five children with her husband. What strikes me is people's emphasis on Gloria leaving her husband and children behind, not on the act of violence nor the suspicion of infidelity that preceded it. It is hard to believe that she is having an affair because I have never seen this woman outside of her home, but most people keep insisting all the same. Most of her closest neighbors said her husband was just being a drunk *machista* that night. And many of them eventually agreed it would be hard for her to pull off an affair because of the high visibility of her small restaurant and her husband's control of the household and her mobility. Though the factual details of this event remain contested, the retelling of this story demonstrates that while the jealousy and the vio-

lence was commonplace, the departure of a woman from her home and children was highly unusual and morally suspect.

Women also cite the bureaucratic hassle and distrust in the judicial system as reasons for failing to follow through with reporting. Many view the formal process as extremely difficult and challenging. For rural inhabitants, the costs of travel, photocopies, and hidden fees can be substantial. Furthermore, both government officials and citizens believe that cases are unlikely to reach a trial or result in punishment (Boira et al. 2015; Tapia Tapia 2021; Tapia Tapia and Bedford 2021). Aggressors often go into hiding instead of attending trials—an easy strategy in rural, remote areas—and cases are eventually archived. In the end, it is more common for women to use the threat of criminal complaints to negotiate power in their relationship; the law is invoked solely for the most severe violence (Boira et al. 2018).

Women's hesitations about the legal system cannot merely be equated with a lack of access, difficulty, or the potential for retribution (from the perpetrator, the community, or one's family). Instead, we must also ask what justice looks like for these women. For most of them, they want quick, effective, and enduring protection from violence. As Silvana Tapia Tapia has found in her interviews with Ecuadorian survivors of violence, "standard definitions of access to justice as access to litigation are insufficient to convey what most violence survivors envision as justice. . . . Complainants may want the defendant to leave and cease to hurt them, not his criminal prosecution and incarceration. Being legally enabled to pursue and obtain a conviction does not, for most survivors, equate access to justice" (2021, 850).

Wife battering in Las Colinas creates painful and traumatic contradictions in the daily lives of women who want to be "good mothers" but simultaneously live in fear of their own households. As we have seen in Las Colinas and globally, many women find it impossible to leave violent husbands because "their social networks derive from their positions as wives" (Das 2008, 292). Escalating economic hardship exacerbates the challenges of sustaining their families financially even as gender ideologies restrict women's work options. In addition, the strict relegation of women to domestic spheres severely impedes solidarity-building among women. Though women have adopted micro-strategies of resistance to negotiate their positioning within the household and to escape violence temporarily, they are often unable to challenge their treatment and position in any real way.

It is thus not incidental that cases of suicide among women had long been on the rise in Las Colinas. Statistical historical data does not exist, but after surveying community members about cases of suicide, it became clear that these cases were especially prevalent from approximately 2003 to 2015. The bulk of these cases were among women, but there were also many among men who struggled with alcoholism, depression, massive levels of indebtedness, or the shame of being a "bad man and husband" (as one male friend relayed it). Women tended to ingest a pesticide or poison at home, while men tended to kill themselves by gunshot or by hanging. According to the community members, most of the women killed themselves

because they were regularly abused or they were caught in a love triangle with no easy resolution. It appears that the incidence of suicide has decreased in recent years, in part because improved roads have meant that women are able to travel more freely and more easily maintain friendships and relationships outside their nuclear household, allowing for crucial social support that helps mitigate cases of suicide.

CONCLUSION

As in many other settings in which gender violence is common, "women make sense of their familial ties and body-selves . . . within a gendered sociocultural and political context that valorizes women sacrificing their own bodily and emotional well-being for their family" (Kwiatkowski 2015, 15). In Las Colinas, we also see that diverse responses to violence have in turn helped reshape certain understandings of gender and family, as people learn that there are alternatives to women sacrificing their well-being. Unfortunately, the tradeoffs are not easy, and women are often caught evaluating which aspects of their health and happiness they most want to prioritize or sacrifice. People in Las Colinas learn from the examples of Marta and Sofía, but they also learn from various campaigns that women's protection from violence is a thing of value that should be encouraged. Women weigh these messages against the prevailing cultural norms that communicate women's sacrifice as a central component of a woman's identity, and they are caught in between.

Throughout these stories, violence is multidimensional, and certain forms of violence come in and out of focus at different junctures, whether they be life stages or specific women's rights and empowerment campaigns. In the past twenty years, *violencia doméstica* or IPV has become a flashpoint in discussions about gender relations, family health, and community development in Las Colinas. Much like a prism that refracts a single ray of light into the many individual rays of color, this focus on IPV has simultaneously obscured the structural forms of violence that impede women's ability to act on this right. Women like Sofía are unable to reconcile their notions of what they deserve with the realities of economic hardship and male control. Even greater contradictions arise when women are confronted with discourses emphasizing their freedom when these forms of "freedom" are seen by others as antithetical to their role as a mother. Rights-based interventions acknowledge the important intersections between structural violence and gender violence, but they deprioritize structural violence and put women at great risk, holding them principally and unfairly accountable for ending gender violence.

For such reasons, in the next chapter I examine in greater detail the various sets, or streams, of discourses and practices about women's rights and empowerment in Ecuador and how they have become translated, vernacularized, and understood in Las Colinas. Through this process, I argue that the prism of human rights intentionally obfuscates structural violence, thus leading to such dangerous paradoxes and contradictions in men and women's lives.

4 · THE PRISM OF RIGHTS

Empowering Women for Gender Justice

To most readers, the concept of human rights may seem at once self-evident and somewhat unclear: where are such rights located, how do they work, and why are they important? In the early 2000s, when I began working in Las Colinas, few people had heard of "*derechos*" or "*derechos humanos*." Those who had heard of them typically associated them with women and children in the context of very specific campaigns, citing Ministry of Health or Ministry of Education documents about "a woman's right not to be abused," "a woman's right to live without violence," and "a child's right to an education." When I probed, asking people to describe other rights that women had, most would draw a blank. Nobody mentioned men's rights, nor did they define or talk about rights in the abstract. For people in Las Colinas, human rights became meaningful in relation to particularly vulnerable subjects (usually women and children) and through its association with protection.

Discourses, practices, and the language of human rights became much more prominent in Ecuador during Rafael Correa's presidency (2007–2017), as Correa strategically used human rights language and ideas about rights and citizenship to bolster "*el pueblo*" through a "citizen's revolution" (Pugh 2018).[1] Thus, when I asked men and women about human rights in the next decade (the 2010s), they were much quicker to specify a wider range of phrases and particular uses of the term.

However, the question of men's rights continued to puzzle people. Some reasoned that men must also have rights and cited "the right to vote" or "the right not to be abused by police or military." Men tended to say something along the lines of, "I don't know, do we have any rights? I think it's only women who do, but what happens if my wife abuses me: do I not have a right to report that?" Women, on the other hand, usually replied with, "Sure men have rights, but we already knew that, so it's more important that we talk about what women and children need for protection." Or they would agree with men and insist, "Yes, they do, and they shouldn't get hit by their *machista* wives either." Most often, though, men and women responded to the idea of "men's rights" in a jocular way, precisely because "rights" conjured ideas of women's precarity and gender inequality. In short, at the

turn of the millennium, most people in the Las Colinas region understood human rights narrowly, as they were conveyed through particular NGO and government campaigns, and usually in relation to protecting women and children. Thus, rights were more also readily associated with the most vulnerable. Finally, rights tended to conjure images of physical violence, because such violence people deemed more obvious, visible, and actionable.

How did these kinds of narrow understandings become the most common in Las Colinas, especially when the language of rights had come to suffuse much of everyday life during the Correa administration?[2] In 2012, when I asked one woman about what "human rights" meant to her, she immediately understood it in terms of gender, equality, and personal empowerment. She said human rights "means valuing yourself as a person and accepting others as they are, being valued and loved." Then she added, "It's also important for programs and organizations to support human rights, because it's a way for them to help women get ahead (*salir adelante*) so they don't only have to stay at home and care for their kids. They can find other things or interests as well." But, she warned, women can become "too empowered. Some people develop another form of *"machismo"* [probably egoism or self-righteousness, in this case] and they will have lots of problems with their partner and children. It doesn't happen often, but I think it has at times." Here we see a tension that emerges in many discussions of rights in Las Colinas: people associate rights with a form of individualism that can be empowering and important, but also reckless and amoral if taken to an extreme.[3] Similarly, on a sign (Figure 4.1) crafted from colorful construction paper for the first Women's Day march in 2003, another woman proudly communicated that "Women have duties to fulfill, but also rights to demand." Another woman's sign read, "we want to be valued; equality in the couple." Both of these messages call for aspirational *gender goals* in which women are equally valued and have equal decision-making power in the household. Yet these messages still communicate a family-centric understanding of empowerment, which are somewhat at odds with Quito-based visions of liberated and autonomous women pursuing their own individual needs.

These early interpretations of rights demonstrate how supposedly universal legal frameworks become localized or vernacularized. Global norms—even when they are as formal and codified as human rights—are always transformed and adapted as they travel to new cultural, political, and economic contexts, and even in response to the idiosyncrasies of influential individuals (Goodale 2007; 2021; Merry and Levitt 2020). Vernacularization is not simply a process of translation—of rewriting global rights messages in locally intelligible ways. Rather, it is a much more complex process through which communities collectively appropriate and reconstruct rights-based meanings, institutions, and actions through long-term experimentation (sometimes strategic, sometimes accidental). That process of experimentation is based in large part on how rights-based messages, institutions, and actions resonate with hegemonic cultural and political-economic systems and local forces for change. Particularly important are alternative frameworks for negotiating

justice and well-being, such as approaches based on "social justice, economic redistribution, human capabilities, citizen security, religious law, [and] neo-laissez fair economics" (Goodale 2007, 3). Ultimately, this continuous vernacularization of rights results in multiple and sometimes incompatible ways of understanding, pursuing, and enacting human rights.

With all that in mind, I trace the flow of human rights discourse from global summits to local practice, showing how women's rights become recast as they are taken up by diverse Latin American feminists, as they are translated into policies and new government agencies in Ecuador, and then as they are finally brought to Las Colinas by the government and NGOs and put into practice by local men and women. The fact that the meaning of rights is up for debate across all of these scales underscores that Las Colinas' residents do not simply *misinterpret* rights due to a lack of exposure or education, or because of resistance to the idea. Rather, this semiotic diversity is inherent to rights, and arises from the necessity of ver-nacularizing any global concept. What becomes important analytically is what other systems of power and meaning shape vernacularization in each locale, and how diverse understandings across scales create openings and constraints on people's ability to envision, pursue, demand, and secure their rights.

In this chapter, I illuminate three dynamics which, like a prism, have helped refract and shape the vernacularization of human rights in Las Colinas. The first is the political history of Latin American and Ecuadorian feminisms; the pieces of global rights discourses that "arrive" in Las Colinas reflect blind spots, schisms, and compromises among the region's diverse feminisms. The second is the gen-dered political economy of rural life. As people make sense of, respond to, and use new human rights messages and institutions, they are implicitly and explicitly weighing which messages, institutions, and actions resonate with existing gender roles and the political economic realities in which they live. And the third key dynamic shaping vernacularization is that discourses of human rights do not "arrive" in Las Colinas in isolation, but rather are hitched to a broader modernist project that introduces new aspirations, gender goals, institutions, and standards of self-evaluation into rural Ecuador. In Las Colinas, a region where people have limited access to legal and judicial services but are regularly exposed to the liberal discourse of rights, people understand human rights in relation to rural household political economies and as a component of an imagined modernity for which they yearn but which they cannot yet access.

LATIN AMERICA: DIVERSE RIGHTS FOR DIVERSE FEMINISMS

To examine the first stages of vernacularization, I trace the articulation of women's rights and human rights in Latin America, paying particular attention to how they inform both law and practice in Ecuador. How did questions of gender violence and violence against women come to form a central part of the women's rights

agenda in Latin America and the human rights agenda worldwide? To what degree has global strategizing to reduce violence against women been inclusive of and resonant with voices and experiences of the rural poor, both in Ecuador and in other settings?

Latin American women's movements emerged in the 1960s and 1970s in pursuit of a suite of issues including women's access to education, formal employment, and family planning (Guzmán 2001; Lind 2005). At the time, these movements resonated with the field of women-in-development, which sought to improve women's public participation and to capitalize on women's contributions to households and national economies. Both state and transnational governance institutions began to identify violence against women (VAW) as a significant impediment to economic development and security (Bunch and Carillo 1991). The many UN conferences in the 1970s consolidated these concerns, beginning with the 1975 Mexico City Conference and culminating in what is often called the international women's bill of rights, *The Convention on the Elimination of All Forms of Discrimination Against Women* (CEDAW). Adopted in 1979 by the UN General Assembly and ratified in Ecuador in 1981, CEDAW defined discrimination against women and established agendas for national action to end discrimination, including key platforms against VAW.

The preeminence of populist and authoritarian regimes throughout Latin America in the late 1970s and early 1980s first slowed the progress of women's movements because broad restrictions of civil and political freedoms impeded mobilization (Escobar and Alvarez 1992; Jelin 1997). However, it also galvanized a human-rights approach to feminism, which began to compete and take precedence over women-in-development frameworks. Likewise, the regional focus on democratization and civil rights created an openness to liberal, rights-based feminisms oriented toward legal inclusion and state protection, as opposed to Marxist or welfare approaches, which demanded material solutions to societal problems. Simultaneously, during the 1970s and 1980s, many women—particularly low-income and rural women and ethnic minorities, all of whom lacked the protection of class and racial privilege— shifted out of formal politics to focus on more "practical" concerns such as access to clean water, childcare, and food (Müller 1994; Lind 2005). Thus, different camps emerged within the women's movement throughout and between many Latin American countries, with some camps tending to focus on everyday material needs and others that opted for a long-term strategic approach to gain political power. While this characterization glosses over many complexities in the growth of women's movements throughout the region, what is important is that Latin American feminism was constituted by a diverse and dynamic panoply of approaches due to differences in political strategizing, as well as distinct life experiences and social, economic, and political positioning of women fighting for change.

During the 1980s, Ecuador had the highest number of women's organizations in Latin America relative to its population, many of which focused on "practical" issues (Salcedo Vallejo 2012, 32). Through alliances with the United Nations, many

of these women's movements became full-fledged nongovernmental organizations (NGOs) during the 1980s and 1990s. The differences among feminist groups next became evident when some of these movements splintered because many NGOs began aligning with existing state institutions by pursuing a state-centric, rights-based strategy (Herrera 2001).[4] As characterized by Lynne Phillips and Sally Cole (2009), on the one hand, "UN-orbit feminist" chose to pursue gender equality "within present economic and political parameters ... by mainstreaming gender issues into the public sphere and by lobbying for the introduction, maintenance, and improvement of gender equity policies" (190). On the other hand, "another-world" feminists tended to imagine alternative feminist worlds with gender equality as their foundation, which they pursued through improvised practices of accompaniment, solidarity, and the construction of alternative institutions at the grass roots.[5] In and between these two orbits, however, were various strands of feminism and different kinds of feminists already at work within institutions, including the World Bank and Inter-American Development Bank, and in popular sectors, such as low-income neighborhoods, within Ecuador.

Amid these challenges and disagreements, violence against women (VAW) emerged as a unifying issue for women's movements across the region and across the globe, especially as the movements came together for the 1993 Vienna Declaration, in which women's rights to live free of violence were first formalized (Moser 2001), as well as the 1995 Beijing Declaration and Platform for Action. Cole and Phillips (2008) argued that the campaign to end violence against women in Latin America (and specifically in Ecuador and Brazil) actually "helped not only to denormalize and deprivatize gender violence but to revitalize gender feminism as part of a broad front to build progressive societies," highlighting the links between feminism movements and modernizing campaigns more broadly (146). So, while Latin American feminism was shifting according to regional political opportunities, a rose-colored narrative points to the ways that VAW helped provide a point of unity from which Marxist, cultural, and "another world" feminists could contribute to the broader mobilization of women on various issues related to neoliberal globalization, such as the entrenchment of poverty and the reduction of social services.[6] However, at the same time, the turn toward human rights solutions also prioritized a criminal-legal approach to VAW in Ecuador and throughout much of Latin America. Many scholars point to the downstream effects of this approach as a dangerous expansion of "carceral feminism," which depends on criminalization through an oppressive penal apparatus that, ultimately, is highly ineffective for mitigating VAW (Bernstein 2012; Tapia Tapia 2018; 2021).[7]

TRANSLATING LATIN AMERICAN FEMINISM IN ECUADOR: WOMEN, DEVELOPMENT, AND CITIZENSHIP

Despite the diversity of spaces from which feminists have organized, they successfully worked across differences while using the discourse of human rights through

various processes of "translation" (Phillips and Cole 2009, 188). In Ecuador, violence against women (VAW) holds distinct meanings to the actors in the UN orbit (feminists in institutionalized settings) versus the "another world" feminists (who are more radical), even if both use discourses of human rights to advance their concerns. For many in the UN orbit, VAW is an impediment to Ecuador's economic development, while "another world" feminists tend to focus on VAW as a problem of public health, gender equity, and institutionalized poverty. Since the 1990s, discourses of human rights have emerged in Ecuador as a primary vehicle through which feminists voice concerns, appeal for justice, and demand state accountability.

The first step in the formal institutionalization of the women's movement in Ecuador was the 1970 state proposal to open an agency on women's issues. Due to delayed funding, however, the agency, *Oficina Nacional de la Mujer* (OFNAMU, National Women's Office), did not open until a decade later, in 1980 (Lind 2003). At first, the agency devoted much of its work to raising awareness of women's roles in and contributions to the economy and the need for their inclusion in politics. According to Lind (2003), the organization's work in the 1980s "largely reflected the liberal approach to integrating women into development" (2003, 189; Rathgeber 1990; Placencia and Caro 1998). After a couple of iterations and name changes, the agency became *el Consejo Nacional de las Mujeres* (CONAMU) in 1997 and gained more financial backing and power.

At this time, CONAMU became a partial governmental body aimed at supporting women's issues and policy agendas. Their primary objective was "to serve as the interlocutor of gender and development projects on a national level" and in so doing help to determine who was in need and what they needed (Lind 2003). These parameters would become important when laying the groundwork for early policies on gender and violence, which tended to frame women's issues using a discourse of vulnerability, locating women either as minors or as a marginalized group in need of state protection (Guzmán 2001). These protectionist discourses help explain why these movements for the most part have emphasized passing laws against violence and social policies that protect maternity and reproduction (Tapia Tapia 2021). It has also been much easier to push policies that reinforce a split between domestic work and productive work than to promote policies oriented toward modifying the division of labor between men and women, or toward recognizing women as political and social protagonists, not merely recipients of social services (Guzmán 2001).

UN-orbit and state-based feminists in CONAMU tended to prioritize the adoption of transnational rights frameworks in order to gain international cachet, maximize funding, and increase visibility for women's rights issues on national, regional, and global scales. In Ecuador, the feminists of CONAMU were forced to operate in the results-driven environment of the United Nations (UN) since they collaborated regularly with both the United Nations and the United Nations Development Fund for Women (UNIFEM), which opened a regional office in

Quito in 1991.[8] Through these collaborations, the feminists in the United Nations machinery successfully helped increase the visibility of women's issues both nationally and internationally (for example, the *Reacciona Ecuador* campaign described later in this chapter).

On the other hand, they also maintained linkages with "another world" feminists who maintained relationships of accompaniment with popular grassroots women's organizations. "Another world" feminists generally wanted to challenge the broader neoliberal frameworks through which women's rights were being defined in order to push for more expansive social reforms. Thus, the work of the so-called UN-orbit state-based feminists was complex. Many were aware of the contradictions inherent in their work (Lind 2003) while they struggled to maintain a foothold in local and often more radical women's organizations on the ground and worked toward more institutionalized participation. As Lind (2003) characterizes it, CONAMU is one example of feminists working within, against, and for the neoliberal state. These contradictory positions were not unique to Ecuador.

Despite the relationships between local groups and UN-based feminists, more often these connections became tenuous, causing UN-orbit programs to miss the intersecting discriminations affecting women's lives (Phillips and Cole 2009, 206). Overall, tensions *and* collaborations between institutionalized (UN-orbit and state-based) feminists and "another world" feminists shaped the process and outcomes of women's organizing within Ecuador, as it did in other Latin American countries. The women's movement in Ecuador, as elsewhere, has struggled to adopt a platform that could be easily translated into institutional contexts and policy reform and at the same time, was inclusive of diverse Ecuadorian voices.

LIVING WELL AS WOMEN? GENDER AND SEXUAL POLITICS DURING THE CITIZENS' REVOLUTION AND THE POST-NEOLIBERAL STATE

Since 2006, feminist politics in Ecuador have changed dramatically, but not necessarily in the ways that many hoped. Rafael Correa became the new president of Ecuador in 2007 with 56 percent of the popular vote and a pledge to incite an anti-imperial "citizens' revolution" premised on the rejection of neoliberalism as a social, economic, and political model (Lind 2018, 204). Correa's Citizens' Revolution was institutionalized through two major frameworks: the 2008 Constitution, and the 2009–13 and 2013–17 National Plan for Well-Being (*Plan Nacional del Buen Vivir*). Correa's referendum for a Constituent Assembly to draft a new constitution in November 2007 lead to a dynamic re-envisioning of the Ecuadorian state. Among the 2008 Constitution's impressive innovations was its recognition of Ecuador as a "plurinational state" that respected the various identities of diverse groups throughout Ecuador, indigenous and otherwise. It centered the notion of *sumac kawsay/buen vivir* (living well) as a moral principle guiding the country's

development. It also recognized the rights of nature—the first constitution in the world to do so (Lind 2018, 205).[9] The 2008 Constitution also extended state recognition to a much more diverse idea of the family that went beyond the legal definitions of biological kinship to include nonnormative families such as transnational migrant, communal, and same-sex families (Lind and Keating 2013; see Lind 2018, 205).

Feminist scholars who may have once celebrated the rise of the "New Left" with Rafael Correa's (2007–2017) ascendance to the presidency now point to the powerful contradictions that arose during his administration. In particular, they note the disjuncture between the radical feminist vision that informed the planning for the 2008 Constitution and Correa's inconsistent support for feminism in practice, as he often prioritized conservative, heteronormative, and Catholic values, especially as he turned toward a more authoritarian governance style throughout his term (Tapia Tapia 2016; Lind 2018; Wilkinson 2018). The Citizens' Revolution brought about huge successes in the redistribution of resources and significantly reduced inequality and poverty.[10] From 2007 to 2012, the Ecuadorian government under Correa spent "more than three times as much on social spending than did the three previous governments combined" (Lind 2018, 210). In places like Las Colinas, people felt and experienced this largely through improvements to healthcare access (the clinic shifted from NGO-run to state-run), health insurance coverage, greater access to *bonos* (welfare stipends, *Bono de Desarrollo Humano*),[11] road improvements, building projects, and, during certain periods, low prices for gas and oil. But these gains were complicated by the rise in prices of imported goods like cellular phones and televisions, which had become necessities for many, and by the demobilization of community organizations that had once fulfilled similar roles (Friederic and Burke 2018).

Despite major openings for feminists with the 2008 Constitution, "increased formal representation of women" did not necessarily help put feminist agendas into practice, not only because the constitutional achievements were never fully implemented, but also because "rights most directly affecting women [had] eroded as well" (Wilkinson 2018, 270). In this case, Wilkinson refers to two sets of rights: first, rights to resources that were undermined by Correa's shift to an extractivist development model (Wilkinson 2018; Friederic and Burke 2019) and second, because over the course of Correa's presidency, his platform and style became increasingly conservative, allowing for a strong resurgence of heteropatriarchal family values (Wilkinson 2018, 270). In retrospect, Correa's support for feminism was complex and contradictory from the beginning; for example, the early influence of Opus Dei and other right-wing religious groups reaffirmed the constitutional protection of life from the moment of conception, limited marriage to "between a man and women," and restricted adoption to heterosexual couples under his administration (Tapia Tapia 2022).

In many ways, Correa's policies fragmented the organized feminist movement in Ecuador, illustrating the risks of being institutionalized. Women's rights, and

reproductive rights in particular, became increasingly threatened, especially with Correa's 2014 appointment of a highly conservative pro-life administrator as director of the National Interagency Strategy for Family Planning and Prevention of Teen Pregnancies (ENIPLA, *Estrategia Nacional Interseccional de Planificación Familiar y Prevención del Embarazo de los Adolescentes*) (Lind 2018, 212). Then CONAMU (*Consejo Nacional de las Mujeres*), the institutional locus of the Ecuadorian women's movement, was dismantled and labeled a "transition commission" from 2008 to 2014. The state only minimally funded it during this time, despite the National Assembly's promise to transform it into a permanent commission in a timely manner.

Annie Wilkinson (2018) contends that the Correa administration actually "used contingent gains in each area—impressive economic growth, increased formal women's representation, a vibrant LGBT movement, and an internationally celebrated constitution—to justify its overall project in ways that mask[ed] the notable overall setback in advancing transformative feminist agendas" (271). Women did make socioeconomic gains, but extractivist-led development meant that these gains were contingent and were achieved "at high environmental, economic and social costs" that were disproportionately borne by women (Wilkinson 2018, 270).

President Correa often appealed to women "in their roles as mothers and wives to garner their support in heteronormative social reproduction." He used a Mother's Day address to ask women to support the Citizen's Revolution, for example, claiming that the "revolution has a woman's face" (Lind 2018, 201). This messaging was frustrating to Quito's and perhaps Guayaquil's' feminist activists and scholars, especially those on the front lines of struggles for LGBTQI+ rights. But it resonated with the more conservative values of the rural poor in Las Colinas for example. Many Las Colinas men and women have told me over the years that although they agreed with some of the ideas about women's rights and women's decision-making and bodily autonomy (i.e., provisions for safe abortion, family planning, access to legal services), they were more reticent about what they deemed to be "extreme" feminist positions, such as legalizing abortion in all cases, open discussions about the body and family planning, and fighting for LGBTQI+ rights. In essence, Correa considered and treated these more "radical" progressive stances as urban, upper-class, educated, and foreign. In doing so, he successfully framed his conservative Catholic stance as pro-poor and anticolonialist, a frame that resonated with people in Las Colinas.

While urban feminists increasingly viewed this conservative stance as antiprogressive and contradictory, the people of Las Colinas valued it. They appreciated Correa's vision of modernity as one that included various marginalized sectors (even LGBTQI+ individuals) as well as conservative Catholic values. So, while "family norms have been resignified, they have also been renormalized—again, as heteronormative—in a post-neoliberal context" (Lind 2018, 213). When Correa claimed that the Ecuadorian Citizen's Revolution had a "woman's face," he was bringing up outdated women-in-development tropes that reinforce "the neoliberal discourse of the family, in which (especially poor) women are targeted as

recipients of development assistance in their roles as mothers and caretakers, and also are seen as key facilitators of development insofar as they provide unpaid and cheap labor to the economy" (Lind 2018, 203).[12] Despite the potential for a recrafted vision based on *buen vivir*, anticolonial, or (truly) post-neoliberal dimensions of Correa's Revolution, the misogyny within his populist styling and rhetoric linked the anticolonial project with hetero-patriarchal gender norms, while also linking women's liberation to new forms of neoliberalization. To understand how this might translate to state perceptions of women's work and contributions, Lind (2018) argues that whereas the neoliberal mantra was "work harder," the post-neoliberal mantra under Correa becomes not only "work harder" but also to "care more", yet another message that calls for agentive women to do even more (Bedford 2009; Guchín 2010, 203–204).

Fissures and Alliances in Ecua-Feminism: Rural/Urban, Mestizo/Indigenous, State-Based/Autonomous

Despite the contradictions and the ebbs and flows of feminist politics in and alongside the Ecuadorian state over the past twenty years, the major successes of the movement failed to reach poor rural women. The reasons for this are multiple. For one, rural coastal women have had minimal (close to zero) political representation in state-based feminist groups and nongovernmental groups. The experiences of coastal *mestizo* and Afro-Ecuadorian women in rural contexts have largely been overlooked. Feminist organizing in Ecuador has occurred predominantly in urban centers such as Quito and Guayaquil. Satellite organizing in smaller cities has often happened through ethnic-based women's organizations, such as indigenous organizations in the Amazonian lowland or the Sierra highland regions, or through organizations for Afro-Ecuadorian women in Esmeraldas, which was geographically the closest urban center to Las Colinas. Though many of the women in Las Colinas are mestizo *montubios*, they do not strongly identify with the *montubio* ethnic category. Furthermore, formal organizing or political representation for coastal mestizo women outside Guayaquil or the urban centers of Manabí has been scarce. The lack of representation and voice has led to a mismatch between feminist policy and the realities of poor rural women, especially those on the coast.

While the women of Las Colinas benefitted from many of the redistributive policies of the Correa administration, those benefits were uneven and at times fleeting. Ultimately, they were overshadowed by the administration's increasingly pro-Catholic and pro-conservative tendencies. For example, Las Colinas women benefitted from increased welfare (through the *Bono Social* program), better access to health care, and increased judicial resources for women and children. However, in practice, their ability to access their monthly welfare check, family planning, or legal-judicial services was inconsistent. For example, in 2015 Berta explained,

> When I go to the health center, there is never a guarantee that they will actually have the birth control pill. Sometimes I go and the doctor says she can give me

three months' worth, so I don't have to leave my village three hours away to come back here each month. But other times, they say the law only allows a one-month supply at a time. To get my *bono*, it takes me all day to travel to the city and stand in line at a bank, and sometimes I can't get back home in the same day. I have health problems, so sometimes it takes me days or weeks to recover from the trip, and then it's just not worth it.

Or take the example of the new *Fiscalía* (prosecutor's office) erected in 2013 in a flashy glass building in Quinindé, which housed multiple services for abused women and children under one roof. According to multiple women I interviewed in 2015, the staff always seemed to be out of the office for trainings in another city or the lines were too long and women were asked to come back another day. The only woman I know who successfully filed a report against her husband in one day was Marta, and this was before these new services were available. (I attribute her success to the severity of her injury and the involvement of a social worker and a doctor).

During the last ten years, the women's movement in Ecuador has made great, if imperfect, strides in increasing awareness of LGBTI rights (Lind 2018). The increased awareness and acceptance of trans and gay individuals is palpable even in a rural place like Las Colinas, where an openly trans individual opened a success-ful business in 2015, though not without some challenges. But Las Colinas still lacks potable water and sanitation, another significant indicator of modernity and a cornerstone of development. As one Ecuadorian feminist said, "Right now [in 2012] in Ecuador it is easier to talk about homosexuality than water." She was talk-ing about the rural and indigenous protests for the right to water and other natural resources, amidst visible and celebrated campaigns for LGBTQI+ awareness (Coba 2012, cited in Lind 2018, 201). The inability to provide water was unsurpris-ing and therefore not worth noting.

The state's failure to provide fundamental services such as water and sanitation alongside their "success" in the area of LGBTQI+ rights can be viewed in a couple of ways. First, the regimes underlying these distinct priorities are "inherently racialized and classed" in that, "LGBTI individuals are linked to progress, white-ness, urban centers, and class respectability; water, in contrast, is linked to a lack of 'development,' racialized indigeneity [in the Ecuadorian context], rural areas, and poverty" (Lind 2018, 201).[13] Gendered politics resonant with urban settings take precedence over the needs of rural women and families. Second, in a transnational context, the state can celebrate its adoption of progressive human rights platforms while obscuring their inability to provide the infrastructure and resources neces-sary for racial, ethnic, and rural minorities to access their rights. So, feminist organizing based on human rights frameworks, and its inclusion in the state machinery, fails to represent the rural poor who, in fact, would prefer "modernity" in terms of roads, education, and health care, rather than in terms of liberal ideas of human rights.

As part of a platform of "21st-century socialism," Rafael Correa decreed that the struggle against gender violence be a state policy, with funding to be implemented transversally. The decree was implemented across the ministries of health, education, government, and economic and social inclusion, a move that implied the closure of CONAMU. In May 2009, a new entity called *La Comisión de Transición hacia el Consejo Nacional de las Mujeres y la Igualdad de Género* (The Transitional Commission of CONAMU and Gender Equality) was created to guide the transition from CONAMU toward public institutionalism that guaranteed equality between men and women. Together with ten different governmental agencies, the Commission implemented an impressive media and press campaign with television, billboards, social media, newspaper, and radio spots to combat gender violence and discrimination against women and children in Ecuador. The tagline was "React Ecuador! Machismo is violence" ("*Reacciona Ecuador, el machismo es violencia*").[14] The Commission also held public events such as concerts and competitions called "Sing against machismo" (*Canta contra el machismo*). One can imagine the wide range of gender transformative and women's empowerment initiatives that disappeared into the chasm between "revolution with a woman's face" and "singing against machismo." I discuss *Reacciona Ecuador* in greater detail because of its widespread visibility even in remote and rural locales like Las Colinas where it helped sediment people's understandings of women's rights, human rights, and existing laws.

A WOMAN'S RIGHT TO LIVE FREE FROM VIOLENCE: THE VIEW FROM LAS COLINAS

Defining human rights is a challenging task for anyone, even for those of us who feel we have lived and grown up with the concept. For people in rural regions like Las Colinas, human rights are arguably even less visible because of the historical lack of direct state intervention and resources. To understand the nuance in how rights have come to be understood in Las Colinas, I examine *three currents*, or sequences of clustered initiatives that proved particularly influential in shifting people's understandings of gender, rights, violence, and social change. All of these initiatives were aimed at some form of women's empowerment in the interest of gender equality, centering on the international discourse of "human rights." First, I describe the International Women's Day events (*Current I: 2000's*) that grew out of the Women's Bank initiative, this in order to provide a sense of how women in the region first acknowledged and adapted discourses of women's rights in their attempts to bring attention to gender inequality and gender violence in the region. Second, I describe and analyze a national state-sponsored campaign, *Machismo es Violencia (Current II)*, that grew out of collaborations between Ecuador's women's movements and the Correa Administration. This campaign was highly visible throughout Ecuador, and in Las Colinas, it helped consolidate and normalize discourses of human rights and reiterate the role of the state as a protector of women

and an agent of women's rights more broadly. Third, I examine a series of workshops (*Current III*) that I helped coordinate in 2015 on family well-being and healthy communication, building on ten years of NGO and Ministry of Health workshops in the region. Each of these currents is complex in its own right, but here I pay most attention to points of convergence within each current in order to illustrate a few key patterns in the ways that men and women have vernacularized understandings of women's rights.

Current One: International Women's Day and the Women's Bank, Linking the Local to the Global

Although men and women have heard about human rights—and women's rights in particular—from an array of sources, by far their most important reference point is the almost-annual International Women's Day celebration. A pivotal moment in people's understandings of women's rights came in 2003, when Jenni, a volunteer from the United States, taught the women of the Women's Bank about International Women's Day for the first time. That year, twenty-five women from the communities of Las Colinas commemorated the day with a small gathering in the evening. What began as an occasion to unite women, drink coffee, and converse changed in tone after Jenni explained the history of International Women's Day and described women's rights movements worldwide. In response, Sofia asked somewhat incredulously, "If so many women worldwide have managed to organize and achieve change, why is it so hard for us [here in Ecuador, here in Las Colinas] to fight for our rights?" This question sparked an intense discussion, and the women decided another event was in order to celebrate publicly the value of women and perhaps jumpstart a movement of their own. They wanted to raise awareness of women's contributions to both the home and community, the legal and global frameworks that supported women, the prevalence of violence in Las Colinas homes, and the legal and social resources available. The idea that women organized *as women* in communities across the world resonated very strongly with them.

At this new event two weeks later, women, children, and a few particularly supportive husbands marched through Agua Dulce holding signs communicating the need for equality and respect of women. While Jenni provided ideas and logistical support for the series of events that evening, she left the specific plans and implementation up to the women, understanding that these ideas and their implementation should happen on their terms and at their pace. After the march, the women performed a self-designed skit poking fun at gender roles and common household disputes between husbands and wives. In most of these, the women and men had switched roles, with men dressing as women and vice versa. Together, many of the women then read, out loud, Ecuador's Law Against Family Violence (*Ley 103*) in its entirety and made short speeches about women's rights.[15] To end the evening, the women played music and danced with one another in the middle of the plaza. The men of the village gathered to play cards at one end of the plaza, from where they could watch over the festivities without participating. The only men

who actively participated in the dances and skits were men who were very secure in their positions of power in the community, as they already had visible roles in community leadership and had garnered respect from other men through various venues. Others hesitated to participate, but despite their discomfort, they did not directly intervene either.

Years later, women still recall this evening with much fondness. Most of them had never organized nor joined with other women in celebration, much less for an event that centered on valuing women. Many were also extremely nervous, as they had never visibly challenged normative gender roles or gender inequality more broadly. The event was not without its challenges. For example, one of the planned skits was to involve Miguel, a well-known community member. In the dramatization, he was supposed to pretend to stumble home drunk at 2 A.M. and callously demand a warm plate of food from his wife, played by a woman named Erika. However, Erika's real-life husband asked her to withdraw at the last minute. It was understood that her husband did not like the idea that she was playing someone else's wife, and he was concerned that she might make a spectacle of herself. After a long discussion between the women and the few men who had agreed to participate, they all decided to continue with the programming despite the protests from Erika's husband. Erika herself told Jenni that she needed to go through with the event because, "I deserve my liberty." When a female community leader helped read out the text of Ley 103 and gave a moving speech about women's rights, many in the audience noted that Erika placed herself front and center on the makeshift stage, holding a sign that called attention to all the different roles that women play. Ironically, her husband ended up playing a less obvious role, as he was seen in the background of the event, preparing batidos (milkshakes) for sale, a role that had always been Erika's.

International Women's Day is now an almost annual event in the region, led predominantly by the women in the Women's Bank, the Town Council, or women who had participated in this first event. Most years, they plan a march, make posters, share small gifts, and sometimes perform skits focusing on the problem of intimate partner violence. Depending on the year, some men participate, mostly by giving supportive speeches, clapping from the sidelines, carrying posters, or promoting the event beforehand. In years that the women do not organize a large public event, they often still gather and, at the very least, read the text of Ley 103 and subsequent VAW laws, which serve as powerful reminders to women that the state supports them.[16]

For women in Las Colinas, this day is extremely important for a number of reasons. First, women feel empowered by the act of making their suffering visible and having it acknowledged, even if solely (or mostly) by other women. For these women, naming their suffering, whether it be as maltrato (abuse) or violencia (violence), has always been the first step toward restoring dignity. The act of feeling and building solidarity is also extraordinarily powerful, especially in early years when many women lived in isolated households with limited opportunity to

FIGURE 4.1. International Women's Day posters from Las Colinas celebrations over the years. (Photos by author.)

build relationships with other women. Coming together in a central space allows them both to build bonds, and to celebrate and identify with each other *as women*. Some years, the inclusion of women from outside Las Colinas (international volunteers or health center staff from other parts of Ecuador) only reaffirms that the day is in recognition of women as women, despite differences in class, ethnicity, and nationality.

The transnational aspect of womanhood, of women's movements, and laws against gender violence have given the event more weight, as women like Sofía feel strongly that the rest of the world has their backs. International laws are also important in that they hold the state of Ecuador accountable for implementing and upholding their Laws against Family Violence (*Ley 103*, in particular) and thus, this represents a possible end to impunity concerning gender violence. Finally, these events are always opportunities to highlight women's value, contributions to the household, their beauty, and their uniqueness, in ways that reflected a rich array of local norms and values. Thus, Women's Day celebrations regularly speak to how women vernacularize broader themes about gender, violence, and change, and make them resonate with both local morals and material conditions. They also change over time.

Women's Empowerment through the Women's Bank: 2001–2015

While people in Las Colinas often reference local International Women's Day events and celebrations as a focal point for raising awareness about women's rights, these events grew out of the Women's Bank's broader work to empower women and shift gender relations. The Women's Bank was formed at a time when most women were physically confined to their homes and unable to convene independently with other women. Women were almost entirely dependent on their husbands economically and socially, leaving them extremely vulnerable to multiple forms of violence and with few resources to protect themselves. The work of the Women's Bank demonstrates how the women-in-development (WID)[17] approach to economic inclusion can prompt social and cultural ripple effects. The

microeconomic loans provided women with alternative sources of revenue that often increased their economic autonomy and gave them more negotiating power within the household. Also managing the loans themselves gave women the confidence to be more vocal and to participate in both household and community-wide decision-making, and it highlighted the ways in which women could be and were valuable contributors to society. Finally, much of the Women's Bank's impact over the last twenty years has nothing to do with the loans at all: it is a simple result of creating a much-needed space for women's dialogue. It also provided an opportunity for men to get accustomed to helping out at home when their wives were away at meetings.

By and large, the human rights effects of the Women's Bank did not emerge from human rights thinking. Like the Latin American women's groups described above, Las Colinas women joined the Women's Bank for fairly pragmatic reasons, not with a rights framework in mind. However, they did in time learn about and embrace a right-based framework as they sought to make sense of what they had accomplished (in terms of changing gender roles in their homes and communities) and what work was left to be done. Activism in their everyday life became an on-ramp to broader thinking about rights and organizing as women.

As I discussed earlier, a Canadian-Ecuadorian NGO (nongovernmental organization) established the Women's Bank in 1998 to provide women with microloans to increase their involvement in income-generating activities. According to one staff member of that NGO, there was almost no preliminary analysis of gender in the region before they started the bank. This staff member was given the directive to help start the bank with local women, and the extent of the information she had received before arriving in the community was, "It is a typical macho society" (Salazar, personal communication, 2004). This staff member recalled many hiccups and mistakes during those early years, one of which was the fact that the NGO initially organized workshops as full-day affairs without consideration for women's household obligations. In addition, bank membership was more feasible for women who could afford a registration fee and who could get their husband's approval via signature for each loan request. In reality, the project was typical of women-in-development projects at the time in that it sought to include women in household and community economies without recognizing their existing nonremunerative contributions to household reproduction.

Although the idea of a women's microcredit organization may conjure familiar ideas of empowered women joining in solidarity without dependence on men, the Women's Bank was actually inaugurated on quite different terms. Most women had to be convinced by their husbands to join. In many cases, husbands longed for the economic benefits of additional credit, especially given the precarities of the coffee and cacao economies, and they wanted their families to benefit. One member recalled her husband saying explicitly, "Okay, fine, I'll register myself in this bank by sending my wife." Many women resisted joining because they were scared

of stepping outside of their typical roles and because they lacked confidence. They were uncomfortable taking on leadership roles, being subjected to community censure, and perhaps opening themselves to disagreements with their husbands or extended family. Many women doubted their abilities, especially if they had not received much education. They had been told for so long that they were not smart enough to handle economic decision-making that many believed it. Finally, many were hesitant because they knew how joining the bank would disrupt their other household work. Women complained that the monthly full-day meetings were difficult to attend. Some lived up to six hours' walking distance away from the meeting house and, since they were not usually allowed to travel alone, attending a meeting meant losing at least two days of labor for the woman and another family member. Furthermore, they felt extremely guilty about leaving their children in the care of others and leaving their family without three hot meals a day. This latter point arose repeatedly, and in fact prompted one of the more powerful effects of the Women's Bank: their husbands' eventual acceptance of household chores, which played a significant role in creating more equitable relationships within their families.

The Las Colinas women who joined the Women's Bank underwent trainings on personal development (including self-esteem and trust), entrepreneurship, and bank management (Salazar, personal communication, 2004).[18] Some of the meetings incorporated husbands with the explicit objective to "demonstrate to the husbands of Bank members the activities that the women are engaged in during their meetings, to encourage husbands to value women's daily work in the home, to elicit lists of virtues that husbands attribute to their wives, and to reflect upon the ways in which decisions within the household are made and how these might be more participatory" (Salazar and Viteri 1998). Even as husbands and male domestic partners wanted access to credit, their actual level of support varied considerably; many community members remained suspicious of the bank's activities for years and husbands had to confront critiques, rumors, and emasculating jokes about their wives' new freedom.

As documented in Sofia's story, many women reported challenges during the inauguration of the Bank. Husbands either resisted or tried to control their wives' involvement and even the financial loans themselves. Many women reported increases in household violence and disputes as husbands had difficulty adjusting to their wives attending meetings without them (often leaving childcare and household duties to them), handling money and economic decisions independently, and traveling independently from one village to another.

When the Bank first disbursed loans, many husbands continued to manage household finances single-handedly, essentially using their wives as proxies, but in most cases, this shifted over time. When I asked the president of the Women's Bank to describe how being a member of the Bank improved her family's economic situation, she stated,

In our family, the improvement was in crop production and animal husbandry. With the first loan we used some money to clean and weed the fields to have a better harvest. With the rest, we bought vitamins [and] antiparasitic drugs for our skinny pig, to strengthen the pig a bit to sell it. This way we improved our [economic] situation a little.

Yet members did not derive economic benefits solely from the capital provided by loans. Women also benefited from the accounting workshops provided by the initial NGO in which they learned basic skills such as organizing and completing legal paperwork "so that we can learn that it is not only a man's task." Their husbands grew to respect their roles in making economic decisions, and the women themselves grew more confident in their abilities to dialogue with their husbands about these issues and to facilitate economic exchanges. Membership in the Women's Bank provided women not only with an opportunity to take greater control of the household economy but also to gain confidence in other aspects of daily life. For example, Fátima felt more confident after joining the bank and undergoing initial training. As the owner and manager of one of Las Cruces' three eateries, her participation helped her overcome the embarrassment she felt when working. She explained that it took years to feel as if it was acceptable for her, as a woman, to work outside the home, take care of cash transactions on her own—even if today she laughs about having felt that way. To Fátima, the workshops on accounting, the loans provided by the bank, and the confidence and reassurance she gained in her solidarity with other women were critical to her success in opening her restaurant.

Many of the projects instituted via the Women's Bank actually increased women's double-burden by providing microcredit specifically for women's productive activities.[19] Women were undoubtedly overburdened by the need to fulfill both productive and reproductive tasks, and in its first five years, the microcredit project was deemed a failure because community women had little to no control over the income derived from these productive activities. This changed over time, as men gradually accepted their wives' participation in business ventures and recognized that women were capable of managing them successfully. Where the precarities of the rural economy had once combined with assumptions of women's feebleness to incentivize a strict and oppressive division of household labor and power (see chapter 2), the slight shifts in gender norms provoked by these trainings and experiences altered those incentives. If women could in fact be trusted to take loans, manage household ventures, and make responsible decisions about money, then it began to make sense to men to harness this resource to enhance each household's economic situation.

Simultaneously, however, husbands increasingly assisted with everyday household tasks such as cooking and looking after the children when women attended Women's Bank meetings. One afternoon in 2010, David, the husband of one of the Bank's members, described this shift in great detail, with an appreciated dose of comic relief. Jenni and I happened to be visiting Las Colinas together, and we

were riding into Las Cruces on the *ranchera*. A loud and boisterous passenger who had come from watching a regional soccer match started poking me on my shoulder and giggling. I had not seen David when I got on, and I hadn't realized that it was his voice. So, he started howling, "Oh, Karin, Jenni, you don't remember me?! I remember you both, from so many years ago!" He was referring to a time in 2003 when I had accompanied Jenni, Women's Bank members, and their husbands to a community meeting together soon after the first International Women's Day celebration. David continued,

> At that time, I was so angry with my wife for embarrassing me in front of the community [because she was leading community meetings and being outspoken]. At first, I didn't agree. My neighbors began to spread rumors that my wife was becoming a *mandona* (a woman who calls the shots in the household). They said she was sleeping with other men. This made me upset and even violent at times. But [and here he chuckled] now I see I have learned. I have learned very much, and we are all grateful in my family. Now I help cook food at home, and do laundry—heck, I even wash all my family's underwear!

David yelled this last line, wanting everyone to hear, and with this image in mind, the truck's passengers erupted in laughter.

On another occasion, David referred to this shift as "shedding his machismo," which was notable because he was one of the more resistant and problematic husbands at the launch of the Women's Bank. Don David's story illustrates a central mechanism through which the Bank advanced women's empowerment, and it evokes the difficult process through which gender norms and normative forms of violence change over time: namely, by increasing (and making visible) women's ability to manage productive tasks, and by showing that men and families could actually benefit from dismantling the symbolic division between productive and reproductive realms, the Bank provided member families with an economic foundation for adopting different gender roles. This kind of women's empowerment—and the denaturalization of masculine control over all household management—was simultaneously challenging and empowering to husbands. In Matthew Gutmann's (1996) seminal work on gender and social change in Mexico, he too found that,

> transformations among women have had a profound effect on men in direct and indirect ways . . . part of the process in which women challenge men to change their thinking and practice involves the contradictions between consciousness that has been uncritically inherited and that which arises in the course of practically transforming the world (93).

These material practices have been fundamental to actually changing gender norms in Las Colinas. They made room for imagining new ways of valuing women's contributions, yet they were only a start.

From 2001 to 2016, thirty women cycled through the Women's Bank. Over this period, their loans increased to $500, and they became the longest-functioning women's microcredit organization in the province of Esmeraldas. Despite the relatively low number of participants, hundreds of families throughout the region had learned from their example and had benefited from events or projects that they sponsored. Nearly all of the women pledged membership for life, but in recent years, many of the founding members of the bank either moved away from the region or passed away. Some members found themselves in spiraling cycles of debt, unable to pay off their loans. This became a much greater problem when people began to have more access to high-interest loans from local banks and other institutions, and I heard countless stories of people strategizing how to use one loan merely to pay off another. With their numbers dwindling and with recouping outstanding loans becoming increasingly difficult if not impossible, in 2016 the Bank members stopped meeting. However, many of the women remain socially and emotionally close because of their struggles and joint commitment, but their economic opportunities have improved only marginally (and in some cases, due to cycles of indebtedness, they are even worse).

In *Current One* (Women's Bank and Women's Day), women and men were beginning to grapple with the notion that gender violence in intimate partnerships did not have to be endured. Even if men were more likely to be violent and hypersexual than women, it was becoming clear that not all men everywhere were this way. Learning about global discourses of women's rights was genuinely empowering for many women, and they began to envision a way out of the routinized suffering they experienced due to intimate partner violence. This optimism was strengthened by community-driven transnational partnerships with NGOs that resulted in one of the first tangible pieces of infrastructure for which this region had yearned communally: a fully functioning health center. On multiple fronts, people in Las Colinas were seeing the possibility of a future with less suffering, as transnational nonprofits intervened to help them organize and make demands on the state. Thus, the messages of empowerment and "aspirant feminism" that suffused this period were not merely due to newly circulating discourses of human rights but also to tangible political economic changes underway (see Friederic and Burke 2019 for a longer discussion of changing state–NGO–community relations in Las Colinas during this period).

The process was far from seamless, however. Optimism and anticipation sparked by transnational partnerships and human rights ideas also came with anxiety about change. Men communicated discomfort about being displaced by the state and by NGOs as protectors of women and children, about the risks of women no longer valuing their families and respecting the household division of labor, and the potential social upheaval of a generation in which "women wear pants, and men wear earrings." Even as women were excited about discourses that reminded their families and communities about the invisible labor and value of women, they were concerned too about women becoming "machista," or too ego-

tistical, selfish, and disembedded in their families and communities. For many, the fear was that women seeking "independence" implied women turning their backs on their families.

Due to these changing ideas and the political economy of the moment, for Las Colinas women, being "good women" in the community came to mean more than being a "good wife." In fact, being a good woman became more strongly associated with being a good mother than ever before. Hearing about the dangers of violence for both them and their children allowed women to see it not as a natural fact of life that came with living with men, and yet, they were not yet able to leave their relationships (due mostly to financial circumstances), nor were they willing to become "immoral women" who turned their backs on their families. To navigate this moral uncertainty, perhaps provoked by protectionist discourses about children, women felt increasingly compelled and justified to circumvent local spatial norms (by beginning to attend community meetings, go shopping alone in a nearby town, and so on). They also felt more compelled and justified to act and respond to violence because it was in order to protect their children. Whereas I had once heard that violence was just how they lived, and even that some violence was deserved when women overstepped their roles, now I began hearing repeatedly that a woman could no longer be considered immoral (or deserving of violence) if her actions were in the interest of her children. Her first and foremost duty was no longer to her husband (or even to his children), but to her own children.

Current Two: Combating Violence through the Machismo es Violencia Campaign: 2010–2012

The *Reacciona Ecuador: Machismo es Violencia* publicity campaign was highly visible throughout the country from 2010 to 2012, and most people in Las Colinas referenced it whenever I asked about human rights or gender violence in the last decade. *Reacciona Ecuador* aimed to denaturalize gender-based violence and to publicize the idea that *machismo* itself is violent and punishable by law.[20] A secondary objective was to demonstrate the government's political will to address gender violence, as part of the National Plan to Eradicate Gender Violence (*Plan nacional de erradicación de la violencia de género*), which was set in motion by a 2007 national decree signed by President Rafael Correa.[21] According to an analysis of the campaign by Salcedo Vallejo (2012), *Reacciona Ecuador* targeted men aged fifteen to thirty-five and aimed to disrupt the repetitive patterns that underlie and lead to violence. Its three central strategies were to raise awareness of the causes of this violence, clarifying that it is not normal, nor should it be permissible; to make fun of *machismo* and propose new ways of building gendered relationships; and to illuminate the diverse consequences of gender violence (Salcedo Vallejo 2012, 9–10). For the first time, the Ecuadorian government chose to portray *machismo* as a sociocultural phenomenon, acknowledging that traditional gender roles were social and not biological factors that underpinned violence against women (VAW) (Tapia Tapia 2018).

While *Reacciona Ecuador* was pitched across television, radio, billboards, and other platforms, the television campaign was the most memorable and most discussed element in Las Colinas. The television advertising spots can be categorized into those that provided statistics on gender violence in Ecuador based on national surveys on the prevalence of violence, mocked hegemonic or dominant forms of *machismo*, and encouraged the transformation of social roles and gendered relationships. Despite the different aims of the campaign, the advertisements in the second category were by far the most remembered by most Ecuadorians, including men, women, and youth in Las Colinas.

In the first category, short, compelling advertisements communicated the following messages: "Eight in ten women in Ecuador have been victims of physical, psychological or sexual violence," "More than 249,645 cases of violence against women have been filed in the *Comisarias de la mujer y la familia* in the last three years," and "In 2008, 10,672 reports were filed for sex crimes in the *Fiscalia*. Of these reports, only 300 led to sentencing." This last message was included in an advertisement showing men's shoes trampling a stuffed animal as they walk up a set of stairs to what appears to be a government or office building. As the stuffed animal falls, a tag reads, "21% of children and adolescents in Ecuador have experienced at least one incident of sexual abuse." Naturally, most people could not recall the exact numbers that were communicated in these advertising spots and billboards, but these promotions successfully raised awareness of the enormous scope of the problem of gender violence. They highlighted the various forms of violence by including data about physical, psychological, and sexual violence. They also made visible and explicit the state's stance vis-à-vis gender violence. The slickness of the promotional campaigns made clear that the issue was worthy of everyone's attention, and that the state was responsive.

Some of the ads most often recalled, even years later, were those that used humor to make fun of men, especially two spots that represented *machista* men as prehistoric cavemen. In one, five schoolchildren followed a tour guide through the futuristic "Ecuadorian Museum of the Evolution of Man," a modernist space distinguished by soft techno music and a high-tech blue glow. In an exhibit on abusive "prehistoric" men, they scrutinize artifacts encased in round glass cylinders, including a skull, a caveman, and a skeleton, with the following narration:

GUIDE: This is an Ecuadorian of the macho type who lived in an epoch . . . when people believed that the man . . . who consumed the most alcohol . . . and hit his woman . . . [*Video focuses on the skeleton's left hand wielding a whip, and right hand holding a beer glass. Brief shot of a child who, with his mouth open, looks up in amazement*] or had an attitude that was disrespectful . . . of women . . . believed himself superior. . . . This specimen could belong to any social or economic class. . . . As you can see, it happened to be part of a history that should never be repeated.

CHILD: How behind the times we were back then . . . how great that we've made that thing extinct.

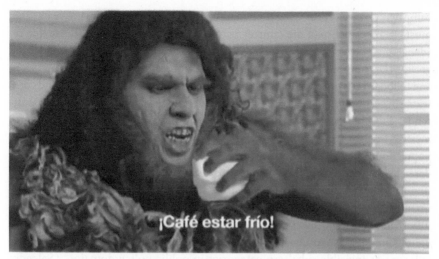

¡Café estar frío!

FIGURE 4.2. Screenshot of a still from *Machismo es Violencia*, Cavernícola advertisement. Source: https://www.youtube.com/watch?v=GD4ok7oIobg

GUIDE: Since we have eliminated machismo today, we will have a future without violence.

Much like Don Ernesto's pronouncement that "we're more civilized now," this commercial suggests that the *machista* is a prehistoric relic that is ripe for extinction. A civilized future—one that celebrates respect for women, modernity, and technology—hinges on its removal.

Yet another memorable ad sets up a similar dichotomy between the past and future by equating machismo with behaviors from prehistory. This commercial opens with a husband and wife conversing at the kitchen table of a middle-class apartment, presumably in urban Ecuador . . . but the husband is a caveman. Raising a coffee cup to his mouth, he takes a sip and anger washes over him.

The delicate objects on the kitchen table are contrasted with the enormous club he wields, and, lowering the cup from his lips, the caveman yells. His unintelligible grunts are translated in subtitles: "*coffee be cold!*" His rage escalates, accentuated in the ad by an increasing intensity in color, movement, and music, and he stands up, smacks the table, grabs his club, and storms out of the room. The ad then transitions to an office environment, where the caveman appears as a businessman hiring new staff. Seeing an attractive woman, he exhorts, "Hire! She good. Hire!" The advertisement continues through the end of his workday, transitioning back to his domestic space where he demands of his wife, "Food be ready?!" A pause, and the narrator says, "Your absurd violence is prehistoric. React, Ecuador. Machismo is violence."

The discursive effects of the campaign, especially how it was received by rural coastal mestizos and Afro-Ecuadorians, deserve a closer look. In Las Colinas, the

campaign was well-received and certainly memorable, even after many years. The most blatant criticism of the campaign concerned the inadvertent reaffirmation of (dangerous) hegemonic gender stereotypes and the lack of rural and marginalized groups (i.e., non-mestizo inhabitants) in the campaign messaging. The television and billboard ads only represent people with light skin, usually in clothes and contexts suggesting they are urban and middle or upper class. The advertisements render invisible people who identify as nonwhite (over 94 percent) or non-mestizo (approximately 30 percent)—in total over 20 percent of the Ecuadorian population. They also fail to depict any semblance of the daily realities or gendered experiences of the rural people who constitute over 36 percent of Ecuador's population, and they completely dismiss the particularities of nonheteronormative forms of violence experienced by members of the LGBTQI+ community (Salcedo Vallejo 2012; INEC 2019). Instead, the ads assume a homogenous, light-skinned, mestizo Ecuador, evidence that "racial and ethnic minorities are still seen as invisible subaltern categories in public policy domains" (Salcedo Vallejo 2012).

There are many reasons to believe that, in failing to interpellate the rural, poor, and darker-skinned population of places like Las Colinas, the campaign was not only less effective but also reinforced hegemonic gender stereotypes. Furthermore, it communicated a vision of the future in which modernity, urban cosmopolitanism, whiteness, and liberal progress are aligned but perpetually inaccessible. Despite its catchy and simplistic allure, the campaign's evolutionary framework was later criticized in multiple studies and analyses in Ecuador (Valencia and Valeria 2014; Estévez et al. 2011; Salcedo Vallejo 2012). In this supposed "modern era of expanded state services" and "inclusionary policies for women and children," men who still perpetrate gender violence and women who suffer from it are framed as backwards, irrational, and traditional—that is, as undeserving of participation in modernity (Plesset 2006). The Las Colinas women known to *aguantar*, or "put up with violence and suffering" because they see no other option than to live with physical violence, are then rendered shameful.

To be sure, the *Machismo es Violencia* campaign and the *Plan de Erradicación* (the National Plan for the Eradication of Gender Violence against Children, Adolescents and Women, the comprehensive policy package of which it was a part) incorporated an expansive view of violence, explicitly discussing physical, psychological, and sexual violence (CONAMU 2007; Ecuador 2007; ONU Mujeres Ecuador et al. 2015). Studies of the campaign's effects celebrated the emphasis on psychological violence in particular, with media addressing the harms of street harassment and everyday insults that men direct at wives and partners. In places like Las Colinas, these forms of psychological violence had always been identified as wrong and hurtful. However, the degree to which this message was understood also depended on rural women's sense that they could successfully access and lobby state services in practice. Despite the widespread denaturalization of various types of violence, Las Colinas women continued to reiterate what Paola told me

in 2013: "we know the insults are wrong, we even know that the government says so, but what can I do? I can show the authorities a bruise, but I can't really show them how he treats me at home. They just don't care, and he will just say it isn't true, so I don't bother." Thus, contrary to its intentions, the campaign rendered certain forms of violence more invisible than ever because, on the one hand, they were not perceived as easily identifiable in a court of law, and on the other hand, they became even more closely associated with a primitive male located in a "prehistoric" past that nobody wanted to associate themselves with.

The problem was not that women lacked access to judicial institutions to address these other forms of violence. The *Plan de Erradicación* also included new judicial services, thus going beyond mere awareness raising (Ecuador 2007).[22] Indeed, in cities near Las Colinas, judicial and social support services expanded between 2009 and 2011 under the Correa Administration. For example, the new prosecutor's office (*La Fiscalía*), a tall building covered with mirrored windows, looked like a truly modern spectacle in a small city usually marked by dusty streets and mud-worn cars. It replaced a cramped dark office on the third floor of an unmarked building, one which had operated on virtually zero budget for the past ten years. But the impressive façade did not stave off disappointment when local residents found that the *Fiscalía* was extremely inconsistent, with constant turnover making women distrustful of the availability and quality of services. On multiple occasions, I accompanied friends on the two-hour journey from Las Colinas, only to find that the corresponding staff member was off that day or had been dismissed without having been replaced. In order to file a complaint, one friend had to return to the office six times, waiting in the office for hours on some of these fruitless journeys. Improved funding and "access" clearly have not meant that services are readily available to inhabitants in rural sectors like Las Colinas.

Instead, the discursive impact of this campaign was much more notable: the message that was understood best by people in Las Colinas was that the state explicitly denounced physical violence against women, calling on women as "agents of change" to stop violence and ridiculing those men who continued to engage in it. The primary messaging of the campaign included powerful appeals to individual Ecuadorian citizens to "React!" "Inform Yourself!" "Speak!" "Act, already!" "Say No!" and "Denounce him!" with an implicit orientation toward women as the most important audience.[23] Ultimately, the campaign framed women as in need of protection *from men* by the state. However, to avail themselves of state protection, women were first called on by state authorities to respond and react, to stop putting up with violence, and to prompt the state to intervene.

Left entirely unstated here is that women and children in the region had never been without protection. As the historical political economy of gender relations in the region has shown (chapter 2), women and children were—and often still are—seen to be under the protection of their husbands. This is central to masculinity, family relations, and the various privileges and oppressions of being male or female in the *campo*. What human rights did, then, was introduce a new and

VIOLENCIA
DEFINICIONES DE LOS TIPOS DE VIOLENCIA

Violencia Física:

Todo acto de fuerza que cause daño, dolor o sufrimiento físico en las personas agredidas, cualquiera que sea el medio empleado y sus consecuencias.

Violencia Sexual:

Se considera violencia sexual la imposición en el ejercicio de la sexualidad de una persona a la que se le obligue a tener relaciones o prácticas sexuales con el agresor o con terceros, mediante el uso de la fuerza física, intimidación, amenazas o cualquier otro medio coercitivo.

[1] Ley contra la violencia a la mujer y la familia, art. 4, literal a, b, c.
[2] Convención Belém do Pará.

INEC Instituto nacional de estadísticas y censos — Encuesta Nacional de Relaciones Familiares y Violencia de Género contra las Mujeres

SI ERES VÍCTIMA DE CUALQUIER TIPO DE VIOLENCIA

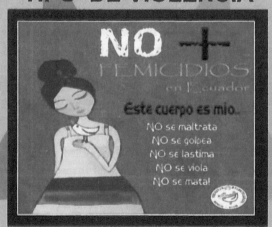

NO + FEMICIDIOS en Ecuador

Éste cuerpo es mío.
NO se maltrata
NO se golpea
NO se lastima
NO se viola
NO se mata!

DENÚNCIALO!

FIGURE 4.3. Photo of a brochure available at the District Attorney's office in Quinindé in 2014.

competing framework for protecting women, which affected not only how women understood themselves in relation to violence but also how men understood their own masculinity in relation to the state (as we see in the next chapter).

Current Three: NGO Public Health Workshops about Human Rights, Family Planning, and Sexual and Reproductive Health (2001–2018)

Local, NGO-run workshops about healthy families often reinforced the new ideas about gender and violence communicated in national campaigns, sometimes unwittingly. Since 2001, Las Colinas' inhabitants have received countless lectures, trainings, and workshops related to children's and women's health, sex education, family planning, childcare, nutrition, sanitation and hygiene, and healthy household communication, among other topics.[24] Health center staff (Ecuadorian doctors and nurses), international volunteers (including myself and nearly forty others who have done long-term work at the health center), and sometimes Ecuadorian consultants, have delivered these workshops, and most of them have tried to tailor content to local gender dynamics, though they have understood those dynamics in different ways and to different degrees. This health outreach has repeatedly highlighted (1) the vulnerability of women, (2) the distinctive and separate needs of women versus men in the family and community, and (3) the obligation for women (and not men) to respond. Let's look at one sexual/reproductive health workshop to see how these messages get communicated.

In this workshop, Ecuadorian nurses provided a dry, straightforward, objective lecture about various methods of contraception and prevention of sexually transmitted infections (STIs). Following a national curriculum, they stressed the importance of family planning and carefully emphasized that couples should make decisions and attend health appointments together. Often, however, the most revealing and memorable lessons came when nurses went off script. Many trainers argued that women should have sovereign authority in decisions about their own bodies. In this case, the head nurse linked this to contraception and STIs in a way that directly—but humorously—confronted men. Nodding toward the men, who were seated together in one corner, she said:

> I'm sorry, but if you come home after a night of drinking, and you want to have sex with your wife [nurse chuckles, followed by audience], and she doesn't want to— or she doesn't want to have sex without a condom—then you do not force her. She decides, as much as you're not used to that. And if you do force her, she can go to the law.

Indeed, even when the curriculum itself was not focused on gender equity, the trainers' status as cosmopolitan outsiders and "experts" often gave them liberty to address gender oppressions that they perceived (or assumed) within local households. In the process, they often hinted that women and men in Las Colinas had distinct—and even antagonistic—needs and wants.

As this example shows, three related messages were often reinforced throughout these workshops, many of which resonated with *Machismo es Violencia* and other state-led campaigns. The first message was that of women's vulnerability and need for protection from men. While the idea of women needing protection from men in general was not new, what was new was that women also needed protection from men within their own households, and that protection and advocacy would be provided by the state, NGOs, or their functionaries. The second message is the assumption that both women and men in these contexts are wholly autonomous actors with distinct—and usually competing—needs. A consistent refrain is that men cannot help themselves from wanting sex, that they often fall prey to violence, but that women only want what is best for the family, especially their children. While there are dangers in assuming that men and women's needs and wants are entirely identical, and that they have the same means to achieve them, I suggest that these messages problematically reinforce the idea that men and women are fundamentally different and at odds with one another. The third message which then follows is that women, knowing this about men (and their assumed inability to change) must take it upon themselves to seek the right forms of assistance.

After many years of researching gender violence and these variegated forms of gender empowerment, I became deeply concerned about the differential forms of accountability, whereby men could just continue to be men and women therefore had to work even harder to protect themselves and their families. In my research and writing, I had highlighted the dangers of these messages of "aspirant feminism" (cf. Moore 2016) which often led to depression, suicide, or isolation in a context in which women had virtually no viable economic opportunities that would allow them to actually leave or change their relationships now that they were unwilling to put up with them (see Friederic 2014a). I also understood that many men in the region were not violent nor hypersexual men, and even if many had committed errors in their relationships, it was unhelpful to paint them all with the same brush.

So, in 2015, when I implemented a small pilot project to mitigate the most extreme aspects of gender violence that I had identified in my research, I kept these concerns at the front of my mind.[25] Though funding was limited, the multifaceted project involved educational, microeconomic, and micro-infrastructure initiatives to encourage a more supportive and sustainable socioeconomic environment for men and women seeking to diminish intimate partner violence. Following the lead of local women, many of whom had participated in the Women's Bank, we launched a women's cooperative to raise chickens, provided scholarships to young women to attend high school and university, improved legal literacy by educating people on local judicial resources, and held family communication workshops in several communities. With local women, in-country specialists on gender, violence, and masculinity, and an undergraduate research assistant, we designed and implemented a series of interactive workshops on

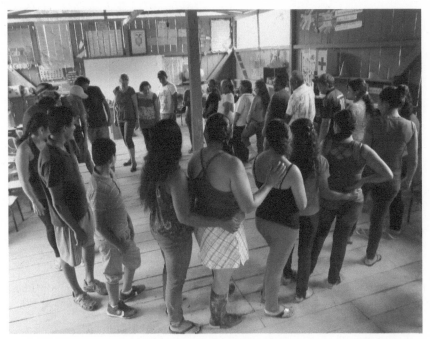

FIGURE 4.4. Participants in circle formation during 2015 workshops on gender, family, and communication in Las Colinas. (Photo by Leonardo Garcia.)

household communication, gender equality, and gender violence, to be held over a three-week period. We purposefully planned workshops that were not merely about lecturing and "raising awareness" but also about creating spaces for men and women of all ages, including husbands and wives, to dialogue and construct shared visions about what healthy, happy families look like. It was important that we give men and women the space to share and identify mutual, conjoined concerns, and to do so in a way that equitably distributed responsibility across the couple and the community.

These full-day workshops included activities such as community mapping, mini-lectures, sociodramas, children's activities, and group painting and drawing. Over 120 people attended, and the workshops were a success. Participants reported that they accomplished important self-reflective work, learned practical take-home lessons, and had lots of fun at the same time. Decompressing from the first workshop, my research assistants and I discussed how the facilitators had done a fantastic job honing participants' sensitivity to how gender organizes and unfairly structures daily life by cataloging women's invisible labor and mapping gendered spaces. They were also successful at eliciting gender norms and people's discomfort with the strictness of these norms. One of our goals was to address family relations in a way that would allow men and women—both jointly and separately in all-male and all-female groups—to reflect on and define what healthy

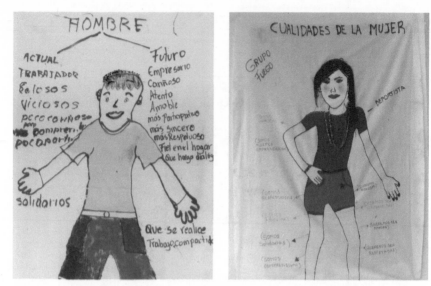

FIGURE 4.5. Drawings of a "man of today and a man of the future" and an "ideal woman" from 2015 workshops on gender, family, and communication in Las Colinas. (Photo by author.)

intimate relationships and family dynamics meant to them. We explicitly provided spaces for men and women to articulate their fears, concerns, and wishes for the future without restricting the conversation to the theme of violence.

But one aspect of these workshops left us uncomfortable. Despite our goals, it proved extremely difficult to foster conversations in which women could be anything but vulnerable and men could be anything but violent aggressors. Like the *Machismo es Violencia* campaigns, the discussions that emerged among participants only seemed to allow for the existence of one kind of man: an aggressive, violent, hypersexual, *machista* male. The communal goal was to get rid of him. Even when women joined together to imagine and draw an "ideal man," certain adjectives, like *attentive, hardworking,* and *loving* emerged, but alongside those, *not-violent, not-alcoholic, and not-machista* clearly had the most weight. There was little room for exploring real or potential alternative masculinities that could replace the ubiquitous *machista* male.

Similarly, the concept of *machismo* played a central role in the workshop discussions. Participants and facilitators mentioned it constantly as "the problem," but nobody placed the concept itself under scrutiny. Although *machismo* refers to a panoply of masculine behaviors (physical, psychological, social, and economic) that demean and control women, during the workshops, the way people used the term suggested that by *machismo* they were referring only to the most egregious of these behaviors: wife-beating. Every time mixed-gender groups were asked to enact common household challenges through sociodramas, their skits featured a

drunken machete-wielding *machista* beating his wife out of irrational jealousy or control. And everyone thought it was hilarious. It clearly resonated.

Again, the men and women continually identified the *machista* as the problem. When one man was asked by another audience member if he was *macho*, he replied, "Sometimes, I guess, but usually not. I've learned to not be *machista*. I don't hit my wife or yell at her for no reason." When some of us prodded him further, his description continued to focus merely on how he opposed the figure of the *machista*. At another point, when various participants noted that not all men were *machista*, one could sense in such comments some resentment that all men were had been characterized by this stereotype. While this was not the facilitators' intent (as they assured us), they and the other participants continually reconstructed men as perpetrators of various violences against women. In the final workshop, we explicitly tried to complicate the trope of the violent *macho* by asking groups to act out more subtle forms of dominance and control, but the impulse to include the *wife-beating machista* was strong; it still featured as the climax of these more subtle oppressions.

The workshop series left me thinking about all the other ways we might reproduce the idea that men are inherently and "naturally" violent, even when we are seeking to destabilize this very norm. In my own workshops and conversations, I have used the figure of the macho to break the ice, poke fun, and register my solidarity with women who disapprove of these behaviors while demonstrating my knowledge of local cultural norms. And while these tactics might work well to get laughs, raise awareness, and encourage conversation, it is especially important that we simultaneously develop strategies and create spaces for imagining and building alternative gendered identities. For example, I learned that I needed to pay closer attention to the fissures and cracks where these stereotypes broke down—the moments when men embodied contradictory postures in their lives—to encourage new ideas of self and masculinity.[26]

GENDER POLITICS OF REPRESENTATION IN EMPOWERMENT CAMPAIGNS

While human rights are supposedly universal, they assume different meanings and take different forms across the world as they become vernacularized. In our case, only certain understandings of rights made it to Las Colinas; typically, a liberal understanding that represented the best compromise across the various strains of feminism in Latin America. Rights do not merely get transposed from global realms to local ones; in fact, the presumption of a "global" discourse falsely implies that human rights, when "global," are somehow disembodied, existing in some illusionary plane of objectivity. Thus, the process of translation is not one in which these global ideas come to have a different meaning locally, one which might be deemed accurate or inaccurate (Gal et al. 2015). Understandings of human rights become transformed as they are refracted and adapted according to

local gender norms, aspirational gender goals, and political economic realities, even in relation to other ideas about celebrated modernity and condemned "prehistory."

Whereas many human and women's rights projects become entangled with various markers of modernity, the extraordinary power of the existing stereotype and trope of the *machista* in Las Colinas (as seen in chapters 2 and 3) not only shaped the interlocutors' approach to gender empowerment but also provided an easy target for NGOs, the government, and local men and women alike. A deeper analysis would tell us even more about the distinct ways that interlocutors or intermediaries each reshaped their messaging according to how they perceived their roles and their audiences (to be sure, the majority of anthropological analyses of vernacularization have in fact examined these intermediary figures in much more depth). However, I have focused here on how Las Colinas men and women understood and adopted these messages, and how they have come to see violence and power differently in their relationships over time. In each of the currents analyzed here, as in many other gender empowerment workshops, people in Las Colinas hear that women need to recognize their vulnerability, seek protection, and assume that their needs are (not may be) different than their husbands.

Through campaigns and workshops, women are targeted as the principal decision-makers when it comes to their own bodies, especially in regard to contraception, how many children to have, and whether or not to have sex (within any relationship, including marriage). These interventions reiterate the wrongness of gender violence, and they encourage women to seek legal recourse when they do experience it. But such interventions also inadvertently assert that it is women who are principally responsible for avoiding or reporting violence because men are naturally and hopelessly violent. When men slip up, they are excused because "even though they shouldn't enact violence, it's in their nature." Thus, the only way we can truly avoid gender violence is if women take up the call to protect themselves.[27] Abstractly, these programs imply that violence will be eliminated when awareness-raising undoes the cultural legitimacy of violence, so women stop *aguantando* (enduring).

In sum, gender violence campaigns such as *Reacciona Ecuador* often depict men as the brutes, the backward perpetrators of violence: the classic *machista* male is physically violent and controlling. While men are stereotyped to be naturally hypersexual and aggressive, the men in these campaigns appear out of control and violent to the extreme, which leads many men, who may in fact be violent, to rebuke violence actively and performatively because they do not want to see themselves as "that extreme." These campaigns discursively create male subjects who are either physically violent (and in need of reform) or not physically abusive (and therefore in the clear, irrespective of the economic or psychological violence to which they might contribute). These stereotypes produce analytic rigidity because they construct types of subjects instead of looking at processes and relationships. Structural and more complex forms of violence fade from focus as the visibly violent *machista* comes into focus as the primary target.

On the other hand, women are portrayed as naïve, childlike, and in need of enlightenment and protection. Now that the state readily provides this protection in the form of welfare, health, education, and legal services specifically aimed at women, it is women's responsibility to recognize the violence and "react!" by using the law. Gender violence campaigns prescribe a specific model of self to which all women should aspire: a responsible, agentive, rights-bearing woman with a social obligation to report gender-based violence and denounce the perpetrators. To be good, progressive, modern citizens—an image based squarely on ideals set by middle-class, urban, mestizo Ecuadorian women—rural women (like those in Las Colinas) must spend their time learning how to protect themselves lest they be cast as irresponsible women who are "asking for it," a phenomenon of unfair gendered accountability that has parallels worldwide.

LA VIOLENCIA YA NO EXISTE: ERASING VIOLENCE IN MODERNITY'S EMBRACE

Ya no somos asi, ya no hay esa violencia.
(We're not like that any longer. There's no more violence.)
 —María

Ya somos más civilizados.
(We're more civilized now.)

 —Don Ernesto

These gendered expectations also compel people in Las Colinas to demonstrate that they are the celebrated, progressive, urban families they see in campaign videos, and it is this pressure that leads María and Don Ernesto (in the above epigraphs) to insist that intimate partner violence is a thing of the past. Participants in our 2015 workshops repeatedly stated that "violence no longer exists," "it's not like it was," or "women no longer accept *machismo*." At the same time, I continued to hear stories that one of my *comadres* was stuck in a relationship with a man who physically beat her and controlled her comings and goings. She knew it was wrong, and she asked people for help, but she remained in the relationship for almost two years. In another case, when a woman died at the hands of her husband, people explained that "they weren't really from here." They had just moved to the region a couple of years prior, so their violence didn't count. And when yet another *comadre* found herself in a physically violent relationship, people described it as a fluke or an outlier—her husband had always been irresponsible as a partner, but never aggressive or violent in the many years they had been together.

What we see is that, as women and communities have grown increasingly aware of the "wrongness" of male-against-female violence, their strategies to make sense of the violence and reassert their dignity have also changed. Many women

continue to *aguantar* because they quite reasonably fear the threats of social isola-tion, structural violence, and gender-norm violation, but when they do not escape abuse or report violence they are often struck with a new form of shame. As we will see more fully in the next chapter, this dilemma extends to communities as a whole, who are also struggling to renegotiate their identity in the context of modernizing discourses, new political-economic openings, and continuing struc-tural violence.

5 · CULTIVATING MODERN SELVES

Reframing Sexuality and Violence within
a Moral Economy of Development

The women's police commissary called a community assembly in the dusty town plaza of Las Colinas, Ecuador in May of 2008.[1] Forty community members gathered to discuss with her the pros and cons of allowing a local businessman to open and operate a brothel called the Sony Nihgtclub [*sic*] (henceforth Sony Nightclub).[2] Liliana, a middle-aged community leader, rose from her seat to argue against the brothel. "We have to think of the youth, of the young people," she said, "we do not want them to be corrupted," implying that a brothel would only expose young men and women to immoral sex, as well as drugs, alcohol, and other vices. An older man from a more remote community then stepped forward and twisted her words to argue for the opening of the brothel. "Exactly. Exactly as she says. We must think of the young people! Young men, without a place to de-stress (*desahogarse*) and unwind, they will only get into more problems— more fights, more violence, and all of your young girls will suffer, since they will be more likely to be raped and get pregnant."

Though on the surface, the brothel debate revealed anxieties about morality, public security, and health, more substantially, it reflected and channeled a much deeper disquiet about modernity, as the people of Las Colinas wrestled with moral-political concerns to define their vision for the future at a moment of great uncertainty. On the one hand, these people felt deeply insecure about their ability to grow food and sustain themselves without sacrificing their autonomy through dependence on the state. Women's (and men's) limited claims on citizenship and the everyday challenges to their livelihoods derive from their dispensable, or disposable, status. Quite literally, they live in a biological reserve, a region the state has designated as a protected area solely for the reproduction of plants and animals, not humans. Continuing legacies of violence and an inability to access justice derive from this marginal, peripheral position. On the other hand, they

experienced social confusion and "moral panic" from the idea that "women wear pants and men wear earrings," as that man on the ranchera had put it (Cohen 1972). This fundamental gender reversal spoke to a much broader sense of instability and anxiety in a new world where they perceived that "anything can happen."

People in Las Colinas feel the turbulence of modern times on multiple levels, from upheavals in everyday gender politics in the home to changing politics of local governance and autonomy. The two are deeply interrelated. Most inhabitants believe that there is no going back to regional autonomy; their futures depend on the strategic acceptance of certain forms of formal governance that simultaneously allow them to participate in decision-making. In the discussion about the brothel, the local men and women are arguing not only about the legitimacy of brothels and the meaning of healthy sexuality but also about the powers they are willing to cede to the central state and the relationships they hope to build with international NGOs.

New, characteristically modern institutions of government and development have already instigated changes in gender roles, sexuality, and intimacy (for example, through Ministry of Health campaigns about family planning, sexual health, and gender violence campaigns, as well as the Ministry of Justice's evolving legal and penal codes on rape, abortion, and violence against women). As an "out-of-the-way" place per Anna Tsing's (1993) characterization, Las Colinas's peripheral status makes it both marginal to and constitutive of the Ecuadorian state. Here, affective and intimate relationships between men and women become a key site for the making of modernity in both its institutional and cultural-subjective forms (McCullough et al. 2013). To reach local, peripheral, out-of-the-way places like Las Colinas, transnational discourses, ideas, and practices do not spread seamlessly via urban centers and globalized cores. Rather, individuals across these spaces remake borders between the local and global, the center and out-of-the-way, as they draw on, redefine, and attempt to remake other ideas and other possibilities into their own. Thus, "out of the way" refers not merely to whole communities living on the edge of modernity but to "the intimate spaces of social life and the unexplored folds, fringes, and morally troubling cavities of gendered bodies [or polities]" (McCullough et al. 2013, 1). This understanding of the links between the intimate and global political economy builds on previous examinations of how modernity, globalization, and political economic concerns shape intimate relationships (Giddens 1992; Berlant 1998; Hirsch and Wardlow 2006).

In Las Colinas, "being modern" refers to a set of ideas and narratives of progress, understood as a clear break from "the past," whether that past be the previous generation or the proverbial "prehistoric past" associated with the barbaric machista. Thus, while the term modernity can encompass many dimensions and characteristics, such as "individualism, commoditized social relations, and narratives of progress," that make up the cultural dimensions of capitalist expansion, nation-state building, and globalization, in this chapter, I am most interested in the gendered aspects of the narratives of progress, and particularly "the way in which gender is deployed as a trope to represent progress or its lack" (Hodgson 2001; Hirsch et al.

2009, 9). Claiming and performing human rights, here, is another way of performing modernity. As the prism (metaphor) of human rights brings to mind, there is a constellation of ideas, morals, and values about modernity, progress, and gender that are hitched to rights projects and discourses. Thus, for people in Las Colinas, performing modernity through rights-talk becomes a form of currency within a new moral economy of development in the region: it positions them advantageously vis-à-vis NGOs, or nonprofit organizations, who are more likely than the state to let them "develop" and "do development" on their own terms.

By choosing to align themselves with progressive ideals and assumed characteristics of modernity, the different (predominantly male) factions hold something in common: to them, building legitimacy by adopting discourses about women's rights is a crucial concession for ensuring continued community autonomy (regardless of how they may orient themselves morally to the question of women's rights). However, their visions of an autonomous self-governed future are distinct, in no small part because of how they understand the relationships between political sovereignty and masculinity. In a sense, these men are willing to hand over female bodies for surveillance (whether they be the sex workers in the brothels or their wives undergoing regular health checks at the health center), in order to retain a sense of masculinist autonomy and power, to remain distant and free from state surveillance and inclusion.

Throughout history, political power in various forms has been consolidated through women's bodies or for their "protection" (see Abu-Lughod 2002 for a clear example).[3] Bodies, and more precisely, women's bodies have long constituted important political terrain for international development. The "development imaginary" for regions like Las Colinas includes visions of improved education, literacy, and household income, with greater involvement of women and improved gender equality as both a means and an end (Cornwall et al. 2008; Harcourt 2013; Harcourt 2017). As we saw in the previous chapter, family planning campaigns, media spots about gender violence, and workshops on family relations inadvertently prescribe particular ideas of heteronormative "healthy sexuality," small nuclear families, and communicative, loving partnerships as the key to a better Ecuador. As Harcourt (2013) notes, "the attempt to bring women's multiple needs and concerns into the development discourse became translated . . . into an essential passive productive, reproductive, and sexualized female body . . . managed and understood . . . as needing special protection from conflict, violence, or unfair work practices, and sexual exploitation and domestic injustice" (29). Because women's bodies have always been central to international development work and nation building, women have also come to serve as barometers of modernity and development through indicators of their educational levels, employment status, and rates of violence, to name a few of the measures typically employed. In the ensuing discussion, both men and women understand the need to protect the moral and physical integrity of local women's bodies; after all, active male protection of female kin is central to local notions of masculinity (while the bodies

of the sex workers from "*afuera*" [the outside] are rendered entirely insignificant and invisible).

MANABA MASCULINITY AND THE POLITICS
OF AUTONOMY IN AN OUT-OF-THE-WAY PLACE

During the 1950s and 1960s, migrants from Manabí and other provinces began settling here because of their desperate need for productive land and its distance from "*la mirada del estado*" (the view of the state). Local lore has it that many of the original colonists were criminals escaping the law; however, most were honest, hardworking agriculturalists seeking unclaimed forest to clear and make a living in peace. Agrarian reform, land inheritance policies, overpopulation, and severe drought continued to drive people out of Manabí province, especially during the 1970s and 1980s. Protections provided under the Law of Agrarian Reform (specifically, those passed in 1964 and 1973) incentivized land colonization, but later environmental reforms (especially the creation of biological reserves) effectively uprooted these same protections.[4] Las Colinas is thus comprised of smallholders who lack legal land rights, are marginal participants in the national market economy, and have been denied the kinds of infrastructure that would help them become more competitive. Thus, most inhabitants live in a precarious state of poverty due to the low market value of coffee and cacao, difficult access to the markets, and lack of legally recognized land rights.

The Ecuadorian state's largely indirect and invisible role has underscored autonomy as a central value among Las Colinas's *campesinos*. To recall, Manabí is itself constructed in the Ecuadorian public imaginary as a lawless frontier, and Manaba men are known for their *machismo* and their proclivity for resolving all conflict with violence, ruled by the dictates of *la ley del machete*. Before the 1990s, visible state presence in Las Colinas consisted of brief police forays into the region in pursuit of fugitives and sporadic visits by officials from the Ministry of the Environment. At the time, Las Colinas's residents were becoming increasingly resentful and distrustful of the state, criticizing its failure to provide basic services—and yet, often reframing their position as a celebratory demonstration of self-reliance.[5] Despite its peripheral location, national and global tensions and disciplinary practices are negotiated in and through material, social, and political bodies in this out-of-the-way place. Today, a proliferation of community, international, and state-based development projects in the region have changed the calculus, but certain sectors of the population still aim for regional autonomy while others believe that strategic collaboration with the state and NGOs provides the most fruitful possibilities for economic development.

Throughout, however, Las Colinas's residents have struggled to lessen their dependence on the state even while selectively demanding assistance from national ministries, such as the Ministry of the Environment, the Ministry of Public Works, and the Ministry of Health. The history of state–community–NGO relations in Las

Colinas contradicts assertions that NGOs are unambiguously part of neoliberal projects; while NGOs have sometimes substituted for state service provision, local inhabitants have also used NGO partners to struggle with and against the state and to expand both state presence and community autonomy. For example, local Ecuadorian NGOs first paved the way for the declaration of a national reserve, *La Fundación* built a health centre with support from the Ministry of Health, and another NGO successfully promoted ecotourism packages, thus attracting global and national interest and prompting the region's appearance on the internet homepage of Ecuador's Ministry of the Environment.[6] Don Marcelo, one of the first settlers in this area, describes these processes in the following way:

The people who first arrived in this region came with very few possessions—just those they carried on their backs. Then from one moment to the next, the state comes in and says "this is my property and we are no longer going to give you any land title because this is mine, this is protected area now—it is primary forest." So, how do the people feel? They feel cheated, tricked, betrayed. Most of them had sold whatever little property they had in Manabí, or wherever they came from, and they wanted to resettle here and buy land and security for their children; but then they couldn't. Some just returned to Manabí, but for those of us who have stayed, the lack of trust has only increased. Nobody knows what is going to happen. Most people hope for change, but we have lots of doubt because we have lived through so many *engaños del gobierno* (government deceptions).

He went on to describe how deep-seated this anger and mistrust is, claiming that "the distrust will only disappear when the government actually fulfils its promises." Don Marcelo notes that local organizations "turn out looking like liars; they want to make promises to the people, but their promises depend on the unfulfilled promises made by the government." Thus, responsibility, accountability, and distrust are redistributed onto the more local, decentralized organizations. Local organizations are held accountable by their constituents, yet they lack the ability to move resources and fulfill promises independently.

To uncover these dynamics and set them within a transnational and global context, I now describe how neoliberal policies have paved the way for government decentralization, the proliferation of NGOs, and shifting forms of governance and accountability. These changes in governance have created openings that Las Colinas inhabitants are using to negotiate their futures.

Decentralization and the proliferation of NGOs have significantly affected out-of-the-way places like Las Colinas (see Friederic and Burke 2018 for a longer discussion of these dynamics). Community-based committees and organizations grew in legitimacy, gaining legal recognition as representative participatory grassroots organizations from 2005 until today. Community members remark on their changing relationships to the state and a shift in political strategy from clientelism to participation in municipal and national bureaucracies.[7] State-centered efforts

to enliven civil society and implement participatory governance models have little direct impact in Las Colinas because these people live too far from municipal centers to engage formal mechanisms of participatory governance effectively on a regular basis. But the new mode of governance and politicking requires that local committees and community groups strategize around their public image; they must be seen as organized by representative democratic institutions worthy of state investment and as engaged communities capable of morally sound self-governance. As I show next, the regulation of intimacies within the *domestic* sphere—the most out-of-the-way domain of an out-of-the-way region—is deeply implicated in the *public* projections necessary for this region to seek state- and NGO-supported development on its own terms.

Restructuring of the Ecuadorian state, therefore, has upset the temporary local balance of political relations and gender norms in Las Colinas. The community debate about whether to permit the construction of a brothel is only one example of how people in Las Colinas are negotiating their new collective identity in relation to these changes. In what follows, I describe in detail the discourses mobilized during the brothel debate, the different political stances represented, and how "community development" is enacted and refracted through gendered bodies, both those of nonlocal female sex workers barely mentioned in the debate and those of the vulnerable wives and daughters.

SEX, PLEASURE, AND BEING MODERN

As we learned in chapters 2 and 3, preexisting ideas about men and women's "natural essences" shape ideas about the morality and the legitimacy of violence. Biological essentializing is fundamental to how people in Las Colinas understand masculinity, femininity, suffering, and violence. They understand men as inherently violent, physically strong, and hypersexual, yet as having a weak character, which is why they often succumb to violent or sexual impulses. Locals believe that women are physically weak and in need of protection, though their inner character is characterized by strength and patience. While sexual pleasure has long been granted or tolerated for men, it has traditionally been denied to women.

It then follows that one of the most poignant dimensions of women's self-understanding, especially as they enter womanhood and begin families, is that "a woman cannot be both a wife and a lover in her relationship with her husband," a truism I heard repeatedly when I interviewed women. As we saw with Teresa in chapter 3, women are often penalized for either failing as a lover or succeeding too well; a married woman often puts herself at risk, both morally and physically, when she tries to pursue or provide pleasure. This same inability to provide pleasure derogates women to subordinate roles in decision-making about their own bodies, their families, and their marital relationships. A young woman training to be a nurse once reminded me: "Men have to get their pleasurable sex elsewhere; they can't treat or expect their wives to act like prostitutes" by enjoying sex or giving pleasure.

Education about family planning has been introduced and promoted by the Ministry of Health and *La Fundación* in the health center, on health brigades, and in other venues. Despite initial concerns and rampant rumors in the early 2000s, both women and men have come to trust the health center services. They now view family planning as one of the most important tools for family health and stability in the region. International programs that encourage family planning often simultaneously promulgate notions of "the companionate marital ideal" (Rebhun 1999; Hirsch 2003; Adams and Pigg 2005; Hirsch and Wardlow 2006; Padilla et al. 2007). When health professionals and volunteers encourage or assume monogamy, close communication and intimacy, and shared decision-making in workshops on family planning, they propose models of marital union that are different and sometimes jarring. The increased use of family-planning technologies and the introduction of new ideas about physical intimacy, companionship, and "true love" have begun to create spaces for female sexuality separate from reproduction. In these ways, family planning and alternative ideas of marital companionship are contributing to a resignification of sexuality, intimacy, and household reproduction in Las Colinas.

Men, however, have long been allowed and expected to pursue sexual pleasure without any restriction. According to the more traditional models of masculinity among Manabas, the manliest men are those whose sexuality and aggression is left unchecked. Brothels become micro-spaces where men can act as men, and their sexuality is not subject to moralization. Prostitution is legal in Ecuador, and brothels or *casas de tolerancia* are regulated through health and sanitation controls from local health authorities that make them "centers of tolerance" (their official name) (Arunachalam and Shah 2008; Villacres Manzano 2009). As spaces where prostitution and promiscuity are tolerated, brothels are understood locally as a "necessary evil," fulfilling men's need for spaces to act "uninhibitedly" as men (see Kelly 2004 for other examples of zones of sexual "tolerance" in Mexico). The state intervenes legally when brothels pose risks to health (especially via the transmission of STIs and HIV/AIDS) or citizen security (e.g., increased levels of violence, sex trafficking, or the exploitation of minors).

Today, however, with the rise of companionate marriage models, the increased valorization of romantic love, and access to family planning technologies, new spaces have emerged within which men and women, or couples, can now pursue pleasurable sex and reproductive sex simultaneously, and within their home. Despite this possibility, a long history of viewing pleasurable sex within the married unit as immoral makes this change fraught for many men, and especially women.

DEBATING BROTHELS, DEBATING FUTURES

In Las Colinas, unofficial brothels have appeared in several communities over the past ten years, but none has operated for more than two years at a time. Two community disputes have invigorated the debate between pro- and anti-brothel factions

throughout the region. One brothel was opened by two local families but shut down numerous times at the urging of local citizens, most of whom were actively engaged in developing ecotourism in the region. A second brothel functioned on and off from 2005 to 2007, when the owner killed a neighbor over a land dispute and fled the area. In both cases, certain factions of the community mobilized successfully and shut down the unofficial brothels, ultimately because the brothels did not comply with national sanitation codes. The factions were made up of diverse groups of people, but most were aligned with either the Church, the health center, or both. In one case, one of the women who worked at the brothel (all of whom were "outsiders" from nearby cities) had not undergone the health controls necessary for her to retain legal status as a sex worker.

In 2008, rumors began to fly that another brothel was set to open in the central community of Agua Dulce. Álvaro, the local businessman who hoped to open the Sony Nightclub, applied for official permits from the Police Commissary (*La Comisaría*) so he could avoid the legal conflicts that had embroiled the other brothels. He was aware that the *comisaria* would have to conduct an inspection; he did not expect her to call a community-wide assembly to assess opinions about the prospective brothel. In February of 2008, I attended this meeting at the behest of the local Health Committee.

At one o'clock in the afternoon, we gathered in the dusty main plaza where the town council had set out chairs. Representatives of key organizations took seats alongside *la comisaria*. Many of the seats set out for the audience remained empty, as men from the more distant villages chose to stand along the outer edge of the meeting space. No one knew exactly what to expect from a public meeting of this kind with a state official. As if she sensed the confusion, the *comisaría* began by clarifying her reasons for calling the meeting:

> I am here to know and understand the communities and the rural sectors in my precinct, especially those that do not have formal political representation.[8] Communities without this must have my permission in order to operate a brothel. The new government [under President Correa] requires that state officials attend to a community's needs—and without corruption—and that is what I am here to do. You see, prostitution is permitted, but the government must demand that brothels comply with certain standards, because they would otherwise contribute to many societal problems and citizen insecurity.

She repeatedly emphasized the importance of the "general assembly" as the maximum authority of *el pueblo*. By claiming that "it is the community that decides," she adeptly invoked the modernist–populist discourses of inclusion and representative democracy that characterized the Correa administration, which was in its first year at the time. She noted that "a series of documents [presumably from Álvaro] arrived in my office, and each one stated that this community was in full agreement with the opening of the brothel." However, it became clear that she had

called this meeting out of frustration with the businessman. As the *comisaria* explained, "when I arrived to conduct my first inspection of the site, only fifteen people were there to meet me. It was clear that the meeting had not been announced to the entire community."

In this speech, she signaled the transition from clientelism to participatory forms of governance, and she used the occasion to communicate her own moral outrage.

I, like other authorities, have always stated that people have the right to work. And prostitution is permitted in brothels, but brothels must comply with the rules, and it's clear here that for a long time, people here have been committing . . . well, errors . . . as you can see with that ramshackle *ramada*. Can you believe it? They just take a shack that looks fit for chickens or pigs, like the one on the road, and in there, they throw two or three pretty women, and they create some sort of fake fantasy, and Friday, Saturday, and Sunday, men leave happy and head back home. Right? But this isn't a fantasy. We are in reality. What has happened is that you have paid off the right people and gotten your permits somehow, and many of the authorities didn't really know about it. But now, with the new government, we are here to attend to the actual, real needs of the communities. That is what we aim to do, to leave corruption to the side, to end it.

At this moment, she invited the community organizations to share their opinions, insisting that the government is "very respectful of its citizens' opinions, so we want to hear explicitly, really, clearly, what you all think—especially the representatives of this community's organizations."

In succession, various representatives stood up to read letters describing their opposition to the brothel. Though most people in attendance expected to hear these representatives' resistance to the brothel, most were surprised by the sheer number of committees and institutions—including the Health Committee, the Ecotourism Organization, the Town Council, the village chapel, the high school, and the Women's Microcredit Organization—that articulated their opposition. After forty-five minutes of dry but persuasive letter-reading, the *comisaría* called for an open conversation.

An older man stood up immediately and affirmed his support for the Health Committee letter. When he repeated matter-of-factly that "these kinds of businesses jeopardize health in our community," the great majority nodded their heads in unison. Multiple audience members followed his lead and elaborated on the health risks and the risks to foreign volunteers who were cited in the letter. According to health center records, STI prevalence in the region was quite high, and the letter made direct associations between STIs, men's use of brothels, and men's general refusal to wear condoms. Furthermore, the letter argued that the health center was not equipped to provide the controls and weekly examinations necessary to ensure the health of brothel users or employees. Throughout the

meeting, many, including the *comisaría,* would return to this point, emphasizing that it was precisely the lack of regulation and state infrastructure (especially medical staff and a police station) that made a brothel risky and unacceptable.

The Health Committee and health center staff also expressed concern for citizen security, in particular the safety of the medical volunteers who were often stationed at the health center. Though I was not technically a medical volunteer, I knew (from the glances thrown in my direction) that most people included me as a potential person-at-risk. Community members cited numerous incidents of violence associated with brothels in nearby communities, where drunkenness had led to dangerous fights between male patrons, harassment of female community members, and in some cases, rape of young women.

Picking up on these concerns, the conversation turned to the safety of women and children and the importance of preserving the family unit. A few men and women highlighted the moral risks that the brothel posed for the disintegration of families, as it "would jeopardize the family and the home, and not only because of the illnesses that might be transmitted." The spokesperson from the village chapel asserted that the people who were pro-brothel were "neighbors who were walking down that other road," the one that is "contrary to the good customs and morals we should uphold in our lives." Maritza, an older woman who has been at the forefront of many battles to close brothels, passionately argued that the brothel would unfairly humiliate local women. She spoke of occasions when men called her and other women "jealous wives," implying that they were anti-brothel because they were "hysterical that their husbands would visit the brothel and sleep with other women." Threats to the integrity of families were thus perceived to be both physical and moral; a brothel would both degrade women and delegitimize their response to such degradation.

At this time, Don Marcelo, a prominent community leader, reminded the crowd how this might be seen from the outside. The brothel would put the "prestige and morality of the community at risk" not only because of the threats to health and family integrity but also because international and state organizations "do not look positively upon these kinds of activities." After all, this region is now an ecotourist sector, one that "is being evaluated by the outside." A few attendees resoundingly called for a distinction between "good" business ventures and "bad" ones. Everyone is interested in bringing more business into the region, they insisted, but we must choose those businesses that promote the physical and moral well-being of the community. The *comisaría* seized upon this point.

There is so much to develop in this region. Many people want to work—for example, in ecotourism. It would be fabulous, wouldn't it? You could have other educational centers, a place to put a slide, a public pool, places of recreation—where our children and mothers can enjoy themselves. [The opposition to the brothel] is not to deny people the right to work, but to help decide the kinds of work to get involved in and make sure they adhere to certain standards. Of all the communities

I have visited, this is one of the most organized. You could advance in so many areas, you have land, you could do tourism, *artesanías* (handicrafts), nice things; you could make some kind of special food, a special drink, a particular item to sell to tourists. You have opportunities! Open another kind of business!

Moreover, many insisted that a brothel was also bad business from the perspective of community and family economics, because "men throw away family funds on alcohol and prostitutes."

Reflecting on "good" businesses, a man reminded the crowd that the brothel would impede efforts to attract ecotourists, who are viewed by many as central to the region's economic development.

All of you—my friends—you know that this town is visited weekly by people from the outside [implying tourists and volunteers from other areas of Ecuador and abroad], and these visitors sustain many of our businesses here. And if these people no longer came to visit this sector, our businesses would not be developing as they are, so for that reason, I ask you all, *compañeros*, that we take into consideration their well-being.

As we heard in the opening vignette, both groups argued for the importance of ensuring the security and integrity of families within the community. They only differed in their approach to achieving "healthy development." The first group, unequivocally anti-brothel, argued for the moral-legal regulation or prohibition of sexuality. The pro-brothel group argued for healthy development via unfettered sexuality.

The people who rallied in support of the brothel were almost exclusively men who lingered on foot at the edges of the meeting space. Though quiet for most of the meeting, they too adopted the language of the state when they did speak up by discussing the implications of the brothel for health, morality, citizen security, and family integrity. They tried to emphasize the beneficial effects for women and children within the region, yet their argument kept returning to the straightforward economic benefits for Las Colinas families. Álvaro, the businessman who wanted to open the brothel, would benefit as a result, as would his family and other community businesses that could sell more products to the many men drawn here from other villages. They also argued that "men would more likely *save* money for their families because they would not have to travel as far to visit brothels in the city." In this they were adamant, as it was safer for "your sons, friends, and husbands to visit a brothel within the region than to travel to the cities," which were perceived as dangerous. Underlying this statement was the firm assumption that men would inevitably visit brothels, so it was better to have one close by that would reduce travel costs and stimulate local business.

The pro-brothel faction began to whither in front of the steady stream of anti-brothel arguments, but they were reanimated when the older man argued that

"young men, without a place to de-stress (*desahogarse*) and unwind, [would] only get into more problems—more fights, more violence." This argument cut to the core of hegemonic beliefs equating masculinity with sex, violence, and potentially dangerous natural energies. Nodding heads and murmurs of agreement came from the edge of the circle. Then, two more men stepped forward to confirm that the incidence of rape, violence, and murder had been too high in the community precisely because there was no brothel. A brothel would allow men a place to "release" and indulge their sexual urges, and thus mitigate potential violent incidents between men, domestic violence, rape, and pregnancy out of wedlock. In their view, the presence of a brothel promoted healthy sexuality and family relations because "it is 'natural' for men to visit prostitutes and, when men regularly satisfy their urges, they treat their wives better."

In response, the *comisaría* shared an impassioned plea that clearly represented unconventional ideas about family relations, sexuality, and reproduction.

Even if there have been cases of rape, that absolutely does not justify or [. . .] imply that the rape occurred because men don't have a place where they can *release*. *Carramba*! He has his wife! A man should be making love with his woman! Do you all have other women? Visit other women in brothels? If so, then how do you defend yourselves? What kind of situation are you putting your wives in? Where do they come out in all of this!?

At this point, the heated two-hour discussion devolved into quiet murmurings and conversations within small groups. The men who had traveled from afar to support their friend Álvaro began to retreat as they realized their attempts to win over the community and the *comisaría* had failed. While people began to slowly file out of the plaza, the chaplain made a snide remark to Álvaro, referring to a past incident in which a young girl had presumably been raped by one of Álvaro's family members. Álvaro responded, yelling at the chaplain. So the end of the community assembly was marked by a yelling match that escalated into blows between two men. Although friends and neighbors quickly intervened and no one was hurt, it was evident from everyone's nonchalant reaction that this form of conflict-resolution—violence between men themselves—was more commonplace than a community-wide assembly presided over by a female official of the Ecuadorian state.

LOCATIONS, POSITIONS, AND STRATEGIES

During the meeting, arguments both for and against the brothel pivoted on overlapping themes of health, citizen security, morality and family integrity, the protection of women and children, and economic development. The meeting captured the ways in which ideas about gender, sexuality, and legal norms are changing in the region. It also served as a way of looking at how people and community

groups are situating themselves vis-à-vis the state and international development organizations. In this section, I focus on four characters—the *comisaría*, Marcelo, Álvaro, and another leader named Don Jorge—to highlight distinct positions in the debate and to tease apart how their beliefs about appropriate sexuality are intertwined with particular postures toward the state and development.

The *comisaría*, in her role as a democratic representative of the state, was concerned with "listening to the community." In so doing, she took care to break with the past and communicate her administration's commitment to democratic governance. However, she was not merely a neutral arbiter from an objective bureaucracy; as is particularly evident from her final speech above, she also saw herself as endowed with the right, perhaps even the responsibility, to guide the community's social and moral development. So, while she solicited the opinions of the community, she did not shy away from sharing her vision of how things should be in Las Colinas. This was certainly her own opinion, but it dovetailed with the vision encouraged by the Ecuadorian government at both the national and municipal levels: the development of NGO-sponsored ecotourism was a way to transform the "wild hinterlands" into a revenue-producing modern tourist destination (West and Carrier 2004). Conveniently, this particular kind of development demands governmental support, but not the intensive infrastructure development and land reform that regional inhabitants have traditionally demanded.

Don Marcelo shared the comisaría's ideas about "healthy" development through ecotourism, but he was adamant that the state invest in basic infrastructure to enable these processes. As a member of the health and ecotourism committees, he adopted a highly strategic approach. He believed in the benefits of collaboration with the state and NGOs, and he allowed for state intervention, but on terms that valued the autonomy of the community in decision-making. Until recently, Don Marcelo had not seen any benefits from decentralization. State-driven (as opposed to NGO-driven) forms of participatory governance had not yet extended their reach into this region. But he was at ease with the comisaría's approach of grounding state intervention in community decisions, and he later reported, "It's about time an authority came to hear an open—truly open—assembly here."

Furthermore, Don Marcelo was a person who often invoked morality in the community. He especially highlighted how *outsiders* understand morality. He was concerned that the brothel would put both the "prestige and morality of the community in jeopardy." He knew from experience that a weak state required the community to pursue resources through transnational alliances, but his allegiance to transnational partners, like his allegiance to the state, was conditional. He used the debate to hold the health center to task as well. While he supported attempts to teach young couples to use contraception, he bemoaned "the lack of moral education that should always accompany sexual education." He spoke eloquently of human rights, gender equality, and the need for his *compañeros* to educate themselves to bring true progress to the region.

Don Marcelo's view was befitting of a community leader who had worked closely with development initiatives in the region, including cofounding the Eco-tourism Organization and the health center. For he understood that the community needed to provide visitors with a particular kind of exotic experience, one that was self-evidently wild and rugged in terms of the tropical landscape, but moral, egalitarian, and progressive in its social relations.

Álvaro, on the other hand, tended to ignore visitors and organizations from the outside, trusting only his own business sense and his network of *compañeros* in the region. Despite his misgivings about any government or external involvement, Álvaro had learned from previous brothel failures that it was necessary to engage the state. He only hoped that the *comisaría* would grant permission without a full investigation, or perhaps that he could curry her favor through bribery and that a license would provide the freedom to operate without further restrictions. Having been his friend for eight years at the time, I knew that he represented a sizeable sector of the population that deeply resented state intervention. He saw any form of local business as contributing to economic development (with no distinction between *good* and *bad* enterprises). Furthermore, he benefited from the lack of infrastructure in the region, especially roads and water, because the high costs of transportation allowed him to sell vegetables, water, and (he hoped) women to regional inhabitants at high prices. Interestingly, his wife was active in the local women's microfinance organization and she ran one of the most successful businesses in the region. Despite Álvaro's consistent and explicit disdain for women's empowerment, he allowed his wife to join the organization and start her business because of the economic benefits to his family. Thus, Álvaro was truly a business-man accustomed to making his way according to the old rules. The new era of state intervention and formalized bureaucracy, not to mention the emergent discourses of women's rights, presented potential challenges to his power.

When Las Colinas was first colonized, Don Jorge, a respected community leader, was authorized to act as the local "deputy" of the region. His role was well known throughout the region, and people consulted him when serious conflicts arose or there was a death to report. He typically intervened without notifying the police, but when this was unavoidable, he acted as an intermediary to the police. Thus, his role was one of negotiation between state and local legal norms, a bal-ancing act reflected in his approach to regional development. In the past, he had supported regional autonomy and had demanded narrow, specific forms of state support. In his role as arbiter of justice, Don Jorge drew on his standing within the community and his ability to tap into predominant moral discourses. For this rea-son, he positioned himself quite diplomatically in most community disputes. After sitting silently through most of the brothel meeting, Don Jorge offered his opinion immediately before the fight broke out and the meeting ended.

Compañeros ... I do not see a problem here [arising from this meeting], just a need for clarification. It's a shame that this problem has fallen on the community,

because this gentleman [Álvaro] has done good work here—the community has supported you and appreciated your labor. Our doors are generally open, but in this case, I'm in agreement that it be a *healthy business,* no? This is what the community has decided, and therefore I must also say no. But I also understand. You see, I also am a man, I am a man who was known to visit the brothels, but . . . but . . . well, this community has taken a position, and it is NO. As inspector of the community, I have to take these voices of the community and its leaders into consideration. There are no winners or losers here; it's just an agreement that we all must accept.

In this moment, Don Jorge situated himself on both sides of the argument—as a neutral arbiter who consolidated social capital "just from being a man" in the community, and simultaneously as a quasi-representative of the state whose job it was to represent *la comunidad* and ensure that its will was executed. He was obviously modeling good behavior for a new era of governance, when leaders depend more on consensus than raw power, and he was asserting his continuing relevance alongside the new actor of the *comisaría.* Yet, because of his accrued respect as a long-time community leader, he could be forthright and open with his brand of masculinity, especially since his personal history of infidelity, violence, and using prostitutes was already well known.

Casas de tolerancia are visibly hidden spaces within which unregulated male sexuality is condoned by the state. Because they are sanctioned and held to particular sanitation and health codes, they are regulated sites of unregulated sexuality. This distinction becomes only more powerful in a region that has always been "out of the way" and thus distant from state assistance and oversight. In fact, the *comisaría* decided that the historical absence of the state required extra intervention on her part in order to permit a *casa de tolerancia.* Several people noted that the ongoing absence of the state (especially health and police services) made the *casa* particularly risky. Essentially, the region—left to its own devices—would be unable to control a site of unregulated sex.

The contradictions here are not incidental. The *comisaría,* leaders like Don Marcelo, and many female community members argue for men's moral self-regulation (recall "*Carramba!* A man should be making love with *his* woman!") and yet the majority in Las Colinas attribute men's sexual behavior to their biology, not their morality. As we saw in chapter 2, it is thought that men can self-regulate to a degree but that there are things they cannot control, and that in those instances, women must understand.

BODIES, INTIMACY, AND VIOLENCE IN LAS COLINAS

Decisions and regulations about brothels are acted out upon the bodies of men and women throughout the region, not solely on the bodies of the female prostitutes who work there.[9] With limited state involvement and a heightened presence

of NGOs, ideas about planned families, romantic love, and new notions of healthy sexuality and intimacy are taking hold. Many couples conscientiously use contraceptives to avoid, limit, or space pregnancies; women are increasingly filing reports against their husbands in cases of violent behavior; and others report that workshops have encouraged them to attain new levels of intimacy with their partners (Friederic 2011). These ideas and practices are not displacing preexisting norms, but they are being implemented in strategic ways at least as much as they are being resisted and challenged.

In this story, two distinct camps argue over multiple overlapping dimensions of local life and imagined futures that pivot around alternate notions of modernity and development. While this debate may appear as a discursive exercise in community politicking, the results have concrete effects on material bodies. Both factions warned of potential risks to the bodily integrity of the region's women, the physical and moral integrity of its families, and the political integrity, or autonomy, of the community more broadly. Those opposed to the brothel cited evidence that it would increase male-to-male and male-to-female violence. Those in favor countered with deeply embedded folk notions of violence and sexuality as natural, healthy, inevitable extensions of male virility—visiting a brothel allows men to blow off steam that might otherwise be directed at their women. Thus, the pro- and anti-brothel factions clashed most significantly on the anticipated effect of the brothel on male-to-female family violence, a phenomenon that is physical, social, and (increasingly) political.

I have argued that these discussions reflect tensions about community autonomy that play out through gendered bodies and the changing norms about them. The majority of state and NGO interventions have been focused on women and children.[10] For the past twenty years, emergent discourses and practices promoting women's empowerment and children's rights have been challenging politics-as-usual and traditional forms of justice. While I have examined the dynamics of violence and patriarchal control within women's individual bodies and their households in previous chapters, the brothel debate illustrates that they remain relevant in current efforts to remake the body social and body politic. Before the law became a presence in the region, justice was enforced through masculine displays of honor and physical prowess. In recent years, women have begun to use formal legal services that are more responsive to their needs. But now that women access formal legal services more regularly to resolve family violence, recourse to the law has itself become feminized in contrast to masculinist notions of self-reliance. For this reason, both men and women question the validity of women's claims in the Commissary, and they tend to frame interactions with the law as ashamedly feminine and unmasculine. Rather than contesting it substantively, some men find it more useful to undermine "the cultural power of the law" by delegitimizing it as weak and unmanly (Merry 2003). By extension, autonomy—or the community's ability to decide its own future with minimal state intervention—is conceptualized as the markedly male act of

making decisions, resolving disputes, and carving out a future on one's own terms, much like men have always done, by using *la ley del machete* or (in the case of Álvaro and the chaplain) with their fists.

CONCLUSION: INTIMACIES AND FUTURES

In this chapter, we have seen different actors vie for control over the region's future and its development; what appears to be a straightforward discussion of whether to allow a brothel in Las Colinas is actually a complex and contentious debate about how to manage change on many scales. The regulation of domestic life, sexual intimacies, and family violence has challenged local understandings of masculinity and femininity, genderings that have been fundamental to Las Colinas's governance and community identity, and which remain pivotal to locals' imaginings of possible futures. Thus, in the debate described here, certain community factions invoke modernizing discourses of human rights (specifically, women's rights) in their struggle to shut down brothels and mitigate family violence, and they hail the state as a new ally in their struggles against the patriarchal structures of community decision-making. They warn that easy access to commoditized sex may erode men's moral core and produce a range of other antisocial masculine behaviors that destroy the social fabric. The president of a women's microcredit organization insists that "we women, who are profoundly peaceful, hardworking, and farsighted, who are consistently fighting for the children and families of this region, we know our rights and we demand them, with the help of the competent authorities before us." Others argue instead for unregulated male sexuality (*lo natural*) as a way to diminish violence and improve citizen security more broadly, using the safety and protection of women and children as a discursive tactic to maintain patriarchal and masculinist control. In this view, easy access to commoditized sex enables men to be more thoughtful, engaged partners at home. Put differently, because male sexuality is considered to be inherently violent, prostitutes absorb male sexual violence for the sake of (our) women. Preserving hegemonic gender norms in which local men reign over both women and the state in everyday decision-making is the surest way to restore order.

Bodies—especially female bodies—have been central to some of the most evident forms of state expansion in the region thus far. By reasserting their control over and access to female bodies, these men are simultaneously protecting the social and political order (or maintaining the status quo of the body politic). The state, above and beyond its representation in a female policy commissary, becomes a femininizing threat as it challenges many of the traditional masculinist forms of power. The expansion of the state through bodies does not happen without resistance; rather, people are utilizing these openings for their own projects. In this way, debates about sexualities and intimacies have become central to local struggles to balance autonomy with inclusion in broader processes of international development and state restructuring.

Local people and organizations are using transnational alliances to gain leverage and demand resources and infrastructure from the state, but on their own terms. To do so, and to embrace modernity and gain respect in the international eye, they begin to align themselves with new notions of morality, sexuality, and intimacy hitched to the package of "human rights." New modes of governance demand that local organizations appear as representative democratic institutions worthy of state investment, and Las Colinas's communities successfully carry out moral self-governance. To manage the instability and change inherent in the process of modernizing and developing, these community members explicitly allow for the policing of sexuality by the state, the international community, and community organizations. Thus, rural intimacies and the boundaries of state intervention are co-constructed, here, as revealed by the lively debates over the contested Sony Nightclub. To many Las Colinas men and women, the brothel becomes an abject anomaly that must be expelled lest it taint the projection of an authentically natural landscape paired with modern rights-based social relations, as demanded and expected by profitable ecotourists and the agencies that serve them.

CONCLUSION
Vernacularizing Human Rights for Gender Justice

Throughout this book I have sought to explore women's experiences of violence and the promises and pitfalls of human rights in line with what Goodale (2009) calls "a well-tempered human rights"—a human rights practice that demands action in the face of injustice but recognizes that the pursuit of justice will be shaped by human multiplicity and plural normativities. Anthropology can and should support this project, with an approach that is at once critical and hopeful. The original Commission on Human Rights envisioned the work of human rights in "aspirational rather than prescriptive terms," and it behooves us to remember the "aspirational" even while critiquing the ways in which human rights have become "prescriptive" in their application over time (Goodale 2009, 131). This is why I have tried to pair my action with scholarship, knowing that action is always imperfect. In Las Colinas, and in similar rural settings across the world, human rights awareness offers powerful openings for women and families, but their empowering potential is limited due to a failure to reckon with growing social and economic vulnerability as well as discrepancies between rights-based subjectivities and preexisting understandings of the self. Scholarship and activism that uncritically celebrate the spread of human rights as a positive, civilizing force invariably contribute to binaries that are not only conceptually problematic but also pragmatically dangerous. At the other extreme, critical development and human rights literature that critiques the underlying Western bias and neocolonialist tendencies behind the language of human rights similarly oversimplifies and demonizes a movement that has provided important openings and opportunities for families, communities, and nation-states to reduce violence.

Ultimately, I believe that human rights—as concept, as practice, and as discourse—reorganize power in ways that warrant both optimism and critique. In this conclusion, I illustrate how we can bolster that critical optimism by using anthropological analysis of vernacularization to identify local obstacles to

realizing human rights and to reconceptualize rights themselves according to the ways that women embrace and determine their own rights, well-being, and development.

LAS COLINAS THROUGH THE PRISM OF RIGHTS

Thinking back to my introduction to gender violence in Las Colinas when I was awoken in the middle of the night by the young boy, it is perhaps understandable that my own impulse to "do something" would lead me (and countless other well-meaning volunteers and NGO staff) to see a solution in *education*. At the time, I believed that all we needed to do was tell women that they deserved better. If only they could see that intimate partner violence was always wrong, that strong women (like "us") should never put up with it! As someone in her early twenties, recently graduated from an elite liberal arts college in the United States, I could not conceive of a scenario in which battered or abused women could not get help if they really wanted it, despite the fact that this scenario was also commonplace in many pockets of my own country. Eventually, I would learn that knowing that something is wrong and being able to do something about it are two different things entirely. This discovery was mind-blowing to me at the time. Women, and many men, already knew that intimate partner violence was wrong and that it hurt individuals, families, and communities. But it was one form of violence in a suite of many. So, at times, they also knew they had to live it.

Each chapter in this book reveals a different layer in the overall picture of women's human rights in Las Colinas. When we consider them all together, what do we see? Las Colinas at first appears to be a women's human rights success story. Two decades of continuous awareness-raising by trusted community institutions, paired with progressive laws, national educational campaigns, and the creation of new women's police agencies, have indeed shifted views of domestic violence away from what was previously a taken-for-granted, private, and generally unre-markable affair. Many Las Colinas inhabitants now explicitly denounce *violencia doméstica* as an unjustified assault that demands change from victims and assail-ants. And they hold the state accountable for protecting women and children and punishing abusers. In short, the ingredients most commonly considered essential for realizing human rights are all in place: awareness, changed norms, and appro-priate legal institutions and the willingness to use them. Women's rights have become such a commonsense part of local discourse that we even regard appeals to women's protection as part of community debates about other issues, such as the opening of the brothel in the previous chapter.

On the other hand, human rights awareness and legal institutions have not sub-stantially reduced women's experiences of violence. And they have reduced women's room for maneuver. *The Prism of Human Rights* demonstrates that gen-der violence campaigns based on rights awareness and education are not simply insufficient, but they have also plunged women more deeply into other forms of

violence and suffering *and* have made those forms of violence less visible and therefore even harder to assess and address.

Furthermore, communities like Las Colinas, which must perform their suitability for limited state and NGO support, feel pressure to hide violence in order to appear "modern" and "developed." Even when educational campaigns are paired with microfinance and public health programming, this paradigm of rights intervention holds women principally responsible for rejecting and eliminating violence without offering material or ideological alternatives, leading to women's increased self-blame and higher rates of suicide. So, rather than upending long-standing patterns of gendered impunity, human rights campaigns themselves shift the burden of change even further onto women, largely blaming them—and not men—when visible violence continues unabated in local households. At the individual level, most women and some men find themselves in a challenging double bind. Although attracted to the promises of these rights, they keenly feel the limitations of human rights messaging when they do not have the economic, social, or political means to address or avoid violence. In this context, old ways of preserving one's dignity as a victim of violence (coping, preserving public face, or spending more time at an in-town residence) are seen as distinctly unmodern, but new ways of preserving one's dignity as a victim (reporting violence and leaving violent relationships) often violate other aspects of women's identities, or they are economically unfeasible and destroy social links on which many women depend.

Therefore, this book yields two key conclusions for human rights practice: first, that rights-based interventions often render invisible other forms of violence that are central to the social reproduction of gender violence; and second, that the shortcomings that are often written off as a consequence of poorly executed campaigns, or as a short-term hiccup in a longer process of gendered social change, are in fact part and parcel of the human rights regime, a regime that has been hitched to neoliberal policies in Latin America and globally.

This initial story of the successes and shortcomings of human rights campaigns in Las Colinas hints at several very concrete strategies for improving outcomes. First, if human rights campaigners are to avoid increased suicide and self-blame that we saw in Las Colinas, at minimum educational workshops must be implemented with in-depth, long-term knowledge of what is at stake for men, women, and children.

Second, to avoid the double bind of rights without resources, human rights education and judicial services should be accompanied by strong economic and social supports for women. Violence, and women's responses to it, are always already embedded in the political economy of everyday life, as men and women indicated to me from the outset. Gender violence is inextricably bound up in household economies, inheritance patterns, courtship strategies, and the division of labor, family health, and daily subsistence. When we isolate "violence" and its resolution as if they are simply cultural behaviors about which people can be re-educated, or even discrete physical acts, it puts women in situations of extreme

precariousness. They learn quickly that education and escape can be much more costly socially and economically than such a simplistic narrative implies. Unfortunately, economic and social supports are often overlooked because purely educational interventions are more cost-effective and produce a sense of "getting things done" in the politically expedient short term.

A third concrete strategy for improving outcomes is related to the second: that campaigns need to avoid narrowing notions of violence, even unintentionally. People in Las Colinas already had a robust understanding of intersecting violences in the concept of *sufrimiento*, but human rights campaigns and institutions replaced this with a focus on physical *violencia*. Though not intentional, this obscured the risks of combatting violence and the other types of violence that women experienced.

Fourth and finally, human rights interventions might be well served by focusing on historical and future notions of dignity for men and women, considering how those might be threatened, narrowed, or expanded and facilitated by educational messages and other programs.

Moving beyond this initial summary to a more nuanced, anthropological analysis of vernacularization opens up other strategies for creating more locally embedded rights campaigns. As we have seen, there are multiple stages of vernacularization through which the universal vision of Human Rights becomes locally understood and actionable rights. Before human rights ever made it to Las Colinas, they traveled from diverse sites around the world to global summits, where they were debated, negotiated, and standardized according to various ambitions and agendas before being sent back out into the world via governments, nongovernmental organizations, and social movements. On the way from Beijing to Las Colinas, women's human rights were transformed by Latin American women's movements pursuing strategic interests in a turbulent political landscape and Ecuadorian organizations and government agencies tailoring them to a national context. They then "arrived" in Las Colinas in the form of Ecuadorian educational campaigns, new women's police offices and legal procedures, and transnational NGO campaigns for women's health and economic development, some sophisticated and aligned with broader campaigns and others brought in by individual volunteers from the United States or Europe. In all of these cases, rights arrive as part of a package of ideas and values described as "modern" and manifestly good. These ideas include notions of citizenship and responsible states, good parenting and modern women, healthy families and communities, and economic progress over rural backwardness.

The prism metaphor helps remind us of these diverse elements of modernity that are hitched to rights. While human rights may initially appear as a homogenous, uniform, simple beam of white light, when we pass it through a prism, we see that it is composed of a broader spectrum of discourses and values. As it enters the prism, it refracts and splinters, signifying that all the ideas and values bundled up with rights become re-signified and remade in the process. So, while rights have been one of the most discussed forms of change, they are never merely rights but always also a plethora of values, identities, and understandings.

The picture gets even more complex when we add the layers of cultural history and political economy; for the people of Las Colinas, of course, are never a passive blank slate onto which these ideas about rights and modernity are projected. Men and women interpret and transform the ideas according to preexisting cultural norms, political-economic contexts, aspirations, and strategic considerations. This is the process of vernacularization, which in Las Colinas is shaped by three particularly important forces: hegemonic norms of gender and sexuality (and their rootedness in *lo natural*), rural political economy and people's desire for autonomy, and people's conflicted aspirations for modernity amid a moral economy of development.

Chapters 2 and 3 demonstrated that we cannot ignore the deeply entrenched understandings of masculinity and femininity that continue to influence how men and women understand the messaging that comes with women's empowerment and gender violence campaigns. In fact, many gender violence campaigns actually reinforce tropes of naturalized masculine violence and aggression by focusing on *visible violences* (those that are physical and most extreme), even as they purport to denaturalize the links between masculinity and violence. The positive impact is that women and men are less likely to accept extreme violence, but they simultaneously come to view less extreme forms of violence as less problematic or less actionable. This is only exacerbated in a context in which there has been virtually no room for imagining what today's men should and could be, when all cultural-historical precedent for Manabas has firmly linked a man's dignity with his ability to control and tame the natural elements through his will, strength, and sometimes violence. If not through displays of physical prowess, strength, and virility, how do men in Las Colinas today understand themselves as men? While the inability to imagine alternatives may in some cases be due to disinterest, or an unwillingness to cede control, many young men in Las Colinas, like Rafael, are actively seeking answers, only to come up short, imagining instead that they are deficient and unworthy of partners and families.

For women, these campaigns exacerbate burdens, even as they open up aspirations for change. The *feminization of responsibility* for poverty, development, and violence against women is not new, but in Las Colinas, we see it in its complexity, as it becomes entangled with preexisting understandings of the natural state of women as the selfless sufferers who, in order to be good women, must subjugate their needs to those of their family. This, paired with the continued lack of economic supports for Las Colinas women outside of marriage, deeply complicates women's efforts to address and mitigate violence in their households. In her incisive critique of the feminization of poverty in the human rights agenda, Sylvia Chant (2016) aptly notes,

> Part of the human rights agenda is the ability to make choices, but despite the ambitious and inspiring rhetoric embedded in contemporary forward-looking flagship policy documents such as that by UN Women (2015) and their catchy call for "Planet 50:50 by 2030: Step it up for gender equality" given the partial and remedial thrust of on-the-ground interventions thus far, it would appear that

women and girls are not being empowered to make any choices other than those which tie them ever more inextricably to serving others (16).

Broader community concerns about retaining political autonomy further shape the ways in which rights ideas and practices are getting taken up and implemented. The book's final chapter speaks to how Las Colinas's inhabitants had become increasingly aware of how they could perform both "under-developed rurality" and "progressive modernity" to attract the interest of international NGOs and tourists in order to retain some regional independence. Community-level political autonomy is historically interwoven with masculinist notions of freedom and independence, both collective and individual. We saw this in the meeting about the prospective brothel; men in the brothel meeting essentially argued that they need to protect and appease masculine hypersexuality in order to become more governable in a truly "modern" sense.

VERNACULARIZATION: REMAKING RIGHTS FOR A PLURAL WORLD

Given the complex historical, political, and cultural landscape, it is no surprise that women's human rights discourses and practices are understood and refracted in diverse and complicated ways. Precisely because human rights are not, and have never been, a uniform wave of light projected onto a blank screen, the complications of vernacularization are not the end of the story; they are the beginning of the next story, which I want to start to outline here. How can we use vernacularization and ethnographic complexity to envision pluralist and locally adapted discourses and practices of human rights?

As a first step, I think we may need to open intellectual space for pluralism. Human rights campaigners have typically seen the rights themselves as a finished product that is limited to perfect universal diffusion and implementation (Goodale 2021, 4). However, universal diffusion is only possible if human rights live in a closed system confined to policy documents. In the real world, human rights do not merely need to be better translated to local contexts; even more essentially than that, they exist in a state of becoming (Goodale 2021, 4). They are only meaningful because they are taken up by people in distinct locales in ways that resonate and are meaningful to them. Recognizing that variability and pluralism is the fundamental nature of rights lends a different meaning to vernacularization and allows us to use it for a different purpose. As Goodale (2021) writes, the concept of vernacularization becomes useful not only as an analytical tool for understanding how human rights develop new meanings in the field but also, and more importantly, as a compendium of diverse understandings that "help us radically reimagine the grounds of human rights theory itself" (4).

A debate among scholars illustrates how vernacularization is not merely a concept but could also serve as a tool. In their project on the spread of women's

human rights, Sally Merry and Peggy Levitt (2017) interrogate "the processes of travel and vernacularization of women's human rights ideas and practices" paying special attention to four locations: Beijing, China; Baroda, India; Lima, Peru; and New York City, United States. With various collaborators, Merry compares NGOs working on women's human rights at each site "to see how they translated these global concepts into local terms" and asked what women's human rights look like in the day-to-day work of these organizations (Merry and Levitt 2017, 445). They pay explicit attention to the "middle-men," the staff members of these organizations who are doing the most active translational work, helping the ideas of human rights "connect with a locality" so "they take on some of the ideological and social attributes of the place, but also retain some of their original formulation" (446). The concept of vernacularization is more than mere localization or one-way translation from global to local. On the one hand, the "women's rights" that are being translated into local contexts by multiple intermediaries are themselves diverse and plural, even if they appear "fixed" or universal due to their instantiation in legal and policy documents. On the other hand, translation itself "is not replicative but profoundly generative" (Gal et al. 2015, 613). Thus, it would be a mistake to "lament mistranslation" as if accuracy could or should be the goal of vernacularization; instead, we should expect and analyze "the active, performative work of translation across interactions and social locations" (Gal et al. 2015, 610). Merry addresses this danger and acknowledges the ways that these translational practices do performative work as they draw on and resignify the attendant "global values packages" that accompany women's human rights in different fora, "including ones that embrace individuality, modernity and Westernization, and others that encompass religious fundamentalism" (Merry and Levitt 2017, 445). As I have argued here, we cannot make sense of the vernacularization of women's human rights in Las Colinas without acknowledging how they fit into and even help re-signify a larger bundle of values and moral concerns, such as regional political autonomy and ideas about relational kinship, or what it means to be good men or women, and husbands or wives.

A second step, then, is learning to read vernacularizations for their implicit understandings of rights. The holding paradoxes that I encountered in Las Colinas are a guide to this. Because my research unfolded over nearly two decades, it unearthed many contradictions in men's and women's words and actions. Thinking of these contradictory postures as "holding paradoxes of human rights" has helped me recognize these expressions not as confusion, weakness, or inconsistency, but as incommensurability. These contradictions point to places where the aspirations of global human rights are in tension with local rights aspirations and/or local political-economic and social realities. So, when a woman like Marta tells me at one moment that she will never reconcile with a husband who beat her, and at another negates this sentiment by either desiring or acting towards reconciliation, this inconsistency is pragmatically telling. It is not aberrant feminism, nor is it a bastardization of women's rights. From everything I have seen, she desires change, and she

is not merely traumatized into perpetuating a psychological cycle of violence (though I do not mean to discount her trauma). This contradictory posture speaks to the gaps that exist between the "aspirant feminism" she desires, what she perceives as the global feminist ideal, and what she is presently capable of, as she calculates what is at stake (Rubin and Sokoloff-Rubin 2013; E. Moore 2016).

If this is true, then holding paradoxes helps us "reimagine the grounds of human rights" by pointing to two sources of alternative rights visions: the local pragmatics that define achievability and local notions of rights that define aspirations. Let me provide one example from my research. As I have shown, women struggled tremendously with the question of whether and how to escape from violent relationships, even when they knew that ending a relationship was the only way they would ever escape violence. The decision was challenging because of the practical constraints on surviving independently, but also because independence conflicted with their own notions of what was right, good, and even natural. If we resist the urge to treat their aversion to autonomy as a problem—the result of trauma, or a mere accommodation to limitations, or a conservative bastardization of feminism—then we can start to ask what they are actually expressing through their aversion. Part of what women were expressing was a belief that rights should in fact be reconceptualized to protect women as relational beings, not as autonomous ones. Relationality with intimate partners, families, and communities (all of which were interrelated, as they learned when leaving intimate partners) was the source of their dignity. It was the source of critical social and material supports. It was who they imagined themselves as being, at their core. Rights simply could not be right if they had to sacrifice this cornerstone of their personhood.

The next challenge, after learning to read these holding paradoxes for the alternative imaginings of rights they offer, is to learn to facilitate community processes for putting those new visions of rights into practice. This is something that neither I, nor any other scholar or activist I know, has yet done, but it may represent the next era of human rights, in which we move from a global rights framework to a more pluralistic and dialogical one. Though even in that landscape we will need to retain our critical optimism, for rights will always be an exercise in power and culture.

Global rights are ways of organizing power based on a particular set of assumptions: that human rights transcend culture, that the truth of human rights is self-evident, and that human rights reflect a conception of the person that is necessarily universal (Goodale 2009). However, this book illustrates that this simplistic model never quite holds; human rights are not simply another form of moral imperialism that displaces all preexisting moral traces by superimposing a new system of values. Rather, rights are interpreted and adapted wherever they touch down through a process of vernacularization that is based on—and that may reorganize—already-existing relations of power. Rather than being a necessary evil, these adaptations and reinterpretations may in fact be the goal for generating more appropriate, empowering, and effective systems of rights.

EPILOGUE
Gabi's Story, Part III

One February afternoon in 2009, I went on a bike ride to decompress after a day of struggling with my dissertation data; I had returned from the field a few months earlier. When I took a water break, I noticed I had missed a number of phone calls from Ecuador. One missed call would have been of no great concern, but ten was another story. Unfortunately, successive phone calls from there often meant something bad had happened, so I panicked a little. When I finally got through to Doña Mercedes, I learned that Gabi was in the hospital. She had attempted suicide by drinking pesticides. I was shocked, saddened, angry, and eventually, hysterical.

Her sister called to tell me that the hospital staff was not taking her case seriously despite the fact that she was in critical condition because "they don't think she deserves help since she did this to herself." They tried to pump her stomach, but it was not enough. I then called the health center in Agua Dulce and asked the doctor on staff if he would be willing to take the ninety-minute trip to Quinindé to help her. He was definitely willing, but there were no more trucks going out that day; he agreed to leave first thing in the morning on the 7 o'clock ranchera. At 2 o'clock in the morning, however, I got a frantic call. Gabi's condition had been worsening, and her brother and sister decided to transport her to a better hospital in a bigger city just before dawn. She died en route.

When I returned to Ecuador a few weeks later, I was able to piece together the final months of Gabi's story. Ever since her mother's death in August 2008, Gabi had gone back and forth between different sisters' homes. Her sisters felt Gabi should be starting her own family, but she simply wasn't interested. While it might be easy for readers in the United States to understand why she would avoid marriage and relationships, it was much more difficult for these women to understand, for all the reasons I've laid out in this book. I still do not know why Gabi was so different, but she had a particularly irrepressible image of what life could be like if she resolved to fight for her dignity and self-respect.

According to her siblings, she had been quite depressed since her mother's passing. She repeatedly talked about returning to high school, or going to beauty

school, but she never enrolled because she didn't have a regular source of income. When her mother was ill, all the family's income went to medical treatments, and when her mother passed away, none of Gabi's siblings was willing to support her education. She ended up working short-term day jobs and helped care for her sisters' children. She felt she was a burden to her siblings and their families, and she didn't see a way forward for herself. The last time I spoke with Gabi she mentioned wanting "something more, more from life—but I don't know how to get it or, or I guess I don't even know what it is."

Just before her death, Gabi was staying with her sister Laura and her husband José. José had hit Laura more than once, and Gabi often protested and broke up the fights. Laura later recounted that the fights made Gabi extremely upset; she once yelled at Laura that it had to stop, insisting that she could not bear to witness another sister die at the hands of her husband. While telling me the story, Laura brushed this off, stating that Gabi was just being dramatic. After that one incident, Gabi and her sister exchanged harsh words, and Gabi said something about nobody wanting her around anymore. Then she snuck off, and apparently sought out a bottle of pesticides in the storehouse of the hacienda where Laura and José worked as caretakers.

Just hours after Gabi's funeral in Agua Dulce, I was told that the village was abuzz with "the story" of what led to her suicide. Rumors flew about the fight between the sisters, and the way in which Gabi had got in the middle of the fight between Laura and José. However, the story that emerged was somewhat different than the version that I had heard (and that I knew to be true). According to the rumors, it was Gabi herself that had caused the fight between Laura and José. She was having an affair with him, having tempted him, and he had fallen in love with her. When Laura found out, she insisted that Gabi leave and never come back. And so she left, never to return, or so the story went.

But this story, and its silences, only confirmed what people in Las Colinas already knew—that violence is everywhere, and that male violence is unremarkable, as is masculine infidelity. Female sexuality is to blame, reproducing familiar patterns of impunity along gendered lines. The telling of this familiar rumor was itself an act of erasure. It silenced what Gabi had come to feel—that she could no longer tolerate violence—and in so doing, foreclosed the possibility that a young woman like Gabi might choose a different life.

It is hard to tell if circumstances would be different for Gabi now, more than ten years later. Had she lived, she might have found more openings for education, employment, and an independent life. Though of course I will never know, I still doubt that Gabi would have pursued the well-worn path of marrying and having a child if it would imply enduring some forms of gender violence. Even if it appears that women are less likely to suffer or put up with severe violence, my knowledge of Gabi suggests that she would have staunchly refused to accept any gendered assault on her dignity, regardless of its severity, visibility, or public ramifications. For this reason, this book has been written for Gabi, in honor of her struggle to create hope and dignity amid traumatic violence.

ACKNOWLEDGMENTS

This book started twenty-odd years ago, when I was in my twenties having recently graduated from college. As such, it documents not only changes in Ecuadorian families and their understandings of human rights over this long period of time but also the ways I have changed—personally, politically, and intellectually—as a result of this work and the relationships central to it.

My name is on this book's cover, but so are the faces of strong, resilient women from coastal Ecuador. It was important to the women of this region that they be represented, to convey their central role in shaping and filling the pages of this ethnography. To protect research participants' anonymity, however, the specific women on the cover are not featured in this book. This book is dedicated to Gabi, and all the other women and families fighting for a more just future for themselves, for women, and for disenfranchised campesinas and campesinos across the world.

In writing this book, I struggled to balance the immediacy of experience with the distancing of theoretical analysis, while always being conscious of the ethical-political messiness in representing violence, intimacy, and resilience in all their entanglements. I could not have finished this project were it not for the support of many people at various academic institutions, in cities and rural villages in Ecuador, in NGO and activist circles, and in my close network of friends and family. My utmost gratitude is to the women, men, and children of Las Colinas (a pseudonym) for their friendship, collaboration, and honesty at every turn. Even amid the hard stories and circumstances described in this book, we kept each other laughing. Thank you for trusting me with your stories and for always demanding more of me and this work. Any mischaracterizations or inconsistencies in this text are my fault alone. It feels remiss not to recognize certain people by name, but you know who you are, and I am deeply indebted to you.

The foundations for this work were built through conversations with mentors and colleagues at the Colorado College, the University of Arizona, Foundation Human Nature (FHN), MeHiPro Ecuador, and the Minga Foundation. Thanks to my NGO collaborators and co-conspirators from those early days, especially Edwin Aguirre, Fanny Cerda, Jason Cross, Marc Antoine Demers, Martin Eckhardt, Ed Gold, Adrián Jaramillo, Jessica Levy, Erin Lund, Lucia Palombi, and Gabriela Ordoñez, for the enriching and challenging conversations about community-driven development, the politics of which shape the state—NGO—community relations characterized in this book. This ethnography grew out of both my MA and PhD research at the University of Arizona. As such, I am especially grateful to my primary advisor, Linda Green, for pushing me to prod the silences and the gaps continually reproduced through violence, and for encouraging

me to take care of myself in the process. Mark Nichter also kept me grounded, providing generous guidance at every step of my graduate career, and inspiring me to consider how development, health, and policy institutions shaped family health and community politics in Las Colinas. PhD committee members and mentors Laura Briggs, Sally Merry, and Martha Few further challenged me to more deeply situate my work in transnational and historical context. I thank all these mentors for their insights on earlier versions of this work. I genuinely enjoyed being a graduate student at The School of Anthropology at the University of Arizona and I will forever sing the praises of this program, its faculty, and its students. I benefited from many conversations and critical feedback from co-dissertators, friends, and colleagues at various stages, including Wendy Vogt, Heide Castañeda, Brian Burke, Laura Eichelberger, Micah Boyer, Lauren Penney, Nick Rattray, Lauren Carruth, Jenn Thompson, Kay Orzech, Marie Sardier, Andrew Gardner, and Tara Deubel. My other family of historians and social scientists of Latin America helped lighten the load and ground me in interdisciplinary perspectives. Thanks especially to Amanda López, Ryan Alexander, Adam Schwartz, Cory Schott, Michael Matthews, for filling my house with laughter.

I am also indebted to my gender-based violence (SfAA GBV-TIG) colleagues, Jennifer Wies, Hillary Haldane, Lynn Kwiatkowski, Melissa Beske, Jan Brunson, April Petillo, Sameena Mulla, Louise Lamphere, Gabriela Torres, and my college mentor, Sarah Hautzinger, for engaging deeply with my work and providing rich commentary over many years of conferences and collaborations. Readers of various chapters, including Silvana Tapia Tapia, Jennifer Wies, Carmen Dueñas Anhalzer, Karen Hébert, Maylei Blackwell, Susan McKinnon, Michael Brown, Nicole Taylor, Brian Burke, Simone Caron, Kristina Gupta, Amanda Gengler, Adam Kadlac, and WFU students Jordan Buzzett and Adriana Cordova provided crucial insights as I worked through this manuscript. Scholars and activists on gender, rights, and coastal Ecuador, including Tatiana Hidrovo, Carmen Dueñas Anhalzer, Nelly Jacomé, Gloria Camacho, Mercedes Prieto, and Gioconda Herrera, as well as many of the lawyers and staff at shelters, NGOs, archives, and government ministries, patiently answered my persistent queries and helped guide my research. Many thanks to Kimberly Guinta at Rutgers University Press and the anonymous reviewers of this book for the rich insights at the final stage of this project. I am deeply humbled by this opportunity.

In Ecuador, I received institutional support from Fundación MeHiPro and FLACSO-Ecuador (Institute for Social Sciences in Latin America). Over the years, my research has undergone ethical review and been granted permissions by the Human Subjects Protection Program and Institutional Review Boards at the University of Arizona and Wake Forest University, as well as the Ecuadorian Ministry of Health, the Ecuadorian Ministry of the Environment, and the health committee and town council at my field site. I also thank local community organizations for their collaboration and support of my project.

Research for this book was graciously funded at different stages by the National Science Foundation, the Wenner-Gren Foundation, the Anthropology Department at the University of Arizona, SBSRI at the University of Arizona, the Tinker Foundation, the Janet Upjohn Stearns Foundation, WFU Office of the Provost. The following sources of institutional and financial support were crucial for my writing and completion of this book: a PEO Women's Scholars Award, the Harry Frank Guggenheim Foundation Dissertation Fellowship, Wake Forest University (WFU) Humanities Institute, WFU Anthropology Department, and WFU Office of the Provost, and the 2015 Campbell Fellowship for Transformative Research on Women in the Developing World from the School for Advanced Research in Santa Fe, New Mexico. Without this generous support, this book would not have been written. From 2014 to 2016, the Feminist Review Trust (UK) awarded funding for a project entitled, "A Multipronged Approach to Combatting Intimate Partner Violence in Rural Coastal Ecuador," which allowed me to implement a sequence of micro-economic, educational, and family health initiatives in the region, which also form part of the analysis contained herein. Without this support, this book would not have been written. An early version of chapter 5 was published as "The 'SONY NIGHTCLUB': Rural Brothels, Gender Violence, and Development in Coastal Ecuador," in *Ethnos* 79, no. 5 (2015): 650–676. Some material from chapters 2 and 3 appears in a book chapter, "Gender Violence, Social Change, and Applied Anthropology in Coastal Ecuador," *Applying Anthropology to Gender-Based Violence: Global Responses, Local Practices*, edited by Jennifer R. Wies and Hillary H. Haldane and published by Lexington Books in 2015. Material from a short section of chapter 4 appeared in a co-authored newsletter I drafted together with Adriana Córdova for the GBV column of the SfAA newsletter in 2015 (Vol. 26, No. 4).

Thank you to my mother and father for shaping how I see and relate to the world and for always supporting and honoring my decision to pursue a career in academia, even though they may not have always understood it. To all my fellow disability ME/CFS and POTS folx, thanks for becoming my community when I needed one most, and thanks to the friends and family who stepped in to help as I navigated health challenges that have made this book's completion all the more momentous. Thank you, Brian, for all the love, support, conversation, editing, and for modeling alternative masculinities so well. To Brian and Nico, you make it all worth it. I could not have done this without you. Nico Riley, you rock my world, and you know it. I love you.

NOTES

INTRODUCTION

1. Quite literally, people live in an "out-of-the-way" biological reserve, a region the state has designated as a protected area solely for the reproduction of plants and animals, not humans, as land titling and settling were forbidden once the reserve was declared (Tsing 1993).

2. For historical evidence of this pattern in peasant communities worldwide, see Scott 1976; Wolf 1969.

3. Particular terminology shapes how different forms of violence are categorized, experienced, and targeted. In this book, I use multiple terms, including gender violence, intimate partner violence (IPV), and violence against women (VAW). Most often, I use the term gender violence to signal the importance of an anthropological perspective that demands that we understand (1) how violence plays out in particular historical contexts, (2) how it is intertwined with structural forms of violence, and (3) how both men and women are involved in and affected by violence as perpetrators, survivors, and victims. While gender violence is a broader term that refers to "violence whose meaning depends on the gendered identities of the parties," I use IPV when speaking of instances of violence between intimate partners, whether or not they are formally married (Merry 2009, 3). For all intents and purposes, IPV is synonymous with colloquial understandings of the term *domestic violence* and is one of many manifestations of gender violence. At times, I will use the phrase "violence against women" (VAW) or "violence against women and girls" (VAWG) when specifically discussing policies, campaigns or reports from the fields of international development, human rights, and law, as this is the most common term used in that literature.

4. Said differently, I am less concerned with the ways that ideas of human rights are initially produced in activist and policy settings, or the ways they are communicated via international and national campaigns, although these are both important aspects of the global phenomenon of human rights. Readers interested in critical analyses of the production of human rights may wish to consult Sally Merry's *Human Rights and Gender Violence: Translating International Law into Local Justice* (2006) or Saida Hodzic's *The Twilight of Cutting: African Activism and Life After NGOs* (2016).

5. Furthermore, 32.7 percent of women surveyed reported one or more incidents of sexual abuse, 56.9 percent psychological abuse, 35.4 percent physical abuse, and 16.4 percent patrimonial abuse (INEC 2011).

6. He may have been resentful for multiple reasons—he was closely connected to the staff member whose job was in question, and Diana became president after "gender-sensitive" mandates from *La Fundación*—but he chose to channel his anger into undermining her authority as a woman.

7. In the 2000s, *comisarias* were specialized centers to process complaints of violence against women and provide legal, psychological, and social services. They offered protective measures (called *medidas de amparo*) such as: ordering a violent spouse to leave the home; preventing the aggressor from approaching the victim; and awarding the care of minor children to the best qualified person. The city of Quinindé did not have a special commissary devoted to violence against women, but during the 2000s, the Police Commissary of Quinindé processed cases of family violence that were considered less than a misdemeanor. I assisted the Commissary for a couple of weeks to learn about her process of adjudicating cases. Since this time, many of the services provided by the *comisarias* have now transferred to specialized courts for women and

the family, as well as the Prosecutor's Office (*La Fiscalía*), depending on the offense. For more information, see Silvana Tapia Tapia and Kate Bedford, "Specialised (in)Security: Violence against Women, Criminal Courts, and the Gendered Presence of the State in Ecuador," *Latin American Law Review* 7 (2021), 21–42 and Silvana Tapia Tapia, *Feminism, Violence Against Women, and Law Reform: Decolonial Lessons from Ecuador*, Routledge (2022).

8. Ethical clearance for qualitative research on gender and violence in Ecuador was obtained through Institutional Review Boards at the University of Arizona (2002–2012; Project# 03-0316-02) and Wake Forest University (2012-present; IRB# 00021763). Research permissions in Ecuador were obtained by the Ministry of the Environment and the Ministry of Health. Some periods of research were sponsored by Fundación MeHiPro Ecuador and FLACSO Ecuador.

9. Levinson's *Family Violence in Cross-Cultural Perspective* (1989) was one of the first ethnography-based texts to place domestic violence within a universal frame of reference. In the 1990s, two volumes by Dorothy Counts, Judith Brown, and Jacquelyn Campbell on cultural perspectives of wife beating paved the way for a new field of anthropological inquiry focused exclusively on gender violence (Counts et al. 1999).

10. Anthropologists have revealed the wide-ranging effects of visible forms of violence like civil war and more invisible forms such as poverty, hunger, inequality, extralegal profiteering, and limited access to health care (Scheper-Hughes 1992; Green 1999; Scheper-Hughes 2000; Mac-Clancy 2002; Farmer 2003; Nordstrom 2004; Alcalde 2010; Tapia Tapia 2021). Medical anthropologists have used the concept of *social suffering* to describe how violence and suffering manifest within individual bodies (in the traditional biomedical sense) and in broader social and political spheres. Understanding suffering as fundamentally social counters biomedical tendencies to locate suffering—biologically defined as disease or pathology—within the individual body. Kleinman and Kleinman (1996) describe suffering as social because not only do "collective modes of experience shape individual perceptions and expressions" but also, "social interactions enter into an illness experience" (2). This understanding of the fundamentally social nature of intimate partner and gender violence is a crucial corrective to earlier scholarship that tended to examine IPV through a hyper-individualist lens, for example, by focusing only on the psychological effects on the battered woman or the power differential between two partners.

11. Structural violence, as opposed to social suffering, orients us more explicitly toward the systemic, political-economic aspects of violence. Second, it directs attention to establishing and defining complicity and thereby privileges closure and reconciliation in locally salient ways. While the specifics of complicity may not always be clearly determined (especially when it trickles down through complex authoritarian structures), centering impunity as a concept also reminds us of this oft invisible aspect of power that arises from and reinforces a highly unequal social order (Gill 2004).

12. That women's experience of development might differ from men's was largely overlooked until Ester Boserup's classic study, "Woman's Role in Economic Development" (1970), highlighted women's pivotal roles in agricultural production in Africa. To governments and the United Nations, "women were seen as wives and mothers, but not farmers," a blind spot that severely undermined the efficacy of their measurements of women's participation in the labor force (Jaquette and Staudt 2006, 24). Feminist critiques of development demonstrated instead how women's work subsidized capital accumulation (usually controlled by men) and why development agencies' institutionalized male bias should be abandoned (Mackintosh 1984; Elson 1995). Accounting for women became the cornerstone of the women-in-development (WID) approach. WID advocates argued that programs directing resources to women "would improve food production, family welfare, and women's equity—without violating cultural norms"—often based on the assumption that women were more likely to invest in children and family rather than consumer goods (Jaquette and Staudt 2006, 24). The WID approach, however, served as a mere palliative to a development paradigm that prioritized economic growth.

In fact, poverty and inequality were only increasing, and women and mothers were disproportionately shouldering the burdens of the hardship, further contributing to the feminization of poverty. Much like the microfinance project implemented in Las Colinas, many economic development projects aimed at women inadvertently contributed to a triple burden of reproductive, productive, and community work by falsely assuming that women had the free time to volunteer for development (Phillips 1987; Benería and Feldman 1992; Moser 1999; Lind 2005). One significant critique of these projects posited that women became instruments of development rather than active citizens in development.

13. Rather than narrowly focusing on reducing the negative effects of development on women, as WID had done, in the late 1980s, feminist theorists proposed a new model called Gender and Development (GAD) to more explicitly address gender power relations and account for diversity and difference among women (Moser 1999). To achieve these more ambitious goals, GAD encouraged bureaucratic restructuring within development organizations by "mainstreaming gender," calling for the integration of gender-sensitive perspectives into all projects and programs (Jaquette and Staudt 2006, 24). While GAD learned from WID's failures, in practice many programs fell into the same traps, for example, by prioritizing interventions with women over men and adopting tokenizing approaches toward women. In the last decade, research on masculinities in development has begun to fill this gap. This important work encourages incorporating men into gender activism, as well as paying greater attention to the structural factors that underpin gender inequality and help reproduce violent forms of masculinity (Cornwall et al. 2011).

CHAPTER 1 *"SOMOS DEL CAMPO"*

1. Through a friendship that has spanned eighteen years and successive interviews every few years, until the present day, I have rounded out Marta's story. I have also interviewed her husband, Felipe, on numerous occasions and thus include insight into how he views the trajectory of their relationship and the role of violence therein.

2. Due to the strengthening of social programs under President Rafael Correa, Doña Marta was able to acquire a cedula, or national identification card, despite not having a birth certificate. In addition, she was able to take an adult literacy course offered by the government in central rural villages like Agua Dulce.

3. Because of remote access and difficult living conditions, it was rare that newly arrived couples brought their parents into the region, an observation supported by the low number of elderly people in the region. Most couples were between the ages of twenty and forty years when they first arrived. Even if networks of siblings move together to the region, most families in Las Colinas have significant extended family networks in other regions of Ecuador.

4. In other contexts such as in Oaxaca, Mexico, "marriage by robbing" or *rapto* is much more violent. The young man violently carries off the woman and forces her to have sexual intercourse and to "prove" her virginity to her "boyfriend" (Howell 2004).

5. According to Deere et. al (2010), "consensual unions gained similar property rights to those of marriages in 1982 if certain conditions are met: that the union be of at least two years' duration, the relationship is stable and monogamous, and neither person is married to someone else," as reflected in *Ley 115, Ley que regula las Uniones de Hecho* in Corporación de Estudios (2001), and Articles 222 and 223 of the civil code (Ecuador 2009).

6. Couples could also opt to have a religious marriage, usually in a church, but these are on the decline among all social strata in Ecuador (presumably because of the high expense involved in the associated celebrations) (Deere et al. 2010).

7. When I asked one woman about the difference between *unión libre* and formal marriage, she contemplated and eventually replied, "Well, I can't say exactly, but it just seems like things work

better for those who are married. In marriages, the couple respects each other more. They only truly respect each other when they are really married. Like Don X and Doña Z, you never even hear rumors about them fighting or anything. We all respect them as a couple. But, of Don A and Doña B and others who are only *comprometidos*, you hear about difficulties in their households" (Interview, 2007).

8. Between 2001 and 2007, the age of marriage increased by two years for both men and women (Deere et al. 2010, 8). In contrast, the age of women at first birth has been decreasing, indicating that more children are being born in consensual unions or to single mothers. Manabí is one of the provinces where the average age of women at first birth is the lowest and where consensual unions are most common (Deere et al. 2010, 9–10, Table 6).

9. Although the law in Ecuador is consistent for marriage or consensual unions, the risk of patrimonial violence is greater for women in consensual unions. Not only are women in consensual unions less likely to know about their property rights, but also it is more challenging for them to claim assets as joint property if there is any question about when the assets were acquired, meaning that they "are more likely to be left without any community property at all" (Deere et al. 2010, 32).

10. Many women, especially in rural areas in Manabí, have very few opportunities to gain any income; for this reason, they often cannot do more than purchase a few dishes and kitchen utensils. If able, however, they will invest in farm animals, which often serve as a "bank" for women and a way for women to gain an income while married (Deere et al. 2010, 10).

11. In Ecuador, if a woman inherits land from her family, it is forever considered her individual property, even after marriage, unless otherwise stipulated through legal agreements or "*capitulaciones*." However, property that a couple acquires while they are together, regardless of whose assets were used in the acquisition, becomes communal or joint property (Deere et al. 2010).

12. When registering major assets, if a man shows his identification and he is not married legally (only by common law), his national identification card reads "single" instead of "married" and thus the asset is likely to be registered solely in his name. Of all provinces in Ecuador, this identification practice was most common in Manabí (Deere et al. 2010, 14).

13. Feminist economists, sociologists, and anthropologists now emphasize that it is important to examine status differences, or how women's access to resources compares to their partners' access. The 2010 Ecuador Household Asset Survey (EAFF) shows that a "women's share of couple wealth is significantly associated with lower odds of physical violence in Ecuador" and "the association between women's share of couple wealth and IPV is contingent on the household's position in the wealth distribution" (Oduro et al. 2015, 1).

14. From 2007 to 2014, approximately 61.3 percent of rural women (above age fifteen) in Ecuador engaged in agricultural activity, compared with 15.2 percent in small business and 8.1 percent in manufacturing (CEPAL 2017).

15. In Las Colinas, as elsewhere in the world, life in the countryside has undergone major transformations as rural households must devote more of their time and capital to selling their goods at market. In more academic terms, rural men and women have been challenged by the transformation of peasant economic systems that prioritized subsistence into capitalist modes of production. The effects of these transitions on rural women's livelihoods have been well documented, showing in particular how women have lost access to the means of production and to productive decision-making in the process (Boserup 1970; Benería and Sen 1981; Deere and León 1987; Hamilton 1998).

CHAPTER 2 "SOMOS ASÍ POR NATURALEZA"

1. In remote areas like Las Colinas, trucks are often used as buses, especially in areas where buses might get stuck. *Rancheras* (or *chivas*, as they are known in other parts of Ecuador) are

large, flatbed trucks retrofitted with a tin roof, open wooden sides, and uncomfortable rows of wooden-plank seats.

2. Decades of feminist analyses have helped uncover the ways men and women are socialized into performing gender and reproducing gendered inequality through those performances. At different points, the field has emphasized the role of biological differences (including genitalia and physical strength) (see Brownmiller 1975), political-economy (ranging from hunter-gatherer to capitalist societies), and social construction (Messerschmidt 2018) in establishing and perpetuating unequal gender relations. Anthropological analyses of gender emphasize how masculinities and femininities are constructed through performance, how they develop in relation to one another, and how they intersect with other forms of identity such as class, race, and ethnicity (Merry 2009). Although anthropologists and feminist scholars have long prioritized constructivist views of gender that challenge the essentializing of sex, gender, and sexuality, in local Las Colinas understandings, sexuality and gender are presumed to be deeply biological.

3. See Fuller (2012) for a longer theoretical discussion about the foundation of gender binaries and oppositions, as well as complementarity, in naturalized understandings of the male and female bodies, drawing from the seminal work of Bourdieu (1998) and Laqueur (1990).

4. *Mi Recinto* is a satirical comedy show set in an ambiguous rural location in coastal Ecuador that pokes fun at rural *campesinos* and provides humorous commentary on politics and societal injustice. According to León Franco (2008), "the show's characters come from various classes and, together, they are perceived to represent local *montubio* culture through humorous stereotyped representations of race, class and gender" (Translated by author, 7). The show was initially launched as *Pura Paja* and disseminated by TC Televisión, Ecuador (León Franco 2008).

5. According to Gomez (2012), the 1930s in coastal Ecuador was marked by multiple sociopolitical tragedies and disappointments, such as "massacres of workers, the unfulfilled promises of a hopeful revolution, major pandemics and sanitation catastrophes (i.e., bubonic plague amidst precarious settlements) and the economic crisis as a result of financial speculation and the drop in cocoa exports" (9–10). The machete is agentive in this multivocal literature, subsuming the role of politicized figures, as there is "no complaint because the evils are known and there is no protest . . . there are no narrators or indignant characters, there are no critical positions or positions taken. Only the construction of a violent text that reproduces from its surface formality the social violence that floods Ecuadorian society" (Translation by author; Gómez 2012, 9–10).

6. Many of these ideas about masculinity are in fact rooted in the image of the revolutionary *alfarista* (or *montonero*, a supporter of Eloy Alfaro). According to historian Tatiana Hidrovo (2003; personal conversation, 2008), bandits, who she argues are figures derivative of the revolutionary alfarista-montonero, appear throughout Manabí in the mid-1900s, to resist and complicate the state modernizing project which was aggressively imposed on "traditional or pre-modern" populations in Ecuador. This has contributed strong support to the myth of the *montubio macho* as a hero who resisted brutal repression by the state (Hidrovo Quiñonez 2003; de La Cuadra 1996 [1937]). Later, with the dearth of cultivable land in Manabí in the 1960s through early 1980s, many Manabita *campesinos* set out to find pure *montaña* yet again, which many found in Las Colinas. But in this new setting, as I show, their opportunities for land ownership were thwarted and their opportunities to survive were further circumscribed by the state, so Las Colinas inhabitants continue to restrategize their position vis-à-vis state, while maintaining their posture of combative or "contestatory logic" (Hidrovo Quiñonez 2003).

7. For example, "experience teaches us that, in love, a woman is a cat and a man, a simple mouse" ("*la experiencia nos enseña; que en las cosas del amor; la mujer es una gata; y el hombre simple ratón*" (Ordóñez Iturralde 2014, 17).

8. "A woman in love; is just like a chicken; if her old rooster is missing; any old chicken can rule her" ("*La mujer en el amor; es igual a la gallina; si le falta el gallo viejo; cualquier pollo la domina*" [Ordónez Iturralde 2014, 27]).

9. Much of the data on the topic of parent-child communication about sex and sexuality is drawn from research carried out with an undergraduate student, Adriana Cordova, in 2015 and 2016.

10. As Rafael described, "Today, though, they talk about this more in the high schools, especially since the year 2000 [when the health center opened]. They probably do it more in the cities, too, but generally it wasn't talked about here in the *campo* [countryside]" (2016).

11. Connell (2005 [1995]) also developed a corresponding concept of "emphasized femininity," that is, "compliance with this subordination" and "oriented to accommodating the interests and desires of men" (183). The concept emphasized how this form of femininity upheld both hegemonic masculinity and hierarchical (or patriarchal) gender relations more broadly. Emphasized femininity is therefore subordinate to hegemonic masculinity and allows for its reproduction without challenge. In the years since, R. W. Connell has admitted that there was too much emphasis on compliance and not enough on the ways that femininities could also resist gender hegemony (Connell and Messerschmidt 2005).

CHAPTER 3 "¿POR QUÉ ME MALTRATE ASÍ?"

1. The bulk of this research was conducted when all open and known partnerships were heterosexual. In fact, during the 2000s and early 2010s, gay, lesbian or queer relationships were largely ridiculed and unaccepted in Las Colinas. Since 2016 (after the bulk of my interviews were conducted), this has changed, quite dramatically, presumably because of the influence of a charismatic queer trans hairdresser who opened a salon in Agua Dulce for a couple of years. Today, many teens in the village openly self-identify as lesbian, gay, bisexual, transgender, and queer, and many (though not all) of their parents are supportive. This shift will serve as the subject of a future publication.

2. In addition, the continuum groups all women together as a homogenous whole without accounting for how class, race, disability, sexual orientation, or citizenship status intersects with women's identities and experiences, rendering some women even more vulnerable than others (Collins 1988; Crenshaw 1991; Speed 2014).

3. Violence during pregnancy appeared commonplace in Las Colinas, but whenever I asked whether the incidence seemed greater during pregnancy, women gave contradictory and unconfident answers. In most situations, women talked about how the violence was more hurtful because they were pregnant, but they never explicitly connected the reason for the violence with pregnancy, other than a couple of comments about stress over household finances. For example, Ana explained to me that she had been pregnant twelve times but had only six living children and five miscarriages. When I asked her why she thought she had had so many miscarriages, she replied, "Well, one time I fell off a horse. Some people say [miscarriages] can happen when it gets cold here. But I don't know. I was always working so hard, harvesting rice and corn, carrying tanks of water from the river. Maybe that is why." I then asked her if she took greater care in the final months of pregnancy, and she quickly retorted, "Oh no, not until the end. I had to work. Who else is there to do these tasks? Plus, my husband would get *bravo* (angry) if I didn't work. He wouldn't let me rest, are you kidding?"

4. I first interviewed Teresa in 2003, but we have remained in touch since. At the time, she had been married for thirty-four years, having gotten married at the age of sixteen. She, like most others in the region, is originally from a small rural village in the neighboring province of Manabí.

5. Though it may appear that women are resigning themselves to live their lives as victims of abuse, they actively harbor hope and optimism that things will improve with time. Older women (above the age of thirty-five, in most cases) reported that violence had in fact decreased in their households over time. The reasons women offered to explain this trend were varied, but

most emphasized either that their husbands' characters grew less aggressive with age, or that they had grown used to one another and to living as a couple. Many women also prided themselves on being able to deal with their husband's anger (for example, when to abandon a sensitive topic or to leave their husbands alone and let them regain a sense of calm), and they recognized this as part of being a strong and smart woman.

6. In Plesset's (2006) work on gender and violence in Parma, Italy, the way women talk about enduring violence (in Italian, "*subire violencia*") is instructive in its ambiguity in two ways: first, the expression refers both to experiencing violence and "putting up with it" at the same time. Second, it can refer to sexual, psychological, and/or physical violence; the distinctions between these kinds of violence is often irrelevant (Plesset 2006, 222).

7. I have conducted successive interviews with Paola over a fifteen-year period, beginning in 2004. Most of her story, as shared in this chapter, came from interviews and conversations in 2008 and 2015–2016. In 2021, she had once again separated from her husband, but most believed their separation would be short-lived.

8. For Bourdieu it includes "the ideologies, words, nonverbal behaviors or communications that express stereotypes, hegemonies and create humiliation or stigma" (Bhattacharyya 2018). For example, Montesanti and Thurston (2015) explain that "symbolic violence is manifested in how gender roles are discussed, portrayed, or rewarded and reinforces gender expectations, legitimizing acts of domination toward women. Women internalize their gender roles, referring to what Bourdieu calls "the habitus." The distinctiveness of symbolic violence lies exactly in the fact that ideologies, dominant discourse, language and words that subordinate and marginalize women are seen as part of "the social order of things" (3). People learn these taken-for-granted norms about gender, like those we saw in chapters 1 and 2, through social institutions such as the family, religion, education, the government (Bourdieu and Passeron 1977; Montesanti and Thurston 2015).

9. In their work on violence in rural Ecuador, Boira et al. (2015) also identify multiple paradoxical claims and ambivalent contradictions in women's speech about interpersonal violence. When they asked focus group participants if they knew of any recent cases of interpersonal violence in their community, a woman responded, "I have never heard anything like that here, I've heard about it in other places, like X and Y (nearby communities), I mean sure, we've heard of these things happening, but I'm not sure we've lived or experienced [here] what we've heard [there]." Later, the same woman spoke of specific experiences she had had concerning IPV. Beyond merely a lack of trust or unwillingness to disclose, the researchers characterized this as one of many points of ambivalence in people's responses about violence, resulting in claims like, "I haven't seen any violence, I know nothing about it, but everyone knows, the entire community knows, so of course it's happening," which amounts to a way of acknowledging both its presence and invisibility, as well as its allowance and its disallowance.

CHAPTER 4 THE PRISM OF RIGHTS

1. *El pueblo* in this instance refers to the imagined community who Correa served, one which was perceived to be inclusive and nationalist (see Pugh 2018). Despite the centrality of rights discourse and inclusive messaging in Correa's Citizen's Revolution, the types of human rights actually supported by Correa's administration followed a conservative agenda and did not include, for instance, sexual and reproductive rights.

2. One example of the infusion of rights discourse in Las Colinas was the appearance of a new poster in the health center in 2014 which read: "I have the right to be treated. I have the right to know my doctor's name."

3. Recall Maria's words quoted in chapter 3: "I don't want liberty or true independence; I just want to be able to leave the house sometimes."

4. In liberal democratic traditions, women saw strength and opportunity in aligning with governments, while those in Marxist or neo-Marxist traditions tended to see the state as a site for the reproduction of existing inequality and thus struggled to isolate themselves from state-sponsored initiatives instead (Herrera 2001, 8).

5. Lind (2003) makes a similar distinction between feminists in Ecuador during the 1990s and 2000s, referring to them instead as "state-based feminists" and "autonomous feminists." Despite some overlap between them, state-based feminists tended to work "to reform and engender neoliberal state policy," while the autonomous feminists "chose to remain ideologically and/or institutionally independent of the state and the internationally funded NGOs" (Lind 2003, 187).

6. Feminist critiques of neoliberalism have adroitly demonstrated how these policies have disproportionately affected women, especially poor and indigenous women (Safa 1995; Paley 2002; Lind 2005).

7. Silvana Tapia Tapia (2021), for one, identifies multiple "empirically identified shortcomings of criminal justice, such as the inadequacy of criminal proceedings to protect violence survivors, the legal system's disregard of women's needs and motivations, the lack of social services to assist them, and the ways in which lawyers misrepresent survivors' behavior when they decide to withdraw from a criminal trial" (849). She also demonstrates how criminal law, by equating "access to justice" with "access to litigation" ultimately masks women's lack of access to urgent social services (Tapia Tapia 2021, 850).

8. UNIFEM's office in Quito serves the entire Andean region (including Bolivia, Ecuador, Peru, and Venezuela).

9. Ecuador's 1998 Constitution had also provided legal recognition to indigenous groups and Afro-Ecuadorians, women, and LGBTI groups, but solely through a "neoliberal multicultural logic" that helped to create acceptable, responsible citizens but failed to provide material support for these groups (Postero 2007; see Lind 2018, 206).

10. For example, poverty levels dropped from 37.5 percent in 2007 to 25 percent in 2014, and extreme poverty rates dropped from 17 to 8 percent. Inequality rates were reduced from 0.55 to 0.48, three times more than the regional average between 2007 and 2012 (SENPLADES 2014; World Bank 2014, cited in Lind 2018, 210).

11. According to *Economia de Ecuador* (2014), the state spent more than US$16 billion on social spending, including on its conditional cash transfer program, the *Bono de Desarrollo Humano* (Human Development Bond), which in 2013 had a budget of just over US$1 billion and through March of that year had 1,901,088 registered beneficiaries (cited in Lind 2018, 210).

12. See Lind 203–204 for a discussion of the differences in how women's contributions are conceptualized in a neoliberal versus post-neoliberal context: whereas the neoliberal mantra was "work harder" the post-neoliberal mantra is not only to "work harder" but also to "care more" (see Bedford 2009, Guchín 2010, as cited in Lind 2018).

13. This is not to say that projects for greater inclusion of queer identities is anywhere near complete, nor that the liberal human rights framework has been an entirely successful one for their inclusion. Many of the lesbian, gay, bisexual, and transgender (LGBT) groups that emerged during the past two decades have held ambivalent relationships to development, modernization, and modernity as they understand it. To begin with, the establishment of liberal human rights mechanisms and globalization has facilitated the rise of public LGBT identities and cultures, albeit in partial and fragmented ways (Lind 2010).

14. The state institutions responsible for the campaign included: Ministry of Government and Police (central coordinator); Ministries of Justice and Human Rights, Health, Education, and Economic and Social Inclusions; Council for Children and Adolescence and Transition Commission: National Council for Women and Gender Equality. The latter was responsible as a main executor, due to the knowledge and experience of CONAMU regarding the subject; on the other hand, the articulation with other ministries and institutions speaks to the complexity

of the problem of gender violence and the need for a broad, comprehensive program to transform Ecuadorian society, with an emphasis on education and security (CONAMU 2007; 2010).

15. My knowledge of the event is based on multiple recollections of the event accessed through subsequent interviews and conversations with those present.

16. In particular, the women would read out the first two articles of *Ley 103* (1995), which outlined the obligations of the State to protect the physical and mental integrity and sexual freedom of women and their family members. When discussing why reading the law was important to women in the region, they tended to highlight three reasons: the commitment of the Ecuadorian state to protect women and any abused family members; the fact that domestic violence can refer to psychological, sexual, or economic abuse, and not merely physical abuse, regardless of relationship status; and the fact that these rules are backed by international instruments, ratified by Ecuador, and thus have the force of law. The 1995 law (*Ley 103*) is no longer in force, as it was partly replaced by the 2014 Penal Code and then fully replaced by the 2018 law to eradicate violence against women.

17. See discussion of women-in-development versus gender-in-development approaches in this book's Introduction.

18. The initial workshops emphasized the development of both self-esteem and trust among participants, in conjunction with the establishment of the various bank committees (Salazar 1998). Later workshops focused on professionalization topics such as accounting, characteristics of a good salesperson, fundamental aspects of small business, public speaking, project planning, guidelines for conducting meetings, and the importance of credit (Salazar and Viteri 1998).

19. Latin American feminist scholars have convincingly demonstrated that economic restructuring has exacerbated women's burden because of women's socialized role in reproduction, their marginalized role in production, and the "targeting of poor women as volunteer contributors to the development process" (Phillips 1987; Benería and Feldman 1992; Moser 1999; Lind 2005).

20. In some ways, this campaign also exemplifies the messaging that has infused parallel campaigns, such as the more limited campaigns offered through the Ministry of Health and various judicial institutions from 2005 to 2015. According to Ecuador's National Commission of Women (CONAMU), the fundamental objective of the campaign was to transform the socially constructed stereotypes which help perpetuate inequality and injustice. More specifically, it would accomplish this goal through awareness-raising, humor, and the denaturalization of violence, by questioning and reenvisioning what it means to be a man and a woman (CONAMU 2007).

21. Article 1 of the 2007 Decree (*Decreto Numero 620*) was to "declare as a state policy a human rights approach for the eradication of gender-based violence against children, adolescents and women, which will result in a plan for the implementation of various actions and measures, including mechanisms for inter-institutional coordination at all levels of the state."

22. These included the transformation of culturally constructed gender norms, the establishment and strengthening of "El Sistema de Protección Integral," a registry, improved access to justice, and inter-institutional collaboration among the principal agencies responsible, including the Ministry of the Government and Police, the Ministry of Justice and Human Rights, the Ministry of Health, the Ministry of Education, the Ministry of Economic and Social Inclusion, Council for Children and Adolescents, and the National Council of Women, which was in the process of transitioning to National Council of Women and Gender Equality (Ecuador 2007; ONU Mujeres Ecuador et al. 2015).

23. This is evident in the action-oriented messaging in these campaigns—React! Inform Yourself! Speak! Act! Say No! Denounce him! In her analysis of the Reacciona campaign, Salcedo Vallejo (2012) notes that "this phrase encapsulates the state's call to action to its citizens: to

react is to 'reject or defend oneself from an aggression,'" which implies a current state of passivity as it pertains to machismo (translation by author). Interviewees also report that state officials specifically criticize women's lack of "empowerment" when they hesitate or fail to file *denuncias*. For example, state officials often say things like "that woman was not empowered" (la mujer no está *empoderada*) or, for things to improve, "women have to learn to become empowered and file the necessary reports" or "mujeres tienen que empoderarse y denunciar." (Interviews and personal communication, Tapia Tapia).

24. Workshop themes have been determined either by the Ministry of Health, the areas of expertise of current staff and volunteers (many of whom have been trained in public health, medicine, or anthropology), the areas of need perceived by current staff and volunteers, and the suggestions of community health workers and community members. The bulk of the workshops have been held in Las Cruces because the health center staff has been more centralized. In the early years of the health center, we had a more vibrant network of health promoters hailing from each of the remote communities and, despite the treacherous travel conditions, staff and volunteers would take week-long trips to distant communities to offer medical consultations, implement vaccination campaigns, and provide health education through dynamic and interactive workshops with community members. My analysis here is based on detailed participant observation of approximately fifty workshops over the past two decades.

25. These initiatives formed part of an applied project entitled "A Multipronged Approach to Combating Intimate-Partner Violence in Rural Coastal Ecuador," for which I received funding from the *Feminist Review Trust* in 2014. As part of this project, I helped implement workshops to improve family health and communication as well as micro-economic programs for women and educational scholarships and training for young women in the region of Las Colinas.

26. Even in my own research, I learned that I must take care to not reproduce certain norms even as I allowed local cues to guide my research. Continual references to men as machistas who beat their wives run the risk of overly associating masculinity with violence. If not addressed, this elision between masculinity and violence may result in either emasculating nonviolent men on the one hand or in making false claims that "violence no longer exists" simply because men aren't as machista (i.e., as physically abusive) as they used to be.

27. As one example, in a limited survey administered in 2008 to twenty-four women in Las Colinas, I asked whether women or men were predominantly responsible for eliminating gender violence in their households and community. Eighteen of twenty-four responded that women were mostly responsible.

CHAPTER 5 CULTIVATING MODERN SELVES

1. This chapter contains revised material from Friederic (2014b), "The 'Sony Nightclub': Rural Brothels, Gender Violence, and Development in Coastal Ecuador." *Ethnos* 79 (5): 650–676.

2. The Sony Nihgtclub (sic) was the name most commonly used in conversations for the brothel-to-be, as it was supposed to replace an illegal brothel which had Sony Nihgtclub (spelled as such) scribbled on its wooden wall in barely perceptible yellow paint. However, in the remaining text, I will use the American English spelling Sony Nightclub to avoid confusion. In this region, many business ventures that involve music and electronics added the word Sony to their names—in reference to the Japanese brand of electronics. For example, a storefront that used to sell pirated DVDs has the name Sony scribbled on its cement post and the local disc jockey, a man who happens to own the best sound system with a microphone, refers to his suite of services as the Disco Móvil Sony Music. While the word literally signifies the presence or use of quality electronics in many cases, it has also become a marker for being modern in a transnational sense.

3. For example, Stoler (2002) interrogates the connections between the management of sexuality and affective ties in colonies and the politics of colonial rule in metropoles, providing an interesting parallel with the management of sexuality through human rights–based development paradigms, as exemplified in Las Colinas (Adams and Pigg 2005).

4. Cultivatable land was becoming scarce in Manabí for a number of sociopolitical and climactic reasons. El Niño and La Niña events during the 1980s brought heavy rainfall, followed by strong droughts that negatively impacted agricultural production and discernibly augmented economic hardship on Ecuador's coast. Agrarian reform and the growth of cattle farming also contributed to the marginalization of small farmers in the region.

5. In the 1990s, both governmental and nongovernmental organizations took an interest in this area of virgin cloud forest because of its rich biodiversity, which was on the verge of destruction due to increasing colonization. In 1996, campesinos were "tricked" into signing over their land, the region was declared a national biological reserve, and they lost all formal land rights.

6. Las Colinas and the ecological reserve also comprise part of the Chocó-Darien-Western Ecuador Hotspot, one of ten ecological "hot spots" worldwide designated in 2001 by the Critical Ecosystem Partnership Fund (CEPF), a joint initiative of Conservation International, the Global Environment Facility (GEF), the Government of Japan, the MacArthur Foundation, and the World Bank. The corridor in which Las Colinas remains identified as one of the most critical and vulnerable priorities, prompting interest in sustainable development of this region by various parties.

7. As one leader said in 2010, "In the past, I just had to make sure I was good friends with the officials in the municipal government, and then they would do us favors once in a while. Like clearing the roads here, this has always been done out of the goodwill of certain leaders. But this is all changing. Now there is paperwork and bureaucracy on all levels. One can't do anything without an *oficio* (a written proposal or letter). Now one has to type things up on a computer in order to get anything done."

8. By this, she means that the region still has not gained formal legal and political status as a rural *parroquía*, or parish. It also indicates the importance of the formalized process of decentralization to the *comisaría* and the municipal administration under which she serves.

9. The women who work at brothels within the region are always women from *afuera*—the outside, or the exterior (in this case, from the cities or Colombia)—and as "foreign others," male and female community members do not pay much attention to their plight.

10. The most successful and sustained interventions have included women's and children's rights education, family planning campaigns, workshops on family violence, maternal and child health programs, and the establishment of the women' s microcredit organization. Though many of these interventions were implemented before the presidency of Rafael Correa, they have been strengthened under the Correa administration's platform of "social inclusion."

REFERENCES

Abu-Lughod, Lila. 2002. "Do Muslim Women Really Need Saving? Anthropological Reflections on Cultural Relativism and Its Others." *American Anthropologist* 104 (3): 783–790.

Adams, Vincanne, and Stacy Leigh Pigg, eds. 2005. *Sex in Development: Science, Sexuality, and Morality in Global Perspective.* Durham, NC: Duke University Press.

Adelman, Madelaine. 2017. *Battering States: The Politics of Domestic Violence in Israel.* Nashville, TN: Vanderbilt University Press.

Alcalde, M. Cristina. 2010. *The Woman in the Violence: Gender, Poverty, and Resistance in Peru.* Nashville, TN: Vanderbilt University Press.

Alvarez, Sonia E. 2000. "Translating the Global Effects of Transnational Organizing on Local Feminist Discourses and Practices in Latin America." *Meridians* 1 (1): 29–67.

Arunachalam, Raj, and Manisha Shah. 2008. "Prostitutes and Brides?" *The American Economic Review* 98 (2): 516–522.

Barres, David Macías. 2014. "Patrimonio Cultural y Lingüístico: El Montubio y El Amorfino." *Histoires de l'Amérique Latine* 10:15.

Benería, Lourdes, and Shelley Feldman. 1992. *Unequal Burden: Economic Crises, Persistent Poverty, and Women's Work.* Boulder, CO: Westview Press.

Benería, Lourdes, and Gita Sen. 1981. "Accumulation, Reproduction and Women's Role in Economic Development: Boserup Revisited." *Signs* 7 (2): 279–298.

Berlant, Lauren. 1998. "Intimacy: A Special Issue." *Critical Inquiry* 24 (2): 281–288.

Bernstein, Elizabeth. 2012. "Carceral Politics as Gender Justice? The 'Traffic in Women' and Neoliberal Circuits of Crime, Sex, and Rights." *Theory and Society* 41 (3): 233–259.

Beske, Melissa. 2016. *Intimate Partner Violence and Advocate Response: Redefining Love in Western Belize.* Lanham, MD: Lexington Books.

Bhattacharyya, Manasi, Arjun S. Bedi, and Amrita Chhachhi. 2011. "Marital Violence and Women's Employment and Property Status: Evidence from North Indian Villages." *World Development* 39 (9): 1676–1689.

Bhattacharyya, Rituparna. 2018. "Symbolic Violence and Misrecognition: Scripting Gender among Middle-Class Women, India." *Society and Culture in South Asia* 5 (1): 19–46.

Boira, Santiago, Pablo Carbajosa, and Raquel Méndez. 2015. "Miedo, Conformidad y Silencio. La Violencia en las Relaciones de Pareja en Áreas Rurales de Ecuador." *Psychosocial Intervention. Psychosocial Intervention* 25 (1): 9–17.

Boserup, Ester. 1970. *Woman's Role in Economic Development.* New York: St. Martin's Press.

Bourdieu, Pierre. 2001. *Masculine Domination.* Stanford, CA: Stanford University Press.

Bourdieu, Pierre, and Jean Claude Passeron. 1977. *Reproduction in Education, Society and Culture.* London: Sage Publications.

Bourgois, Philippe, Seth M. Holmes, Kim Sue, and James Quesada. 2017. "Structural Vulnerability: Operationalizing the Concept to Address Health Disparities in Clinical Care." *Academic Medicine* 92 (3): 299–307.

Brownmiller, Susan. 1975. *Against Our Will: Men, Women, and Rape.* New York: Simon and Schuster.

Bukh, Jette. 1979. *The Village Woman in Ghana.* Uppsala, Sweden: Scandinavian Institute of African Studies.

Bunch, Charlotte, and Roxanna Carillo. 1991. *Gender Violence: A Development and Human Rights Issue.* New Brunswick, NJ: Center for Women's Global Leadership.

Butler, Judith. 1990. *Gender Trouble: Feminism and the Subversion of Identity*. London: Routledge.

Chant, Sylvia. 2016. "Women, Girls and World Poverty: Empowerment, Equality or Essentialism?" *International Development Planning Review* 38 (1): 1–24.

Cockburn, Cynthia. 2004. "The Continuum of Violence: A Gender Perspective on War and Peace." In *Sites of Violence: Gender and Conflict Zones*, edited by W. Giles and J. Hyndman. 24–44. Berkeley: University of California Press.

Cohen, Stanley. 1972. *Folk Devils and Moral Panics: The Creation of the Mods and Rockers*. London: MacGibbon and Kee.

Coker, Donna. 2001. "Crime Control and Feminist Law Reform in Domestic Violence Law: A Critical Review." *Buffalo Criminal Law Review* 4 (2): 801–860.

Cole, S., and L. Phillips. 2008. "The Violence against Women Campaigns in Latin America New Feminist Alliances." *Feminist Criminology* 3 (2): 145–168.

Collins, Patricia Hill. 1988. "The Tie That Binds: Race, Gender, and US Violence." *Ethnic and Racial Studies* 21 (5): 917–938.

Comisión Económica para América Latina (CEPAL). 2017. *Bases de Datos y Publicaciones Estadísticas*. Santiago, Chile: United Nations Comisión Económica para América Latina. https://statistics.cepal.org/portal/cepalstat/index.html?lang=es (accessed December 12, 2017).

CONAMU. 2007. *Plan Nacional de Erradicación de la Violencia de Género hacia Niñez Adolescencia y Mujeres*. Quito: Consejo Nacional de Mujeres (CONAMU).

———. 2010. *Presentación—Rendición De Cuentas Plan Nacional De Erradicación De La Violencia de Género hacia la Niñez*. Quito: Consejo Nacional de Mujeres (CONAMU).

Connell, R. W. 2005 (1995). *Masculinities*. Berkeley: University of California Press.

Connell, R. W., and James. W. Messerschmidt. 2005. "Hegemonic Masculinity—Rethinking the Concept." *Gender & Society* 19 (6): 829–859.

Cornwall, Andrea, Sonia Corrêa, and Susie Jolly. 2008. *Development with a Body: Sexuality, Human Rights and Development*. London: Zed Books.

Cornwall, Andrea, Jerker Edström, and Alan Greig. 2011. *Men and Development: Politicizing Masculinities*. London: Zed Books.

Cornwall, Andrea, and Nancy Lindisfarne. 1994. *Dislocating Masculinity: Comparative Ethnographies, Male Orders*. London: Routledge.

Coronel Valencia, Carolina Valeria. 2014. Representación Audiovisual del Machismo en la Campaña. "Reacciona Ecuador; El Machismo es Violencia": Análisis de las Prácticas Culturales Machistas en los Spots Guantes de Box y Cavernícola. MA Thesis. Facultad de Comunicación Social, Universidad Central del Ecuador, Quito.

Counts, Dorothy Ayers, Judith K. Brown, and Jacquelyn C. Campbell. 1999. *To Have and to Hit: Cultural Perspectives on Wife Beating*. Chicago: University of Illinois.

Craven, Christa, and Dána-Ain Davis, eds. 2013. *Feminist Activist Ethnography*. Lanham, MD: Lexington Books.

Crenshaw, Kimberlé. 1991. "Mapping the Margins: Intersectionality, Identity Politics, and Violence against Women of Color." *Stanford Law Review* 43 (6): 1241–1299.

Das, Veena. 2008. "Violence, Gender, and Subjectivity." *Annual Review of Anthropology* 37 (1): 283–299.

Das, Veena, Arthur Kleinman, Pamela Reynolds, and Mamphela Ramphele, eds. 2000. *Violence and Subjectivity*. Berkeley: University of California Press.

Deere, Carmen Diana, Jacqueline Contreras, and Jennifer Twyman. 2010. "Property Rights and Women's Accumulation of Assets over the Life Cycle: Patrimonial Violence in Ecuador." Paper presented at the International Association for Feminist Economics (IAFFE) International Conference, Buenos Aires, Argentina, July 22–24, 2010.

Deere, Carmen Diana, and Magdalena León, eds. 1987. *Rural Women and State Policy: Feminist Perspectives on Latin American Agricultural Development*. Boulder, CO: Westview.

Deere, Carmen Diana, and Jennifer Twyman. 2012. "Asset Ownership and Egalitarian Decision Making in Dual-Headed Households in Ecuador." *Review of Radical Political Economics* 44 (3): 313–320.

Ecuador, República del. 1995. Ley contra la violencia a la mujer y la familia. http://www .ministeriodelinterior.gob.ec/dinage/ley_contra_la_violencia_a_la_mujer_y_a_la _familia.html (accessed May 25, 2013).

Ellsberg, Mary, Henrica A.F.M. Jansen, Lori Heise, Charlotte H. Watts, Claudia Garcia-Moreno. 2008. "Intimate Partner Violence and Women's Physical and Mental Health in the WHO Multi-Country Study on Women's Health and Domestic Violence: An Observational Study." *The Lancet* 371 (9619): 1165–1172.

Elson, Diane. 1995. "Gender Awareness in Modeling Structural Adjustment." *World Development* 23 (11): 1851–1868.

Escobar, Arturo. 1995. *Encountering Development: The Making and Unmaking of the Third World*. Princeton, NJ: Princeton University Press.

Escobar, Arturo, and Sonia E. Alvarez, eds. 1992. *The Making of Social Movements in Latin America: Identity, Strategy, and Democracy*. Boulder, CO: Westview Press.

Esteva, Gustavo. 1992. "Development." In *The Development Dictionary: A Guide to Knowledge as Power*, edited by W. Sachs, 2–26. London, Zed Books.

Estévez, Mayra, Edgar Vega, and Santiago Pérez. 2011. "Estudio Cualitativo De La Campaña Reacciona Ecuador, El Machismo Es Violencia." In *Cuaderno De Trabajo*, edited by E. Vega, 1–181. Quito, Ecuador: Comisión de Transición Hacia el Consejo de Las Mujeres y la Igualdad de Género.

Fadiman, Maria. 2005. "Cultivated Food Plants: Culture and Gendered Spaces of Colonists and the Chachi in Ecuador." *Journal of Latin American Geography* 4:43–57.

Farmer, Paul. 2003. *Pathologies of Power: Health, Human Rights, and the New War on the Poor*. Berkeley: University of California Press.

———. 2004. "An Anthropology of Structural Violence." *Current Anthropology* 45 (3): 305–325.

Fassin, Didier. 2013. "Why Ethnography Matters: On Anthropology and Its Publics." *Cultural Anthropology* 28 (4): 621–646.

Fernandez, Nadine T. 2010. *Revolutionizing Romance: Interracial Couples in Contemporary Cuba*. New Brunswick, NJ: Rutgers University Press.

Flake, Dallan F., and Renata Forste. 2006. "Fighting Families: Family Characteristics Associated with Domestic Violence in Five Latin American Countries." *Journal of Family Violence* 21 (1): 19.

Friedemann-Sánchez, Greta, and Rodrigo Lovatón. 2012. "Intimate Partner Violence in Colombia: Who Is at Risk?" *Social Forces* 91 (2): 663–688.

Friederic, Karin. 2011. "The Challenges of Advocacy in Anthropological Research on Intimate Partner Violence." *Practicing Anthropology* 33 (3): 27–31.

———. 2014a. "Violence against Women and the Contradictions of Rights-in-Practice in Rural Ecuador." *Latin American Perspectives* 41 (1): 19–38.

———. 2014b. "The 'SONY NIGHTCLUB': Rural Brothels, Gender Violence, and Development in Coastal Ecuador." *Ethnos* 79 (5): 650–676.

Friederic, Karin, and Brian J. Burke. 2019. "La Revolución Ciudadana and Social Medicine: Undermining Community in the State Provision of Health Care in Ecuador." *Global Public Health* 14 (6–7): 884–898.

Friederic, Karin, and Lucia Palombi. 2001. "La Vuelta De Salud (the Circle of Health): A Health Assessment." Unpublished report. Quito, Ecuador: FHN (MeHiPro).

Friederic, Karin, and Charles Roberge. 2002. "Creciendo Juntos (Growing Together): A Survey of Demographics, Health and Treatment-Seeking in Rural Ecuador." Unpublished report. Quito, Ecuador: FHN (MeHiPro).

Fuller, Norma. 2001. "She Made Me Go out of My Mind: Marital Violence from the Male Point of View." *Development* 44 (3): 25–29.

———. 2003. "The Social Constitution of Gender Identity among Peruvian Males." In *Changing Men and Masculinities in Latin America*, edited by M. C. Gutmann, 134–152. Durham, NC: Duke University Press.

Fuller, Norma J. 2012. "Rethinking the Latin-American Male-Chauvinism." *Masculinities & Social Change* 1 (2): 114–133.

Gal, Susan, Julia Kowalski, and Erin Moore. 2015. "Rethinking Translation in Feminist NGOs: Rights and Empowerment across Borders." *Social Politics: International Studies in Gender, State & Society* 22 (4): 610–635.

García-Moreno, Claudia, Christina Pallitto, Karen Devries, Heidi Stöckl, Charlotte Watts, and Naeemah Abrahams. 2013. *Global and Regional Estimates of Violence against Women: Prevalence and Health Effects of Intimate Partner Violence and Non-Partner Sexual Violence*. Geneva: World Health Organization.

Giddens, Anthony. 1992. *The Transformation of Intimacy: Sexuality, Love, and Eroticism in Modern Societies*. Stanford, CA: Stanford University Press.

Gill, Lesley. 2004. *The School of the Americas: Military Training and Political Violence in the Americas*. Durham, NC: Duke University Press.

Goldstein, Donna M. 2003. *Laughter out of Place: Race, Class, Violence, and Sexuality in a Rio Shantytown*. Berkeley: University of California Press.

Gómez, Facundo. 2012. "Ecuador Violento: Los Que Se Van y la Estética de la Machete." *La Plata*, 7, 8, y 9 de Mayo de 2012—ISSN 2250–5741. http://citclot.fahce.unlp.edu.ar/viii-congreso.

Goodale, Mark. 2007. "Introduction: Locating Rights, Envisioning Law between the Global and the Local." In *The Practice of Human Rights: Tracking Law between the Global and the Local*, edited by M. Goodale and S. Merry, xii, 384. Cambridge: Cambridge University Press.

———. 2009. *Surrendering to Utopia: An Anthropology of Human Rights*. Stanford, CA: Stanford University Press.

———. Forthcoming. "Vernacularization as Anthropological Ethics (Pre-Print)." In *Festschrift in Honor of Sally Engle Merry*, edited by P. Alston.

Green, Linda. 1999. *Fear as a Way of Life: Mayan Widows in Rural Guatemala*. New York: Columbia University Press.

Gutmann, Matthew. 1996. *The Meanings of Macho Being a Man in Mexico City*. Berkeley: University of California Press.

———. 2003. "Introduction: Discarding Manly Dichotomies in Latin America." In *Changing Men and Masculinities in Latin America*, edited by M. C. Gutmann, 1–26. Durham, NC: Duke University Press.

———. 2021. "The Animal Inside: Men and Violence." *Current Anthropology* 62: S182–S192.

Guzmán, Virginia. 2001. *La Institucionalidad de Género en el Estado: Nuevas Perspectivas ee Análisis*. CEPAL, Mujer y Desarrollo 32.

Hamilton, Sarah. 1998. *The Two-Headed Household: Gender and Rural Development in the Ecuadorean Andes*. Pittsburgh, PA: University of Pittsburgh Press.

Harcourt, Wendy. 2013. *Body Politics in Development: Critical Debates in Gender and Development*. London: Zed Books.

———. 2017. *Bodies in Resistance: Gender and Sexual Politics in the Age of Neoliberalism*. London: Palgrave Macmillan.

Hautzinger, Sarah J. 2007. *Violence in the City of Women: Police and Batterers in Bahia, Brazil*. Berkeley: University of California Press.

Heise, Lori L. 2011. *What Works to Prevent Partner Violence? An Evidence Overview*. London: STRIVE Research Consortium and the Policy Division of the UK Department for International Development.

———. 2012. "Determinants of Partner Violence in Low and Middle-Income Countries: Exploring Variation in Individual and Population-Level Risk." Doctoral Thesis, London School of Hygiene & Tropical Medicine.

Herrera, Gioconda, ed. 2001. *Antología De Estudios De Género* [Anthology of Gender Studies]. Edited by G. Herrera. Quito, Ecuador: FLACSO-Ecuador : ILDIS [Instituto Latinoamericano de Investigaciones Sociales].

Hidrovo Quiñonez, Tatiana. 2003. *Manabí Histórico: Del Conocimiento a La "Comprensión."* Portoviejo: Editorial Mar Abierto.

Hirsch, Jennifer S. 2003. *A Courtship after Marriage: Sexuality and Love in Mexican Transnational Families.* Berkeley: University of California Press.

———. 2009. "The Geography of Desire: Social Space, Sexual Projects, and the Organization of Extramarital Sex in Rural Mexico." In *The Secret: Love, Marriage, and HIV*, edited by J. S. Hirsch, H. Wardlow, D. Jordan Smith, H. M. Phinney, S. Parikh, and C. A. Nathanson, 53–83. Nashville, TN: Vanderbilt University Press.

Hirsch, Jennifer S., and Holly Wardlow. 2006. *Modern Loves: The Anthropology of Romantic Courtship & Companionate Marriage.* Ann Arbor: University of Michigan Press.

Hirsch, Jennifer S., Holly Wardlow, Daniel Jordan Smith, Harriet M. Phinney, Shanti Parikh, and Constance A. Nathanson. 2009. *The Secret: Love, Marriage, and HIV.* Nashville, TN: Vanderbilt University Press.

Hodgson, Dorothy L. 2001. *Gendered Modernities: Ethnographic Perspectives.* New York: Palgrave.

———. 2011. "Introduction: Gender and Culture at the Limit of Rights." In *Gender and Culture at the Limit of Rights*, edited by D. L. Hodgson, 1–16. Philadelphia: University of Pennsylvania Press.

Hodžić, Saida. 2009. "Unsettling Power: Domestic Violence, Gender Politics, and Struggles over Sovereignty in Ghana." *Ethnos* 74 (3): 331–360.

Howell, Jayne. 2004. "Turning Out Good Ethnography, or Talking Out of Turn?: Gender, Violence, and Confidentiality in Southeastern Mexico." *Journal of Contemporary Ethnography* 33 (3): 323–352.

ICRW. 2006. *Property Ownership and Inheritance Rights of Women for Social Protection—the South Asia Experience.* Synthesis Report of Three Studies. Washington, DC: International Center for Research on Women.

INEC. 2011. *Encuesta Nacional De Relaciones Familiares y Violencia de Genero contra las Mujeres* [National Survey of Family Relations and Violence-against-Women]. Quito, Ecuador: Instituto Nacional de Estadística y Censos (INEC).

———. 2019. Encuesta Nacional Sobre Relaciones Familiares y Violencia de Género contra las Mujeres—Envigmu. Quito, Ecuador: Instituto Nacional de Estadística y Censos (INEC).

Inhorn, Marcia Claire. 2012. *The New Arab Man: Emergent Masculinities, Technologies, and Islam in the Middle East.* Princeton, NJ: Princeton University Press.

Jaquette, Jane S., and Kathleen A. Staudt. 2006. "Women, Gender, and Development." In *Women and Gender Equity in Development Theory and Practice: Institutions, Resources, and Mobilization*, edited by J. S. Jaquette and G. Summerfield, 17–51. Durham, NC: Duke University Press.

Jelin, Elizabeth. 1997. "Engendering Human Rights." In *Gender Politics in Latin America*, edited by E. Dore, 65–83. New York: Monthly Review Press.

Jones, Gareth A., and Dennis Rodgers. 2019. "Ethnographies and/of Violence." *Ethnography* 20 (3): 297–319.

Jubb, Nadine. 2008. Mapeo regional de las comisarías de la mujer en América Latina. CEPLAES.

Kandiyoti, Deniz. 1988. "Bargaining with Patriarchy." *Gender & Society* 2 (3): 274–290.

Kelly, Patty. 2004. *Lydia's Open Door: Inside Mexico's Most Modern Brothel.* Berkeley: University of California Press.

Kleinman, Arthur, and Joan Kleinman. 1996. "The Appeal of Experience, the Dismay of Images: Cultural Appropriations of Suffering in Our Time." *Daedalus* 125 (1):1–25.

Klugman, Jeni, Lucia Hanmer, Sarah Twigg, Tazeen Hasan, Jennifer McCleary-Sills, Julieth Santamaria. 2014. *Voice and Agency: Empowering Women and Girls for Shared Prosperity*. Washington, DC: World Bank Group.

Kwiatkowski, Lynn. 2015. "Women, Embodiment, and Domestic Violence in Northern Vietnam." In *Applying Anthropology to Gender-Based Violence: Global Responses, Local Practices*, edited by J. R. Wies and H. Haldane, 15–27. Lanham, MD: Lexington Books.

———. 2018. "A 'Wife's Duty' and Social Suffering: Sexual Assault in Marital Relationships in Vietnam." *Journal of Aggression, Maltreatment & Trauma* 28 (1): 68–84.

Laqueur, Thomas Walter. 1990. *Making Sex: Body and Gender from the Greeks to Freud*. Cambridge, MA: Harvard University Press.

Larrea Holguín, Juan. 2000. Código Civil con Jurisprudencia y Legislación Conexa. Vol. 1. Quito: Corporación de Estudios y Publicaciones.

León Franco, Dayana Litz. 2008. "Imaginarios de Género en Mi Recinto: Programa de la Televisión Ecuatoriana." Thesis, Facultad Latinoamericana de Ciencias Sociales, FLACSO-Sede Ecuador.

Levinson, David. 1989. *Family Violence in Cross-Cultural Perspective*. Newbury Park, CA: Sage Publications.

Lind, Amy. 2003. "Gender and Neoliberal States: Feminists Remake the Nation in Ecuador." *Latin American Perspectives* 30 (1): 181–207.

———. 2005. *Gendered Paradoxes: Women's Movements, State Restructuring, and Global Development in Ecuador*. University Park: Pennsylvania State University Press.

———. 2018. "After Neoliberalism? Resignifying Economy, Nation, and Family in Ecuador." In *Feminists Rethink the Neoliberal State: Inequality, Exclusion, and Change*, edited by L. Fernandes, 196–220. New York: New York University Press.

Lind, Amy, and Christine Keating. 2013. "Navigating the Left Turn: Sexual Justice and the Citizen Revolution in Ecuador." *International Feminist Journal of Politics* 15 (4): 515–533.

Low, Setha M. 1985. "Culturally Interpreted Symptoms or Culture-Bound Syndromes: A Cross-Cultural Review of Nerves." *Social Science & Medicine* 21 (2): 187–196.

Lyon, Sarah, Tad Mutersbaugh, and Holly Worthen. 2017. "The Triple Burden: The Impact of Time Poverty on Women's Participation in Coffee Producer Organizational Governance in Mexico." *Agriculture and Human Values* 34 (2): 317–331.

MacClancy, Jeremy, ed. 2002. *Exotic No More: Anthropology on the Front Lines*. Chicago: University of Chicago Press.

———. 2019. "Introduction: Taking People Seriously." In *Exotic No More: Anthropology for the Contemporary World*. 2nd ed., edited by J. MacClancy, 1–17. Chicago: University of Chicago Press.

Mackintosh, Maureen. 1984. "Gender and Economics: The Sexual Division of Labour and the Subordination of Women." In *Of Marriage and the Market: Women's Subordination in International Perspective*, edited by K. Young, C. Wolkowitz, and R. McCullough. London: CSE Books.

McCullough, Megan B., Jan Brunson, and Karin Friederic. 2013. "Introduction: Intimacies and Sexualities in out-of-the-Way Places." *Ethnos* 79 (5): 577–584.

Medeiros, Melanie A. 2018. *Marriage, Divorce, and Distress in Northeast Brazil: Black Women's Perspectives on Love, Respect, and Kinship*. New Brunswick, NJ: Rutgers University Press.

Merry, Sally Engle. 1990. *Getting Justice and Getting Even: Legal Consciousness among Working-Class Americans*. Chicago: University of Chicago Press.

———. 1997. "Gender Violence and Legally Engendered Selves." *Identities* 2 (1–2): 49–73.

————. 2003. "Rights Talk and the Experience of Law: Implementing Women's Human Rights to Protection from Violence." *Human Rights Quarterly* 25 (2): 343–381.

————. 2006. "Transnational Human Rights and Local Activism: Mapping the Middle." *American Anthropologist* 108 (1): 38–51.

————. 2009a. *Gender Violence: A Cultural Perspective.* Malden, MA: Wiley-Blackwell.

————. 2009b. "Introduction." In *Gender Violence: A Cultural Perspective*, 1–24. Malden, MA: Wiley-Blackwell.

————. 2011. "Gender Justice and Cedaw: The Convention on the Elimination of All Forms of Discrimination against Women." *Hawwa* 9 (1–2): 1–2.

Merry, Sally Engle, and Peggy Levitt. 2017. "The Vernacularization of Women's Human Rights." In *Human Rights Futures*, edited by S. Hopgood, J. Snyder, and L. Vinjamuri, 213–236. Cambridge: Cambridge University Press.

Messerschmidt, James W. 2018. *Hegemonic Masculinity: Formulation, Reformulation, and Amplification.* Lanham, MD: Rowman & Littlefield.

Montesanti, S. R., and W. E. Thurston. 2015. "Mapping the Role of Structural and Interpersonal Violence in the Lives of Women: Implications for Public Health Interventions and Policy." *BMC Womens Health* 15:100.

Moore, Erin V. 2016. "Postures of Empowerment: Cultivating Aspirant Feminism in a Ugandan NGO." *ETHOS* 44 (3): 375–396.

Moore, Henrietta L. 1988. *Feminism and Anthropology.* Cambridge, UK: Polity Press in association with B. Blackwell, Oxford, UK.

Morrison, Andrew, Mary Ellsberg, and Sarah Bott. 2007. "Addressing Gender-Based Violence: A Critical Review of Interventions." In *The World Bank Research Observer*, 25–51. Vol. 22. Oxford: International Bank for Reconstruction and Development and The World Bank.

Moser, Caroline O. N. 1999. *Mainstreaming Gender and Development in the World Bank: Progress and Recommendations.* Washington, DC: World Bank.

————. 2001. "The Gendered Continuum of Violence and Conflict: An Operational Framework." In *Victims, Perpetrators or Actors?: Gender, Armed Conflict and Political Violence*, edited by C.O.N. Moser and F. C. Clark, 30–51. London: Zed Books.

Müller, Astrid. 1994. *Por Pan Y Equidad: Organizaciones De Mujeres Ecuatorianas.* Quito, Ecuador: Ediciones Abya-Yala: ILDIS: FEPP: CECLOP.

Nordstrom, Carolyn. 2004. *Shadows of War: Violence, Power, and International Profiteering in the Twenty-First Century.* Berkeley: University of California Press.

Oduro, Abena D., Carmen Diana Deere, and Zachary B. Catanzarite. 2015. "Women's Wealth and Intimate Partner Violence: Insights from Ecuador and Ghana." *Feminist Economics* 21 (2): 1–29.

Ofei-Aboagye, Rosemary Ofeibea. 1994. "Altering the Strands of the Fabric: A Preliminary Look at Domestic Violence in Ghana." *Signs* 19 (Feminism and the Law)(4): 924–938.

Ordóñez Iturralde, Wilman. 2014. *Amorfino: Canto Mayor del Montubio, Colección Yachana.* Quito, Ecuador: Casa de la Cultura Ecuatoriana Benjamín Carrión.

Ordóñez Llanos, Gabriela. 2005. "Inequities and Effective Coverage: Review of a Community Health Programme in Esmeraldas–Ecuador." MA Thesis, Public Health. Amsterdam: KIT Royal Tropical Institute.

Padilla, Mark, Jennifer S. Hirsch, Miguel Munoz-Laboy, Robert E. Sember, and Richard Guy Parker. 2007a. "Introduction: Cross-Cultural Reflections on an Intimate Intersection." In *Love and Globalization: Transformations of Intimacy in the Contemporary World*, edited by M. B. Padilla, J. S. Hirsch, M. Munoz-Laboy, R. Sember, and R. G. Parker, ix–xxxi. Nashville, TN: Vanderbilt University Press.

————. 2007b. *Love and Globalization: Transformations of Intimacy in the Contemporary World.* Nashville, TN: Vanderbilt University Press.

Paley, Julia. 2002. "Toward an Anthropology of Democracy." *Annual Review of Anthropology* 31 (1): 469–496.

Panda, Pradeep, and Bina Agarwal. 2005. "Marital Violence, Human Development, and Women's Property Status in India." *World Development* 33 (5): 823–850.

Parson, Nia. 2013. *Traumatic States: Gendered Violence, Suffering, and Care in Chile*. Nashville, TN: Vanderbilt University Press.

Pequeño, Andrea. 2009. Violencia de género y mecanismos de resolución comunitaria en comunidades indígenas de la sierra ecuatoriana. In *Mujeres Indígenas y Justicia Ancestral*, edited by M. Lang and A. Kucia, 81–89. Quito, Ecuador: UNIFEM.

Phillips, Lynne. 1987. "Women, Development, and the State in Rural Ecuador." In *Rural Women and State Policy: Feminist Perspectives on Latin American Agricultural Development*, edited by C. D. Deere and M. León, 105–123. Boulder, CO: Westview Press.

Phillips, Lynne, and Sally Cole. 2009. "Feminist Flows, Feminist Fault Lines: Women's Machineries and Women's Movements in Latin America." *Signs* 35 (1): 185–211.

Placencia, Mercedes, and Elvia Caro. 1998. *Institucionalidad para Mujer y Género en América Latina y el Caribe*. Quito, Ecuador: InterAmerican Development Bank.

Plesset, Sonja. 2006. *Sheltering Women: Negotiating Gender and Violence in Northern Italy*. Stanford, CA: Stanford University Press.

Postero, Nancy. 2007. *Now We Are Citizens: Indigenous Politics in Postmulticultural Bolivia*. Stanford, CA: Stanford University Press.

Pugh, Jeffrey D. 2018. "Universal Citizenship through the Discourse and Policy of Rafael Correa." *Latin American Politics and Society* 59 (3): 98–121.

Quesada, James, Laurie Kain Hart, and Philippe Bourgois. 2011. "Structural Vulnerability and Health: Latino Migrant Laborers in the United States." *Medical Anthropology* 30 (4): 339–362.

Rahier, Jean Muteba. 2011. "Hypersexual Black Women in the Ecuadorian 'Common Sense': An Examination of Visual and Other Representations." *Civilisation* 60 (1): 59–79.

Rahnema, Majid, and Victoria Bawtree. 1997. *The Post-Development Reader*. London: Zed Books.

Rathgeber, Eva. 1990. "Wid, Wad, Gad: Trends in Research and Practice." *Journal of Developing Areas* 24 (July): 489–502.

Rebhun, Linda-Anne. 1999. *The Heart Is Unknown Country: Love in the Changing Economy of Northeast Brazil*. Stanford, CA: Stanford University Press.

Rose, Nikolas. 2007. *The Politics of Life Itself: Biomedicine, Power, and Subjectivity in the 21st Century*. Princeton, NJ: Princeton University Press.

Rostow, Walt W. 1959. "The Stages of Economic Growth." *The Economic History Review* 12 (1): 1–16.

Rubin, Jeffrey W., and Emma Sokoloff-Rubin. 2013. *Sustaining Activism: A Brazilian Women's Movement and a Father-Daughter Collaboration*. Durham NC: Duke University Press.

Safa, Helen Icken. 1995. *The Myth of the Male Breadwinner: Women and Industrialization in the Caribbean*. Boulder, CO: Westview Press.

Salazar, Lorena, and Cesar Viteri. 1998. Informe de Visita No. 1: Implementación Bancos Comunitarios para Mujeres. Unpublished report. Quito: Fundación Natura.

———. 1998. Informe de Visita No. 3: Implementación Bancos Comunitarios para Mujeres. Unpublished report. Quito: Fundación Natura.

Scheper-Hughes, Nancy. 1992. *Death without Weeping: The Violence of Everyday Life in Brazil*. Berkeley: University of California Press.

———. 2000. "The Global Traffic in Human Organs." *Current Anthropology* 41 (2): 191–224.

Scheper-Hughes, Nancy, and Philippe Bourgois. 2004. "Introduction: Making Sense of Violence." In *Violence in War and Peace: An Anthology*, edited by N. Scheper-Hughes and P. Bourgois, 1–33. Malden, MA: Blackwell Publishing.

Schuler, Sidney Ruth, Rachel Lenzi, Sohela Nazneen, and Lisa M. Bates. 2013. "Perceived Decline in Intimate Partner Violence against Women in Bangladesh: Qualitative Evidence." *Studies in Family Planning* 44 (3): 243–257.

Schuler, Sidney Ruth, and Sohela Nazneen. 2018. "Does Intimate Partner Violence Decline as Women's Empowerment Becomes Normative? Perspectives of Bangladeshi Women." *World Development* 101:284–292.

Schuler, Sidney Ruth, Syed M. Hashemi, and Shamsul Huda Badal. 1998. "Men's Violence against Women in Rural Bangladesh: Undermined or Exacerbated by Microcredit Programmes?" *Development in Practice* 8 (2): 148–157.

Schuler, Sidney Ruth, Syed M. Hashemi, Ann P. Riley, and Shireen Akhter. 1996. "Credit Programs, Patriarchy and Men's Violence against Women in Rural Bangladesh." *Social Science & Medicine* 43 (12): 1729–1742.

Scott, James C. 1976. *The Moral Economy of the Peasant: Rebellion and Subsistence in Southeast Asia*. New Haven, CT: Yale University Press.

———. 1998. *Seeing Like a State: How Certain Schemes to Improve the Human Condition Have Failed*. New Haven, CT: Yale University Press.

Speed, Shannon. 2008. *Rights in Rebellion: Indigenous Struggle and Human Rights in Chiapas*. Stanford, CA: Stanford University Press.

———. 2014. "A Dreadful Mosaic: Rethinking Gender Violence through the Lives of Indigenous Women Migrants." *Gendered Perspectives on International Development (GPID)*. 304:78–91.

Stern, Steve J., and Scott Straus. 2014. "Introduction: Embracing Paradox, Human Rights in the Global Age." In *The Human Rights Paradox: Universality and Its Discontents*, edited by S. J. Stern and S. Straus, 3–28. Madison: University of Wisconsin Press.

Stoler, Ann Laura. 2002. *Carnal Knowledge and Imperial Power: Race and the Intimate in Colonial Rule*. Berkeley: University of California Press.

Sweet, Paige L. 2014. "'Every Bone of My Body:' Domestic Violence and the Diagnostic Body." *Social Science & Medicine* 122:44–52.

Tapia Tapia, Silvana. 2016. "Sumak Kawsay, Coloniality and the Criminalisation of Violence against Women in Ecuador." *Feminist Theory* 17 (2): 141–156.

———. 2018. "Feminism and Penal Expansion: The Role of Rights-Based Criminal Law in Post-Neoliberal Ecuador." *Feminist Legal Studies* 26 (3): 285–306.

———. 2021. "Beyond Carceral Expansion: Survivors' Experiences of Using Specialised Courts for Violence against Women in Ecuador." *Social & Legal Studies* 30 (6): 848–868.

———. 2022. *Feminism, Violence against Women, and Law Reform: Decolonial Lessons from Ecuador*. London: Routledge.

Tapia Tapia, Silvana, and Kate Bedford. 2021. "Specialised (in)Security: Violence against Women, Criminal Courts, and the Gendered Presence of the State in Ecuador." *Latin American Law Review* 7:21–42.

True, Jacqui. 2012. *The Political Economy of Violence against Women*. New York: Oxford University Press.

Tsing, Anna Lowenhaupt. 1993. *In the Realm of the Diamond Queen*. Princeton, NJ: Princeton University Press.

UN Women, Ministerio de Justicia, Derechos Humanos y Cultos, Ministerio del Interior, Ministerio de la Educación, Ministerio de Salud Pública, Ministerio de Inclusión Económica y Social, and Consejo Nacional de la Niñez y Adolescencia. 2015. *Plan Nacional Para la Erradicación de la Violencia de Genero hacia la Niñez, Adolescencia y Mujeres*. Pamphlet. Quito: UN Women.

Villacres Manzano, Pamela. 2009. *La Industria del Sexo en Quito: Representaciones sobre las Trabajadoras Sexuales Colombianas*. Quito: FLACSO-Sede Ecuador, Ediciones Abya-Yala.

Vallejo Salcedo, Lili Carolina. 2012. "Análisis y Percepciones de las Piezas Publicitarias de la Campaña Reacciona Ecuador el Machismo es Violencia." MA Thesis. Quito: Facultad Latinoamericana de Ciencias Sociales sede Ecuador (FLACSO).

Wentzell, Emily A. 2013. *Maturing Masculinities: Aging, Chronic Illness, and Viagra in Mexico.* Durham, NC: Duke University Press.

West, Paige, and James G. Carrier. 2004. "Ecotourism and Authenticity: Getting Away from It All?" *Current Anthropology* 45 (4): 483–498.

Wies, Jennifer R., and Hillary J. Haldane. 2011. *Anthropology at the Front Lines of Gender-Based Violence.* Nashville, TN: Vanderbilt University Press.

———. 2018. "Structures of Violence Throughout the Life Course: Cross-Cultural Perspectives of Gender-Based Violence." In *International Handbook on Gender and Demographic Processes,* edited by N. E. Riley and J. Brunson, 329–340. Dordrecht, Netherlands: Springer Nature.

Wilkinson, Annie. 2018. "Ecuador's Citizen Revolution 2007–17: A Lost Decade for Women's Rights and Gender Inequality." In *Seeking Rights from the Left: Gender, Sexuality, and the Latin American Pink Tide,* edited by E. J. Friedman, 269–303. Durham, NC: Duke University Press.

Wolf, Eric R. 1969. *Peasant Wars of the Twentieth Century.* New York: Harper & Row.

World Health Organization. 2005. *Addressing Violence against Women and Achieving the Millennium Development Goals.* Geneva, Switzerland: WHO.

Yarris, Kristin Elizabeth. 2011. "The Pain of 'Thinking Too Much': Dolor De Cerebro and the Embodiment of Social Hardship among Nicaraguan Women." *Ethos* 39 (2): 226–248.

Zheng, Tiantian. 2022. *Violent Intimacy: Family Harmony, State Stability, and Intimate Partner Violence in Post-Socialist China.* New York: Bloomsbury Publishing.

INDEX

Note: References in *italic* and bold refer to figures and tables. References followed by "n" refer to endnotes.

ABOUT THE AUTHOR

KARIN FRIEDERIC is an associate professor of anthropology at Wake Forest University. Her research examines how transnational human rights and global health campaigns reconfigure gendered subjectivities, family relationships, and ideas about citizenship and violence in rural communities in Latin America. Trained in four-field anthropology, with a specialization in applied medical anthropology, she integrates critical and applied approaches to global health, development, humanitarianism, and transnational feminism. Since the year 2000, Friederic has also worked with Ecuadorian communities in their efforts to obtain health services and mobilize against gender violence. In 2003, she cofounded a nonprofit organization, The Minga Foundation, which is dedicated to improving global health through community-led development.